Painter X
for
Photographers

Dedicated to
My wife Doreen

Painter X
for
Photographers

Creating painterly
images step by step

Martin Addison

AMSTERDAM • BOSTON • HEIDELBERG • LONDON • NEW YORK • OXFORD •
PARIS • SAN DIEGO • SAN FRANCISCO • SINGAPORE • SYDNEY • TOKYO

Focal Press is an imprint of Elsevier

Focal Press is an imprint of Elsevier
Linacre House, Jordan Hill, Oxford OX2 8DP, UK
30 Corporate Drive, Suite 400, Burlington, MA 01803, USA

First edition 2007

Notice
No responsibility is assumed by the publisher for any injury and/or damage to persons or property as a matter of products liability, negligence or otherwise, or from any use or operation of any methods, products, instructions or ideas contained in the material herein. Because of rapid advances in the medical sciences, in particular, independent verification of diagnoses and drug dosages should be made

British Library Cataloguing in Publication Data
Addison, Martin
 Painter X for photographers : creating painterly images
 step by step
 1. Corel Painter (Computer file)
 I. Title
 006.6'86

Library of Congress Number: 2007927929

ISBN: 978-0-240-52033-9

For information on all Focal Press publications visit
our website at www.focalpress.com

Printed and bound in Italy

07 08 09 10 11 11 10 9 8 7 6 5 4 3 2 1

Layout and design by Martin Addison QuarkXpress

Contents

MARILYN SHOLIN FINE ART

323–4 Ives Dairy Road, Miami, Florida 33179 USA
305.582.4750

Foreword

My art training began when I was very young. My mother always took me to New York City to the museums and theatres. She was adamant that I would be exposed to all there was in the art world from paintings and sculptures to movies and plays. I think she was attempting to create an artist out of me, as she was a frustrated artist and couldn't create, but enjoyed. Our home always had books about artists on the coffee table and the walls were covered with paintings.

Unfortunately, I turned out to be mostly a kindergarten artist specializing in finger-painting and paper mache. So instead, as an adult I became a photographer. But the art background left me frustrated that I couldn't create the paintings I saw in my mind, but couldn't put on film. Then I discovered Painter software and my world opened up and changed. My photographs now collided with Painter and I finally was able to create the art that is in my heart and mind.

In my continuous search for education and artistic improvement, I found Martin Addison's first book. It immediately stood out as a book that was easy to understand and gave specifics on how to use the tools in Painter. It became one of my favourite references for my own education and an instant favourite with my friends and students.

In the recent past, there was very little Painter education available. Now, with digital art booming and being accepted by the art world, there is much more to read and see. Still, in a world full of information, this book stands out for its fresh ideas and full coverage of the medium from the creation of the painting, to the finishing of the digital file including printing and presentation. It is a wealth of specific lessons and information.

Martins visuals combined with clear and concise tutorials have become a favourite of Painter artists everywhere. His tutorials are written step by step and nothing is assumed.

The reader could be a beginner or an advanced Painter and still, they would gain a tremendous amount from this book. It is clearly laid out and easy to follow. Specific settings and information are given on every page.

Every page of this book has the trademark of his personal commitment to having the reader not only understand the information, but be able to replicate it with their own paintings. It is a great resource and will help the readers to explore the art world and all that they can create with Painter. Enjoy the journey from photographs to pure artistic pleasure with Martins help.

Marilyn Sholin
Artist
Corel Painter Master
PPA Certified, Professional Photographers of America
Master Craftsman, PPA
Master Photog., PPA

Introduction

Who is this book for?

Whether you are new to digital imaging or are already familiar with Painter and other graphics programs, I am confident that this book will help you to expand your creative abilities and make many brilliant new pictures from your photographs.

As the title suggests, this book is aimed solely at photographers of all types.

For the professional photographer there are techniques which can turn a standard portrait or wedding picture into a premium priced product which is unique and desirable.

If you are a serious amateur photographer you can learn how to make pictures which are subtle or powerful according to your intentions and which are very different to work produced by many others.

For the casual photographer who would like to turn family snapshots into painterly pictures suitable for hanging on the wall there are simple step-by-step demonstrations to guide you from the original photograph to the finished picture.

What's special about this book?

There are other books which teach you how to use Painter from an artist's point of view, but this is the only one to focus solely on the photographic aspect. This approach has the great advantage that everything in the book is relevant and useful to photographers.

Painter X for Photographers progresses step by step from very simple techniques to more advanced technical expertise. Throughout the book the many illustrations are intended to provide ideas and inspiration combined with clear instructions to make the very best of your own image.

The purpose of this book is to give you a sound knowledge of the tools which Painter provides and of the techniques needed to use them. There is a wide range of skills to be learned and this book guides you through them in a simple, logical and exciting way. Of course this is only the starting point, good technique does not ensure that you make a good picture but it is essential to master this first. Once that is done your own imagination and personal style will lead you to make the great pictures that you are visualizing.

All the image files for the step-by-step examples are provided on the accompanying DVD, use these first and then try out the technique on your own photographs.

Why use Painter?

Photography is about documenting the reality around us, the photographer deciding how to interpret that reality through the choice of lenses, viewpoint and composition. Sometimes however this reality is not enough, it doesn't reflect the feelings that we originally experienced. This is not surprising of course as the conditions have changed, the sensory pleasure has been lost, the smells, sounds and atmosphere are all gone and all we now have is a one-dimensional piece of film, print or electronic image.

So we often want to take our picture further to better reflect what we felt at the time and to communicate this to the viewer who has no recall of the original experience.

This is where the fabulous Corel Painter program comes in, it is quite unique in the way it replicates traditional media and gives us the opportunity to take our pictures into another dimension altogether, revealing the hauntingly beautiful, mysterious and alluring world of the imagination.

What's in Painter X for Photographers?

Learning the basics

'Getting started in Painter' is a simple guide to the Painter program, this is for the total beginner and takes a brief look at the main tools and palettes and includes general hints and tips on how to get the best out of the program. It also gives help to Photoshop users in understanding the differences between the two programs. If you have used Painter before you could skip this section and go straight on to the first cloning chapter. 'First steps in cloning' shows the process through which we transform photographs from their original state to a new and exciting existence. Even at this early stage of the book, you will be able to make beautifully soft images and we are still only on the first chapter!

Understanding brushes

Brushes are at the heart of everything we do in Painter and understanding which brush to use and how it works is crucial to working creatively. 'Choosing brushes' illustrates every one of the main brush categories and explains how they differ. Examples of finished pictures are provided as a source for ideas and inspiration. The 'Customizing brushes' chapter shows how the standard brushes can be customized using the Brush Creator.

Paper textures are great

Paper textures are an essential part of using Painter, they provide depth and texture to the picture and the program has hundreds to choose from. 'Exploring paper textures' explains what textures are and how to use them. 'Applying surface textures' illustrates how to apply textures at the end of the painting process. Chapter 15 contains illustrations of every paper texture which is available in the Painter program and is an invaluable resource.

Advanced techniques

The chapter on 'Layers and montage' explains how layers work including the way in which individual layers can be combined creatively to produce stunning new effects. The first chapter on cloning explains the basics of cloning but there are several other chapters which have more advanced techniques. The 'Watercolor, oils and pastel' chapter explains how these traditional media types can be replicated while 'Mosaics and other clones' covers more special types including the fascinating Mosaics section where you can make your own Roman mosaic.

Portraits

Following the publication of my first book I received many requests from readers to include more examples on how to make pictures of people. So there are two chapters covering this subject. 'Children and young people' shows how to create beautiful soft pictures from photographs of children and 'Portraits' uses step-by-step examples to transform portraits and special occasions into distinctive and unique images.

Other ways to use Painter

'Hand tinting and toning' is a fascinating subject and Painter excels in providing all you need to make delicate tinted alternatives which are so popular in making pictures that little bit different.

There are also lots of 'Special effects' available, everything from simulating burnt paper to making kaleidoscopic images. This section is great fun and packed full of colorful examples.

Printing and presentation

When you have completed your picture you still need to print and present it to the best possible advantage. This chapter gives some ideas on presentation and design plus practical advice on printing including what file size you should use.

What should I know before I start?

This book has been written on a PC and all the screen shots reflect that platform. Painter operates virtually identically on both PC and Macintosh computers. Keyboard shortcuts are of course different, the Ctrl key on Windows becomes the Cmd key on the Mackintosh, and likewise the Alt becomes Opt.

If you have used Painter before and are following my step-by-step instructions it may be advisable to return the brushes to their default settings before you begin, or they may not react as predicted. To do this, click on the small triangle on the Brush Selector and select Restore All Default Variants.

Always remember to save your picture regularly to avoid losing work, it is also good practice to work on a copy of your picture and keep the original safe.

Where can I get help?

www.painterforphotographers.co.uk
Painterforphotographers is the website which accompanies this book. There are additional step-by-step techniques, galleries, information and links to other Painter sites, plus amendments to this book and FAQ's from readers.

www.corel.com
The home site of Corel is where you can find information on the latest versions of Painter, updates and training. Look out in particular for the Painter Canvas, a regular newsletter which has tutorials and news about Painter.

www.digitalpaintingforum.com
Marilyn Sholin runs this Digital Painting Forum which allows members to participate and share ideas and pictures with other Painter users.

What's new in Painter X?

RealBristle Brushes
As always there are some interesting and useful features in the new upgrade and for me the most exciting development is the new range of brushes called RealBristle brushes. These brushes are brilliant because they replicate the natural movement of the artists brush and give simply beautiful bristle effects not possible before. Used for cloning photographs the textures are delightful and so easy to use. Chapter 3 illustrates this lovely range of brushes.

Photo Painting system
The three new palettes which make up this system provide a quick way of creating painterly pictures and makes the process of underpainting very easy. Chapter 9 shows how to use the Auto-Painting palette while the Under-painting palette is covered in Chapter 14.

Workspace Manager
This useful feature allows you to create and save workspaces for particular projects, there is a demonstration on its use in Chapter 1.

Divine proportion
The divine proportion can be used to help artists form a really strong composition. For photographers this can be of great help in the final stages when creative cropping can enhance the final result. This feature is available from the Toolbox together with the Layout grid option; they are both controlled via a palette in the Window menu. Take a look at the Painter Help files for more detail on this feature.

Speed enhancements

Depending on your system hardware, Corel Painter X provides up to five times faster start-up performance compared with previous versions of the software. Plus, brush engine performance is 35% faster, opening RIFF files is two times faster, rendering effects is two times faster, running scripts is 25% faster, and file saving is now up to 40% faster. As with any application, the larger file you use or create, the more processor power you will require and you can change the percentage of memory usage dedicated to Corel Painter in the preferences.

Other enhancements

These include the Match palette effect which will allow you to copy the color and intensity of one image and apply it to another, an improved use of the Mixer palette when painting with the new bristle brushes and new Dodge, Burn and Rubber Stamp tools in the Toolbox.

An excellent upgrade.

Acknowledgements

I would like to thank the following people for their help in the making of this book.

June Cook for allowing me to use one of her delightful dog pictures, she can be contacted at june.cook@virgin.net

Carol Addison for allowing me to use her picture of Harvey.

Annabel, Bob, Diane, Donna, Dorette, Griff, Harvey, Jan and Rebecca for allowing me to use photographs of them in various chapters of the book.

Everyone at Focal Press for their encouragement and assistance at all stages of the book production.

Chris Boba at Corel for doing all the technical checking.

Permajet Ltd of Warwick UK (www.permajet.com) for providing me a range of their excellent inkjet papers and ink systems.

Marilyn Sholin for writing the excellent Foreword.

Most of all to my wife Doreen for not only letting me use several of her photographs, but also for her unfailing support and encouragement, not to mention keeping me working on the book!

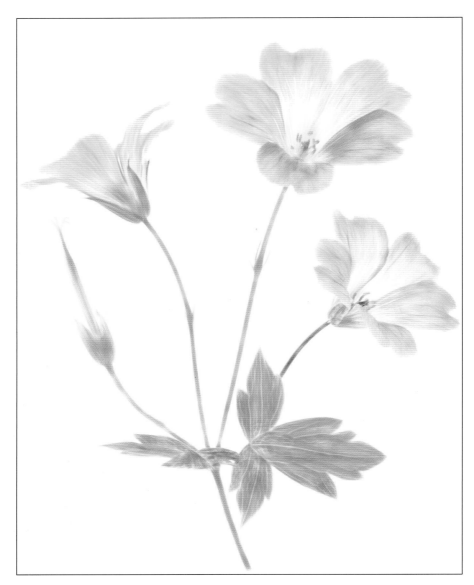

Figure 1.1 *Geraniums.*

1

Getting started in Painter

The Painter X workspace

Setting up preferences

Painter X – Photoshop

The first part of this chapter is intended for complete beginners to Painter and contains simple exercises to guide the user in identifying the key areas of the workspace prior to first using Painter. If you have previously used Painter you may wish to skim this section or just pick up on the newer features.

The second part of the chapter contains information to enable you to customize the program to your own requirements and covers the use of Graphic Tablets and setting Preferences to make the work process smoother and quicker.

Both sections can be used as a quick reference guide to the key elements as you work through the step-by-step examples in later chapters.

Information on printing and color management can be found in Chapter 14.

Many readers will have already used and be very familiar with Adobe Photoshop and for them I have included a section highlighting the differences between the two programs, sometimes the naming of techniques differs and of course where to find particular commands. There are also tables of file compatibility, tools and keyboard shortcuts.

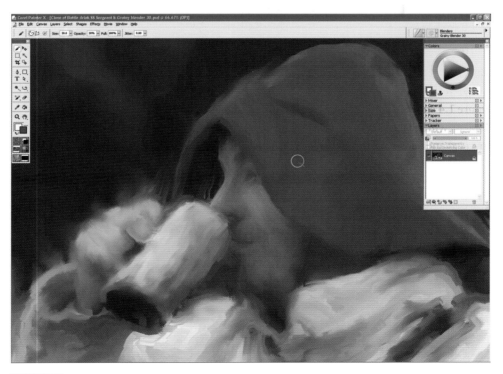

Figure 1.2 *The Painter X workspace.*

The Painter X workspace

The default view

Figure 1.3 shows the default view of Painter X with the File bar at the top of the screen, the Properties bar just beneath, leading to the Brush Selector on the right. The Tools are on the left and a selection of palettes on the right.

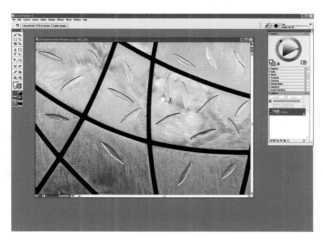

Figure 1.3 The default view of Painter X.

Toolbox

The Toolbox is where all the tools are stored (no surprise there then) and Figure 1.4 shows the Painter X Toolbox with all the hidden tools revealed and shown in red.

To access the hidden tools click and hold the visible tool and the other options will appear to the side, just click the one required.

Some of the important tools which are being used in this book are detailed in this chapter, but most are very obvious by their icons.

Figure 1.4 The Toolbox with hidden tools shown in red.

Keyboard shortcuts are set up for many of the regularly used tools and others can be customized in the Preferences menu.

A full explanation of all the tools can be found in the Painter program under Help> Help Topics.

Opening a picture in Painter

Painter X can open and 'save as' a wide variety of photographic files, including JPEG (JPG), TIFF, CMYK TIF, BMP, PCX, PSPIMAGE, FRM, TGA, GIF, Adobe Photoshop (PSD), and RIFF (Corel Painter native format).

*Adobe Photoshop formats (PSD) — Corel Painter preserves layers, layer masks, alpha channels, and composite methods. Layer effects and adjustment layers are not supported and should be merged or flattened in Adobe Photoshop.

**RIFF — Corel Painter native format (RIF) — The benefit of using this file format is that it is uncompressed and will preserve all the native layers and features of Corel Painter X (for example your paint will stay wet).

It is generally desirable not to use very large image files as they will slow the program down and some of the complex brushes in particular can be very slow.

If the image is to be printed then a resolution between 150 and 300 dpi is preferable which means a file size of between 10 and 20 Mb. For web use a much smaller file size can be used, in most cases around 1 Mb. More information on file sizes and printing can be found in Chapter 14.

Figure 1.3 shows the first picture on the DVD which is opened from the file bar by going to File> Open> DVD> Step-by-step files> '01 Stained glass window'. You can use this or if you prefer use your own photograph.

Brush Selector

The Brush Selector is where the type of brush is chosen, brushes are at the heart of everything in Painter and are dealt within a lot more depth in Chapters 3 and 4.

On the right of the Properties bar is the Brush Selector. Click the brush icon on the left and the drop down menu will reveal the extensive range of brush categories that are available. Click and drag down the right bottom corner of the menu to see the full list of brush categories or use the scroll bar on the right.

Click on the right hand icon to reveal another drop down menu that shows the list

Figure 1.5 The Brush Selector.

of variants for the Oils brush category. Once again you will need to drag down the list to reveal all the variants. This is a very large category and will give some idea of the huge number of brushes available. Click on the Bristle Oils 30 brush as illustrated in Figure 1.5.

Picking a color from the Colors palette

To choose a color to paint with go to the Colors palette, which should be visible on the right of the screen. If this is not the case go to Window> Color Palettes> Show Colors and it will appear.

Figure 1.6 shows the Colors palette. Click in the outer colored circle to choose the hue or color. The inner section defines the brightness of the color, the pure color is on the right, the darker colors bottom left and lighter at the top, click within the triangle to choose the tone. The blue square (bottom left in Figure 1.6) is the Main color and confirms which color has been chosen. The Colors palette is explained in more detail in Chapter 10.

Draw some lines on the picture to get a feel for the brush. If you are using a graphic tablet you will see that the brush responds differently depending on the angle used, this is common to many of the brushes. I recommend that you use a graphic tablet as it is essential for getting the most out of the program. At the end of this chapter there are some tips on setting up your graphics tablet for Painter.

Now try a brush from the Chalk brush category, click on Square Chalk 30 which is very different to the Oil brush. Try some of the other brush categories yourself but for the

Figure 1.6 The Colors palette

moment avoid the Watercolor and Liquid Ink categories as they need a special layer to work on and will be explained in more detail in Chapter 8.

Properties bar

Figure 1.7 shows the Properties Bar, this is a context sensitive bar and changes to whatever tool is currently active. In the example shown it is relevant to the Brush and this is where the brush size is usually changed. Alongside this is the Opacity setting that adjusts the density of color being put onto the paper. The other settings will be dealt with in more detail in Chapter 4.

Figure 1.7 The Properties bar.

Correcting mistakes

Your image will now be covered with paint strokes so this is a good point to show how to correct mistakes and if necessary return a picture back to its original state.

The very valuable Undo command is found in the Edit menu and as we have been using a brush the line will read Undo Brush Stroke. Click on this and the last brush stroke will be undone, click on it again and the previous brush stroke will also be

Figure 1.8 Correcting mistakes.

undone. As you can see, the command works backwards and continues to remove the last action taken until you reach the maximum numbers of Undo, which is 32 steps. This number can be changed in the Preferences menu which is covered later on in this chapter.

Rather than go to the menu every time you want to use the Undo, it is much quicker to use the keyboard shortcut which is Ctrl/Cmd + Z. If you are a Photoshop user you will need to be aware that the Undo command in Painter works differently and is not a toggle action.

To ReDo an action, go to Edit> ReDo or use the shortcut Ctrl/Cmd + Y.

If you want to get back to the original, go to File> Revert. Confirm you want to do this by clicking Revert in the pop up dialog box and the picture will return to its original state. This will work provided the original picture is still in the same place from which it was loaded, either on your computer or on the DVD.

Moving around the picture

One of the great advantages with all graphic programs is the ability to enlarge the picture to work at a more detailed level. The quickest

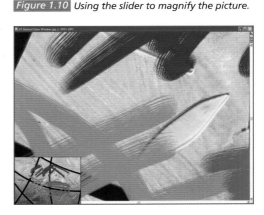

Figure 1.9 Magnifier options on the Properties bar.

way of doing this is to use the keyboard shortcuts, but I will give the Toolbox method as well.

Click on the Magnifier in the Toolbox and click in the picture, this will enlarge the picture by 25% each time you click. To reduce the magnification, hold down the Opt/Alt key and click in the picture again. When the Magnifier tool is active there are three buttons on the Properties bar that give pre-set views.

Actual Pixels show the image at 100% enlargement, which is very useful for checking detail.

Fit on Screen will show the whole picture on the screen as large as possible without being hidden by anything else.

Centre Image will return the image to the centre when it has been magnified.

Another way to change the magnification is to use the slider at the base of the document window (Figure 1.10). The percentage number shown on the right of the bar is the current magnification of the picture. Type in an amount and press enter to go to a specific magnification. Increase the magnification significantly then click on the binoculars icon shown in Figure 1.10 to the left of the slider, this will show you which part of the image is being magnified.

Figure 1.10 Using the slider to magnify the picture.

The screen is shown in Figure 1.11 with the full picture in the small rectangle bottom left and a red rectangle showing the part of the picture that is being shown on screen. Click and drag inside the rectangle to move the point of magnification.

Click the Grabber (hand icon) in the Toolbox and the cursor will change to a hand, click and drag in the window to move the image. Double click on the Grabber icon in the Toolbox and the picture will change from a magnified view to the full picture being visible on screen.

Figure 1.11 Using the Navigator.

Rotating the canvas

The Grabber is one of several tools that have alternative options in the Toolbox. Click and hold the Grabber and select the second icon with a circular arrow. This is the Rotate Page tool and allows the picture to be rotated to make it easier to paint with certain brushes. Don't get this confused with the Rotate Canvas command in the Canvas menu, this tool simply turns the picture around in the same way a traditional artist might move a canvas around to get a better angle.

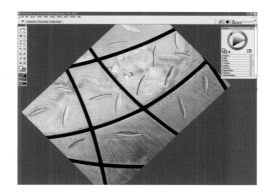

Figure 1.12 *Rotating the canvas.*

Click and drag in the document window to see the image rotate, to return to the original position click once on the canvas or double click on the Rotate Page icon in the Toolbox. Figure 1.12 shows the rotated canvas.

Normal view

The Normal view is shown in Figure 1.13 and the picture is contained within its document window. The Full Screen option frees the image from the confines of the document box and fills the entire screen including behind the palettes and Toolbox. This is a good way to work as it allows more freedom to move the image around on screen and removes much of the clutter.

Figure 1.13 *Normal view.*

Full screen view

Figure 1.14 shows the Full Screen View, to use this mode either go to the Window menu and click on Screen Mode Toggle or use the keyboard shortcut Ctrl/Cmd + M. This is a toggle action so pressing the keys again will revert to the normal view.

Figure 1.14 *Full screen view.*

Keyboard shortcuts for the screen

Ctrl/Cmd ++ will magnify the image.

Ctrl/Cmd +− will reduce the magnification.

Ctrl/Cmd + Alt/Opt + 0 will show the picture at 100% (Actual pixels).

Ctrl/Cmd + 0 will make the image fit on the screen.

Pressing the Spacebar while painting will activate the Grabber to enable the image to be moved.

Using and organizing palettes

There are over 30 palettes in Painter X and even though they will collapse and stack very neatly they do take up room on the screen that could be used for the image. Many of them are not usually needed when using photographs so fortunately they are easy to organize and unwanted ones can be removed.

To remove a palette from the screen, click on the cross in a square on the palette header. To show palettes not visible on the screen, go to the Window menu and click on the name of the palette you want, some of the palettes are arranged in groups for convenience.

To expand or close a palette, click either on the triangle on the left or on the name of the palette itself. To move and link palettes together click on the blank area to the right of the palette name and drag the palette over another palette and they will dock together.

Figure 1.15 shows the palettes that I keep on the screen and use regularly, they are usually kept collapsed as shown and opened when required.

Figure 1.15 *Useful palettes to keep on screen.*

Creating custom palettes

It is often very useful to create custom palettes, some to use on a regular basis and others just for a particular picture or project. Here is a quick guide to creating a custom palette with a variety of shortcuts.

Select a brush variant from the brush selector, click on the variant icon and drag it out into the main workspace. A custom menu will be immediately

Figure 1.16 *Custom palette.*

created as in Figure 1.16; you can now add further items to the palette. Select a brush from another brush category, drag that onto your new custom palette, and position it to the right of the original icon.

The icon can be positioned anywhere on the custom palette, alongside or below. If you want to re-arrange the icons hold down the shift key and drag the icon to where you want it to be. To delete an icon hold down the Shift key and drag the icon off the palette.

Now add a paper texture, open the Papers palette or use the quick icons in the Toolbox and drag the paper icon from the palette onto the Custom palette.

Menu commands can also be added, go to Window> Custom Palette> Add Command and the dialog box shown in Figure 1.17 appears, select the name of the palette you are working on. To add the Tracing Paper command, go to Canvas> Tracing Paper then return to the Add Command palette and click OK, the shortcut will appear on the new palette.

Figure 1.17 Add command to custom palette.

To delete or rename custom palettes go to Window> Custom Palettes> Organizer, highlight the palette you want to change and click the relevant button. Painter will remember this palette each time you open the program but to save a really useful palette permanently it can be saved as a file by pressing Export. The Import button will add palettes previously saved. Figure 1.18 shows an example of a Custom palette fully created.

Figure 1.18 A custom palette for cloning.

Palette menu

One further note regarding palettes: on the right side of the palette name is a small triangle (circled in Figure 1.19) that indicates the palette contains a Palette menu. This is a further selection of options relevant to that particular palette, click and hold on the triangle to see the drop down menu. The various palettes will be looked at in more detail as you work through the step-by-step examples in the book.

Figure 1.19 The palette menu extended.

Brush Creator

The Brush Creator is covered in some detail in Chapter 4, but gets a quick mention here as it is used in a few step-by-step examples in earlier chapters.

Figure 1.20 The Brush Creator.

This palette, which is accessed by the Ctrl/Cmd + B shortcut or from Window>Show Brush Creator, houses the controls for customizing brushes. Clicking on a category from the list on the left opens the relevant sub palette and reveals the sliders and options available. On the right is the Scratch Pad where brushes can be tried out prior to use.

In Painter X all the sub palettes are also available as separate palettes that can be brought on the screen individually which is very useful as many of the palettes are rarely used. One palette I recommend you keep on screen is the General palette and this is available from Window> Brush Controls> General. In some earlier versions of Painter this is not available separately but it can be accessed from the Brush Creator.

Using a graphic tablet

A graphic tablet with a pressure sensitive stylus is a must to obtain the Painter brushe's full potential. Wacom are the leading brand of tablets and have a large range from small to very large sizes. I personally find the A5 (6 × 8 inch) size ideal, it is large enough to have ample room for brush strokes yet not take up too much space on the desktop.

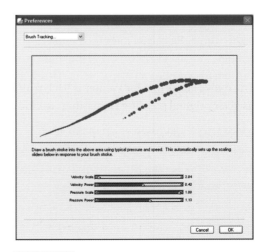

Figure 1.21 Brush tracking in the Preferences menu.

How you set up the button configuration for your pressure sensitive pen is a matter of personal preference, once the software has been installed on your computer the controls can be accessed via the Control Panel for Windows or in Applications on Mac OS X.

All the brush and opacity settings used throughout the book are for use with a graphic tablet. If you are using a mouse you will need to reduce the specified opacities quite considerably.

Brush Tracking is a control within Painter to adjust the sensitivity of the pen to suit your own hand. In the Edit menu go to Preferences and select Brush Tracking in the dialog box.

Make a few sample strokes pressing at various intensities in the Scratch Pad as in Figure 1.21 and Painter will automatically adjust the pen sensitivity to your own hand pressure.

Saving images

There are three options for saving images available from the File menu.

Save, will save the image, overwriting the original file.

Save As, will save a copy under a different name if required.

Iterative Save, is very useful when you need to keep interim versions of the image showing different stages of completion. Each time the image is saved Painter adds an incremental number to the file, 001 then 002 and so on. This is a very useful option for returning to an earlier stage, usually these interim saves are deleted when the image is completed.

Painter will save images in several file formats, but generally it should be saved in the same file type in which it was originally opened. In the case of photographs this will usually be PSD if it has come via Photoshop or JPEG if from a digital camera.

Images that started as JPEGs should be saved as a PSD, or RIFF (see below) while being worked on in Painter, as continually saving in JPEG format will degrade the image quality.

The native file format for Painter is RIFF which would be chosen were the program being used for original painting rather than working from photographs.

It is however advantageous to use RIFF when particular brush categories are used, these are mainly Watercolor and Liquid Ink, in RIFF file format these can be saved and re-opened at a later date and brush strokes can be edited. Mosaics are another case where it is useful for RIFF to be used for the same reason. If you are a Photoshop user it is easy to think of these as adjustment layers which are permanently editable until the file is flattened. Dynamic Plug-in layers which are available from the bottom of the Layers palette are also very similar to Photoshop adjustment layers and are not editable once the file is saved in any format other then RIFF.

Default settings

As you continue to use Painter you will be changing the settings of many brushes and Painter remembers these from session to session which is very useful, however it is often desirable to return to the default settings from time to time.

To return an individual brush variant to its default setting either click the brush icon on the far left of the Properties bar or click the palette menu triangle in the Brush Selector and choose Restore Default Variant. In the same place is the option to restore all of the brushes to their defaults.

Should you wish to restore all of the Painter defaults to their original settings then hold down the Shift key when you open the Painter program and this will give you the option of returning all the defaults to factory settings. You will of course lose ALL of your changes throughout the whole program so think carefully before doing this!

Setting up preferences

Preferences – General

Apart from the Brush Tracking already mentioned there are a number of other important and useful settings to be found in the Edit> Preferences menu.

Figure 1.22 shows the controls under the General heading and the top left controls the appearance of the cursor.

The Cursor Type is usually best set to Brush and a shape can be selected from the menu alongside.

Enable Brush Ghosting means that the size of the brush can be seen on screen before painting, it changes to the cursor during actual painting.

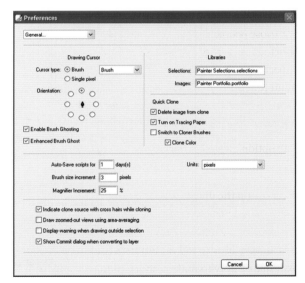

Figure 1.22 Preferences, General section.

Enhanced Brush Ghosting stays as a circle but also has a point/line to indicate the centre and in which direction the brush is painting, this is particularly useful when using large brushes as you can identify very precisely the point at which to paint.

Brush size increments control the amount of increase or decrease in brush size when the square brackets keyboard shortcut is used.

The Quick Clone options control the steps that are carried out when Quick Clone is used. I suggest that you set them as in Figure 1.22 to start with.

All other options can be left on the default settings.

Preferences – Operating System

Tick both boxes in this dialog box, the No Device Dependent option is for Windows users who use 16 bit monitors, if you use other monitors it will not have any effect.

Preferences – Undo

In this dialog box the number of steps of 'undo' Painter will remember is specified. The decision on the number to set will be based largely on the amount of RAM that is installed on the computer. The higher the number, the more flexible the undo is, but the downside is that this uses more memory as Painter keeps track of the undo steps. The maximum number is 32.

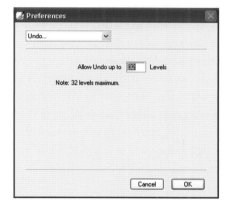

Preferences – Customize Keys

For those people, like myself, who use keyboard shortcuts a lot the Customize Keys option is superb. It allows shortcuts to be made for all the

Figure 1.23 Undo Dialog box.

main functions in Painter and you can also change the default ones if you wish. It is particularly useful if you use another program like Photoshop for instance, as you can use the same shortcuts in both programs.

The option existed in earlier versions of Painter but in Painter X the dialog box has had an overhaul and is much more user friendly.

To bring up the dialog box, go to Edit> Preferences> Customize Keys. Figure 1.24 shows the dialog box at this stage. It is all very easy to follow, but here is an example of how to make a shortcut for the Revert option (which has the function key F12 in Photoshop).

Open the dialog box and click on the plus sign to the left of the word File, this will bring up the list of commands in the File menu. Highlight Revert and as you will see there is no shortcut allocated to it. Press the F12 key to set this as the

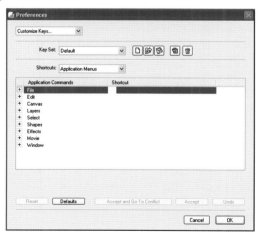

Figure 1.24 The Customize Keys dialog box.

shortcut, make any more shortcuts in the same way then press OK to accept all the changes you have made. It is that simple.

Apart from commands in the menu bar, keyboard shortcuts can be set for the palette menus and tools, change the option in the Shortcuts dialog box to access the other areas.

The changes you have made will be saved for immediate and ongoing use, but if you have to reload the program they may be lost, you can therefore save your own set by pressing the save icon. You can also save and load different sets for specific types of usage.

Customize workspace

A new feature in Painter X is the ability to create and save custom workspaces and to share created workspaces with other people. This can be particularly useful when you want to do a particular type of work, for instance you may want to create a workspace for cloning pictures in which you have particular papers or brush libraries on view while others are hidden.

To create a new workspace go to Window> Workspace> New Workspace and give your new workspace a name.

Arrange the palettes and tools how you want them, you could make a custom palette with favorite brushes and papers, this is shown earlier in this chapter.

Figure 1.25 Customize workspace.

Figure 1.26 Naming a new workspace.

Painter X – Photoshop

This book has been written so that no knowledge of any other program is necessary, however I am well aware that many readers will already be very familiar with Adobe Photoshop as it is the premier professional image editing program.

Therefore this section aims to explain the main differences between the two programs: how the names for the same procedure differ, an explanation of how files can be interchanged the consequences of doing so and some workarounds to make life easier.

Terminology and usage

PHOTOSHOP	PAINTER X	COMMENTS
Actions	Scripts	Work in a similar way
Background	Canvas	Similar but does not always work in the same way
Background Color	Not available	What looks like the Background color is actually the Additional Color which is used for two color brushes
Color Picker	Color Picker	Single click in Toolbox in Photoshop, double click in Painter
Duplicate Canvas	No option – see right for workaround	Activate Canvas, Select> All, Edit> Copy, Edit> Paste in Place to make a copy at the top of the layer stack
Duplicate Layer	Duplicate Layer	Right click layer in Painter
Fill	Fill	Under the Effects menu in Painter
Flatten Image	Drop All	Available from the Layers palette menu
Foreground Color	Foreground Color	This works in the same way
Filters menu	Effects menu	Filters are in the Effects menu
Image adjustments menu	Effects menu	Image adjustments are in the Effects menu
Layer Blending Mode	Layer Composite Method	Works in the same way but not all layer modes are compatible, see below for more details.
Merge Visible	Collapse	Select all the layers to be merged by holding down the Shift key and clicking on each layer. Click the layer command icon which is bottom left in the Layers palette and select Collapse to merge the layers.
Transform	Orientation	In the Effects menu

File compatibility

PHOTOSHOP TO PAINTER X	
Adjustment layers	Effect ignored, opens as an empty layer
Alpha channels	Compatible
Layer	Compatible
Layer blend modes	The modes which open correctly are: Normal, Dissolve, Darken, Multiply, Lighten, Screen, Overlay, Soft Light, Hard Light, Difference, Hue, Saturation, Color and Luminosity. All other layer blend modes will change to Default.
Layer effects	Ignored
Layer masks	Compatible
Layer groups	Compatible
Smart layers	Converts to normal layer
Text layers	Converts to normal layer

PAINTER X TO PHOTOSHOP	
Alpha channels	Compatible
Dynamic Plug-in layers	Converts to normal layer
Layer	Compatible
Layer blend modes	The modes which open correctly are: Normal, Dissolve, Darken, Multiply, Lighten, Screen, Overlay, Soft Light, Hard Light, Difference, Hue, Saturation, Color and Luminosity. All other layer blend modes will change to Normal.
Layer groups	Compatible
Layer masks	Compatible
Liquid Ink layers	Converts to normal layer
Mosaics	Converts to normal layer
Text layers	Converts to normal layer
Watercolor layers	Converts to normal layer

Tools

PHOTOSHOP	PAINTER X	COMMENTS
Eyedropper	Dropper	Same usage
Hand	Grabber	Same usage but has an additional tool to rotate the canvas
Move	Layer Adjuster	Same usage
None	Selection Adjuster	A useful tool, Photoshop has the command under the Select menu
Selection Tool	Marquee	Same usage

Keyboard Shortcuts

Change Brush Size	Ctrl/Cmd + Alt/Opt and drag in the document, the circle shows the brush size
Increase Brush Size (Incremental)	Square Brackets – Left (The incremental amount can be set in the General Preferences)
Decrease Brush Size (Incremental)	Square Brackets – Right
Change between active documents on screen	Ctrl/Cmd + Tab
Select All	Ctrl/Cmd + A
Deselect	Ctrl/Cmd + D
Copy	Ctrl/Cmd + C
Paste	Ctrl/Cmd + V
Paste in Place	Ctrl/Cmd + Shift + V
Save	Ctrl/Cmd + S
Save As	Ctrl/Cmd + Shift + S
Undo	Ctrl/Cmd + Z
Re-Do	Ctrl/Cmd + Y
Tracing Paper	Ctrl/Cmd + T
Adjust Opacity	Numbers on keyboard, that is 2 for 20%
Remember that you can change any keyboard shortcut and create your own in the Preferences> Customize Keys	

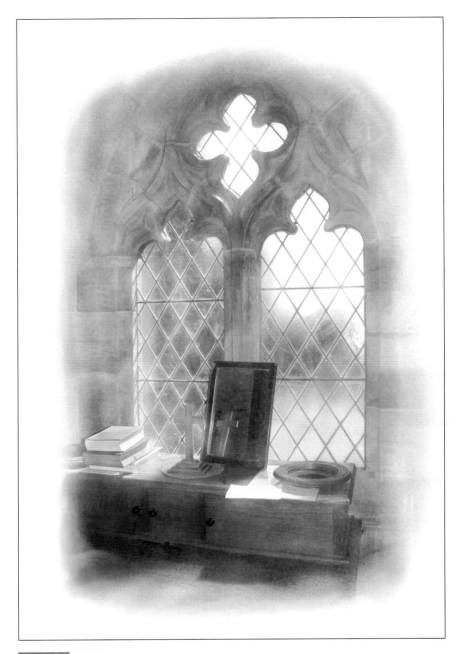

Figure 2.1 Vestry.

2

First steps in cloning

There are many ways to create artistic pictures with Painter: painting from scratch in a blank document, using plug-in filters to change photographs in various ways and using a method called cloning.

The major part of this book deals with cloning techniques of all kinds, so it is worth explaining just what cloning means in this context. The term has a different meaning in other graphic programs such as Photoshop where cloning tools are chiefly used for retouching images. It can mean this in Painter too as there are tools which do just that, however when I discuss cloning photographs I am referring to the process which takes the imagery from an original photograph and reinterprets it in an artistic manner through the use of Painter brushes and paper surfaces.

In this chapter you will learn, through step-by-step examples, the basic clone types in Painter. They are very easy to create and by the end of the chapter you will understand how to make artistic clones from photographs. The remainder of the book builds on these basic techniques and will gradually introduce more complex ideas and other ways to reinterpret your photographs.

Figure 2.2 *Pebbles on rock, made with the Soft Cloner.*

Basic cloning techniques

The steps needed to create a clone copy are easy to follow and the process was made even quicker and simpler when the Quick Clone command was first introduced in Painter X.

Step 1 File> Open and select your picture.

Step 2 File> Quick Clone, this will achieve several steps which in earlier versions had to be done separately. A copy of the original picture is created, all the imagery is removed ready to clone, a brush from the Cloners category is selected and the Tracing Paper option activated.

Figure 2.4 shows the screen after the Quick Clone command has been used.

If you are using a version of Painter prior to X you will need to take the following steps.

File> Open, File> Clone, Select> Select All, Edit> Cut, Canvas> Tracing Paper.

The steps which the Quick Clone carries out can be customized to your preference by going to the Preferences which are explained in Chapter 1. For instance I prefer that this command does not revert to the Cloner brushes each time so I untick that option, but I tick the option for Clone Color which will turn most brushes into cloners. There is a lot more information on individual brushes and which are suitable for cloning in Chapter 4.

You can save your clone copy and continue on another day. Save the pictures as normal. When you want to continue cloning open the original image first, then the clone copy. With the clone copy active go to File> Clone Source and click on the name of your original image.

Figure 2.3 *Tracing paper off.*

Figure 2.4 *Tracing paper on.*

Tracing paper

Tracing Paper is a semi-transparent overlay of the original picture that assists in the early steps of making a clone copy. The overlay can be clearly seen in Figure 2.4 and when the Tracing Paper option is turned off the clone copy will be shown as an empty document (which it is). The overlay is created automatically when the default Quick Clone procedure is used and can be turned on and off at any time. To turn the Tracing Paper on and off click the top icon on the right of the document window, just above the grid icon as shown in Figure 2.5. The keyboard shortcut is Ctrl/Cmd + T and this is a toggle action. It is

Figure 2.5 *Tracing paper.*

important to note that the overlay is purely there to help you start the painting; it is not part of the picture and will not be part of the final image if you print it.

Soft clone

The first step-by-step example in this chapter is what is called a 'soft clone' and this is a clone that does not use any paper texture but has a very smooth finish. It is a simple clone that can result in a beautiful delicate picture and is a good one to start with. Try it with the picture that is on the DVD, it has been tested with this image so it will be easier to follow. Throughout the book the precise settings will be given for each brush and it is most important that you follow these carefully to achieve the desired result with the picture provided. Remember that if you are using a mouse you will need to use lower opacity settings. When you try this with your own picture the settings will vary depending on the content.

This particular cloning brush is used extensively throughout the book as not only can it be used for creating a picture as in this example, it is often used to bring back parts of the original image to a picture made with more painterly brushes.

To avoid any potential problems with brushes working differently to those indicated I suggest that you return the brushes chosen to their default settings. To return a single brush to its default setting first select the brush you are using and then click on the brush icon on the left of the Properties bar. To return all the brushes to their default settings click on the small triangle on the Brush Selector that is at the top right of the screen and select Restore All Default Variants.

Step 1 File> Open> DVD> Step-by-step files> '02 magnolia'.

Step 2 File > Quick Clone. If you still have the Quick Clone settings on their default this should have created a new document, cleared the picture information and overlaid the Tracing Paper.

Step 3 Click on the document bar at the top of the clone and drag it to see the original underneath, Figure 2.4 shows the screen at this point. The

Figure 2.6 *Original Photograph.*

tracing paper overlay is hiding what is now an empty canvas, click the Tracing Paper icon (shown in Figure 2.5) in the top right corner of the clone document window to check that this is indeed empty, click again to reapply the tracing paper. Remember that the original image must stay on the screen at all times as the brush strokes you are about to make will be coming from that linked photograph.

Go to Window> Screen Mode Toggle to put the picture in Full Screen Mode which allows the picture to spread across the whole screen, I prefer to paint in this mode which hides the original picture and makes it very easy to move the picture around. The keyboard shortcut for this is Ctrl/Cmd + M which is a toggle action.

Step 4 The Brush Selector is on the right of the Properties bar and is seen in Figure 2.7.

The Brush Category should now be Cloners and if it is not, click the brush icon on the left and select Cloners in the drop down menu.

Figure 2.7 *The Brush Selector.*

To select a Brush Variant click the icon to the right and a long list of Variants in the Cloners Category will drop down. All these brush variants have been set up to work as Cloners with no adjustments needed which means they are ready for use immediately. Select the Soft Cloner; this variant will give a very smooth and gentle effect. Click the brush icon on the left of the properties bar to return the brush to its default settings.

Step 5 Check the Properties bar at the top and change the settings to those in Figure 2.8. Enter 223.0 in the Size box, this can be done either

Figure 2.8 The Properties bar.

by clicking on the arrow to the right of the figures and using the slider, or by typing the amount in and pressing Enter. This is a very large brush size, which will work well with the low opacity set in the next step.

Step 6 Change the Opacity to 3%, small adjustments of the slider can be made by clicking on the arrows at either end. Very low opacities are common when cloning from photographs but each type of brush will need a different setting so you will need to experiment with each picture before starting to paint. Make a few light strokes in the clone copy, start in the lower right corner and sweep out the strokes in the direction the magnolia petals take. You will probably not see any difference immediately because the Tracing Paper hides the very light strokes you are making. Turn off the Tracing Paper to see what you have painted so far. The Tracing Paper is usually only needed for the first few strokes and then it is better to remove it as it hides the result. Switch it back on every now and then if you need to check progress. Just paint the petals at this stage and leave the background till later.

Step 7 Continue to paint the image into the clone copy, the low opacity brush will allow you to do this very gradually. The effect to aim at is a very soft, delicate and dream-like quality. Check Figure 2.9 to see where you should be at this point. If you need to undo any step use the keyboard shortcut Ctrl/Cmd + Z or go to the File menu and click Undo. The Undo function will continue to undo the previous action until it reaches the limit set in the Preferences section.

Figure 2.9 Screen at step 7.

Setting the preference limit is covered in Chapter 1.

Step 8 Reduce the Opacity to 1% to paint the background. We need just the hint that there is a background present without really showing what it is. Sweep your brush out from the petals but leave the outer edges white.

If you need to enlarge any part of the picture to see more clearly use the slider at the base of the document window. The keyboard shortcuts are Ctrl/Cmd + + to enlarge and Ctrl/Cmd + − to reduce. To move the enlarged section around the screen press and hold the Spacebar and click and drag in the picture.

Step 9 A very light smooth finish is required to create the soft ethereal effect but even by painting with great care there are often areas which are rather darker than is ideal. This is very easy to correct by some erasing of the area that you have cloned. Go to the Brush Selector and choose the Erasers brush category and select the Eraser as the variant. Change the brush size to around 223.0 and make the Opacity 1%, leave the other settings unchanged.

Figure 2.10 *Building the density.*

Step 10 Lightly paint over the dark areas in your picture until the finish is very smooth and even. If you overdo this stage simply change back to the Soft Cloner brush and clone some imagery back from the original picture. The whole process is very flexible and can be repeated as often as is necessary.

This finishes the first cloned photograph, now it is time to find some photographs of your own on which to try the technique. Choose a picture that will benefit from the very soft treatment, an important part of making successful images is matching the right picture with the right technique. You may wish to save your picture for future reference.

Figure 2.11 *Magnolia flower.*

Camel impasto clone

For this next clone we will use the same original photograph of the magnolia but use a very different brush to illustrate how the choice of brush variant can dramatically change the final result.

Step 1 File> Open> DVD> Step-by-step files> '02 magnolia'.
Step 2 File> Quick Clone.
Step 3 Ctrl/Cmd + M to put into Full Screen Mode.
Step 4 Select the Brush icon in the toolbox.
Step 5 From the Brush Selector bar choose the Cloners brush category and the Camel Impasto Cloner variant.
If you are not familiar with traditional painting, the impasto effect implied in the name of this brush refers to paint applied very thickly to the canvas giving the picture a three-dimensional finish. In Painter this effect is achieved through the use of shadows added automatically to the brush strokes as the picture is painted.
Step 6 Change the brush size to 20 and the opacity to 72%.

Figure 2.12 Screen at step 7.

Step 7 With the tracing Paper turned on, start painting the flower, make your brush strokes follow the lines of the petals. After a few minutes take the tracing paper off to view what you have painted, increase the size of the picture on the screen to 100% (Ctrl/Cmd + 0) which will enable you to see clearly the three-dimensional brush strokes. The direction of each brush stroke is critical to the success of the picture so paint over any areas which have the brush strokes going the wrong way.
Step 8 Continue painting the petals until they are complete but avoid painting any background as far as possible. This is unavoidable at times and the dark green will appear around the edges, however this will be dealt with later.

Step 9 If you feel that the brush strokes are too strong they can be softened quite easily. Go to the Brush Selector bar and choose the Impasto brush category and the Depth Smear variant. Use brush size 37 and opacity 15%, paint lightly over the brush strokes and the impasto effect is reduced.

Step 10 Lets deal with the edges now, select another variant from the Impasto brush category this time the Depth Color Eraser. Change the size to 15 and the opacity to 66%. Put the screen size to 100% again and carefully go around the edges of the petals and remove all the dark edges. Start with the brush well outside the edge and gradually bring the brush inwards, it is quite tricky to get a smooth edge which looks right and you may have to use larger or smaller brush sizes.

Impasto
Depth Color Eraser

Figure 2.13 Depth color eraser.

Figure 2.14 Cleaning the edges.

Figure 2.15 Magnolia impasto clone.

Bristle Brush Clone

This step-by-step example uses a brush that has bristles and as you will quickly see, the technique needed to make a good picture is rather different to the soft clone. More care is needed when placing the individual brush strokes to ensure that the textural detail is retained.

Step 1 File> Open> DVD> Step-by-step files> '02 Flower Petal'.

Step 2 File> Quick Clone.

Step 3 Select the Brush icon in the Toolbox.

Step 4 From the Brush Selector bar choose the Cloners category and select Bristle Brush Cloner as the Brush Variant. Using the controls on the Properties bar, change the brush size to 32.2 and the opacity to 65%.

Step 5 Using the tracing paper as a guide, paint in all the areas except the centre stamens, dragging the brush outwards from the centre. Make the brush strokes fairly loose.

Step 6 Paint in the centre of the flower, this time dab with the brush rather than making long strokes. Figure 2.17 shows the picture at this point seen with the tracing paper turned off.

Figure 2.16 Original photograph.

Figure 2.17 Initial brush strokes.

Step 7 Turn the tracing paper off and paint over the picture again until all the white areas are filled, paint the centre with brush dabs as before.

Step 8 To put the finishing touches to the picture change the brush size to 9.6 and the opacity to 100%. This will give contrast to the areas painted and enhance the texture. Follow the darker lines in the petals, and paint with short brush strokes, don't be too exact as this is not intended to be an exact copy of the original photograph. Figure 2.18 shows the final version.

This particular cloning brush partially smears the cloned image, and later in the book other brushes that have this same characteristic in a more pronounced manner will be explored.

Another similar brush in the Cloners category is the Smeary Bristle Cloner which, as its name suggests, smears the image rather more than the brush used in this example.

Figure 2.18 Flower petal.

An introduction to paper grain

Before a painter using a 'traditional', that is non-digital method starts to paint, two important decisions have to be made. Firstly, which medium to use which might be oil, watercolor, pencil, pastel and so on and then the surface on which to paint, perhaps paper, board, sandpaper, etc.

What Painter does is to replicate as closely as possible the result of the chosen combination. A soft camel hair brush on a smooth board will give a clean edged smooth color, whereas when using a piece of hard chalk on a heavily textured paper the chalk will skim the surface leaving the paper indentations with no paint, in other words a very rough effect. These choices will have a major influence on the finished look of the artwork.

It is very similar when a photograph is cloned using the brushes and surfaces available in Painter, the huge range of brushes and papers cover virtually every type available to the traditional artist and many that are not.

There are something like 600 different papers in Painter, some of which have to be loaded separately from the program CD, so the combination of 900 brushes combined with 600 papers is pretty mind-boggling. Figure 2.19 shows a few of the hundreds of textured papers available. Chapters 5 and 6 deal with this subject in a lot of more depth but this introduction will give you a quick understanding before you start on the next step-by-step.

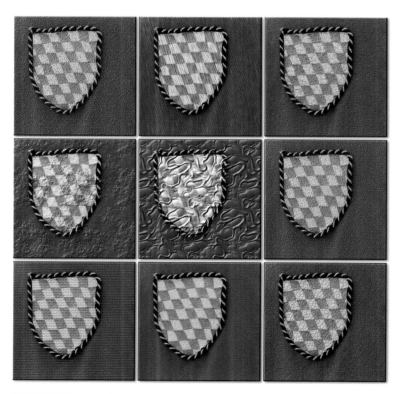

Figure 2.19 *Some of the paper textures in the Painter program.*

Textured Clone

This step-by-step example will look at how to use paper textures when making clones. You will learn how to change the appearance of a photograph to give the impression of painting on a coarse textured paper. The range of paper textures and how to use them is explored in more detail in Chapters 5 and 6.

Figure 2.20 *Original photograph.*

The photograph of St Conan's Kirk in Scotland had some simple repair work done in Photoshop prior to opening in Painter. The contrast was increased slightly and the blue sky was extended down to cover some eye-catching white clouds. It is not necessary to get this very precise, as the cloning process will cover up any minor imperfections.

Step 1 File> Open> DVD> Step-by-step files> '02 St Conan's Kirk'.

Step 2 File> Quick Clone.

Step 3 Select the Brush icon in the Toolbox.

Step 4 From the Brush Selector bar choose the Chalk category and select Square Chalk 35 as the Brush Variant. This brush is not in the Cloners brush category and therefore you will have to change it from the default setting, which is painting color, to cloning mode so that the brush picks up detail from the original image. This applies to all brush categories except Cloning and Smart Stroke. If the General palette is not on screen go to Window>Brush Controls> Show General. You will get all the Brush Control palettes on screen so

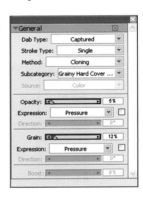

Figure 2.21 *General palette.*

click on the General palette heading and drag it out from the rest, you can then remove the other palettes which will not be needed from the screen by clicking on the X top right of the palette stack.

Step 5 There are two controls to be adjusted to change this brush to work as a cloner. In the Method box change the setting to Cloning, this will make the brush use the original picture as the source for color. Then in the Subcategory box select Grainy Hard Cover Cloning, this will tell the brush to use the paper texture when painting.

Figure 2.22 *Papers palette.*

Step 6 Change the brush size to 35.0 and the Opacity to 5%. If you are using a mouse rather than a pressure sensitive pen I suggest you use 1% or 2% opacity, this will enable you to build up the textures more slowly.

Step 7 You now need to choose a paper texture and if the papers palette is not on the screen go to Window> Library Palettes> Show Papers. Open the Papers palette and click on the small paper icon highlighted in Figure 2.22. This will reveal a drop down menu showing the Painter X default set of papers as shown in Figure 2.23. Select the Italian Watercolor Paper.

Step 8 Paint the main lines of the building with the tracing paper turned on. These initial marks should be very light and you will need to turn the tracing paper on and off many times to see what you have painted. Once you have all the main building areas indicated on the picture you can turn off the tracing paper. See Figure 2.24 for an indication of the clone picture at this point.

Step 9 Gradually build up the picture working from the building outwards keeping the textures light, your brush strokes should be following the direction of the building, never simply stroke the brush across the picture, always think about which way the brush strokes will look best. Once the whole picture has been lightly covered start to go over the buildings again, use the same opacity and this will slowly make the details more distinct. You can slightly increase the opacity if necessary, but it is generally better to allow the brush strokes to build the picture that way you have more control.

| Basic Paper |
| Small Dots |
| Artists Rough Paper |
| Sandy Pastel Paper |
| Rough Charcoal Paper |
| Retro Fabric |
| Hard Laid Paper |
| Gessoed Canvas |
| Fine Dots |
| New Streaks |
| Wood Grain |
| Artists Canvas |
| Charcoal Paper |
| Simulated Woodgrain |
| Thick Handmade Paper |
| Coarse Cotton Canvas |
| Fine Hard Grain |
| Worn Pavement |
| Italian Watercolor Paper |
| Linen Canvas |
| Pebble Board |
| Hot Press |
| French Watercolor Paper |

Figure 2.23 *Painter X papers.*

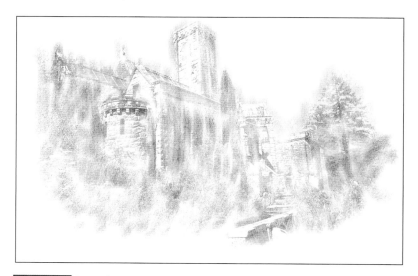

Figure 2.24 *Step 9 keeping the textures light.*

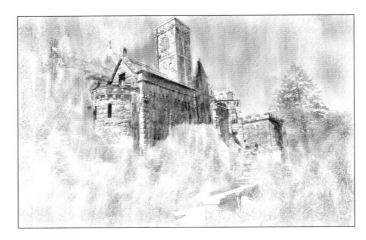

Figure 2.25 *Increasing the density.*

Step 10 Use the magnifier slider below the image to work at a bigger magnification, and then reduce the brush size to about 10.0 and paint over the building outlines making them more prominent. Increase the opacity to 10% and emphasize the shadow areas in the buildings. Figure 2.25 shows the picture at this stage.

Step 11 Experiment with different brush sizes and opacities to see how they affect the picture, try brush size 72 with 5% opacity and sweep over the main areas, this will bring more detail in and smooth out some of the irregularities caused by the brush strokes. One of the most difficult decisions is to know when to stop as it is easy to overwork a picture and bring back too much of the original image. Figure 2.26 shows the final picture.

In Chapters 5 and 6 paper textures will be explored in more detail, learning how to choose different papers and to alter them to suit the style of the picture.

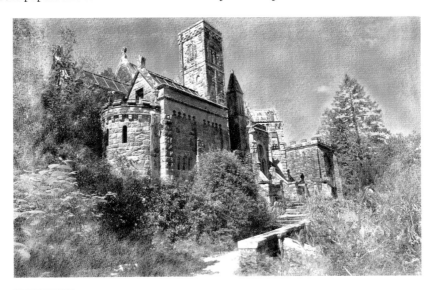

Figure 2.26 *St Conan's Kirk.*

Figure 2.27 Paper towel.

Figure 3.1 Spring.

3

Choosing brushes

Figure 3.2 *Abstract panel: This panel was made using brushes from sixteen different brush categories.*

Brushes are at the heart of everything in the Painter program and it is the sheer volume of choice that confuses many first time users. This section covers the subject of brushes and every brush category in Painter X has two pages devoted to it. Each two-page spread has a short introduction to the category and a series of examples of some of the brush variants available.

There are two examples for each variant, the first showing how the brush stroke looks when cloned from a photograph and then another showing a close up detail of the same picture to illustrate the brush strokes more closely.

The examples shown on the following pages should prove helpful when deciding which brush to use for a particular image. If you look, for instance, at the first two categories, which are Acrylics and Airbrushes, you can immediately see that the Acrylics have a strong brushy texture, while the Airbrushes are quite different and show no brush marks. On the other hand, Chalks show grain texture extremely well. All the examples have been used at the default setting with just the cloning option changed. It is worth mentioning at this point that almost any brush can be changed into a cloner by clicking the Clone Color option in the Colors palette.

On the second page of each spread is a clone picture using one or more of the brush variants in the particular category to illustrate just one of the many ways in which the brushes can be used.

Figure 3.3 *Shoes.*

Quick guide to selecting brushes

When faced with the hundreds of brushes which come with Painter, how do you know which one to choose? The following pages look in detail at each brush category but before you start checking the categories, it is worth being aware of the terminology which is used in Painter to describe each brush. The category and variant name will usually give you a good idea of what to expect, so this is a brief overview of what the names mean.

First select the category
The category name will give you the first clue, most of these are easily recognizable, airbrush, oil, watercolor, chalk, pencils. These speak for themselves. Categories such as Chalk and Conte have very hard finishes and so are good for picking up paper textures.

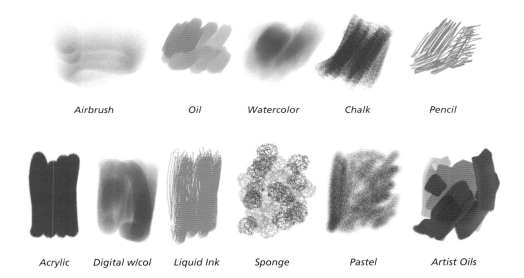

| Airbrush | Oil | Watercolor | Chalk | Pencil |

| Acrylic | Digital w/col | Liquid Ink | Sponge | Pastel | Artist Oils |

Understanding the shapes
Again these are pretty obvious, flat, round, square, tapered, pointed, thick, calligraphic and so on. Another way of recognizing the shape is to check the tiny dab illustration alongside each variant, they will show you the basic shape of the brush.

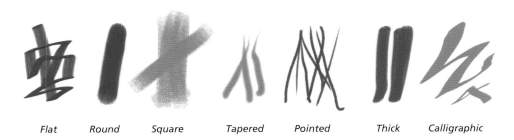

| Flat | Round | Square | Tapered | Pointed | Thick | Calligraphic |

Now for the texture

The texture has a major impact on the appearance of the brush. The examples below show the main types.

Look out for variants named Greasy and Smeary, these will smear the photograph, and paint in the same way that blenders will do. Camel hairbrushes are very smooth while Glazing brushes are set up to paint very gently without hiding what is underneath. The Resist brushes are unique to the Liquid Ink category and are used to protect areas which are not to be painted over.

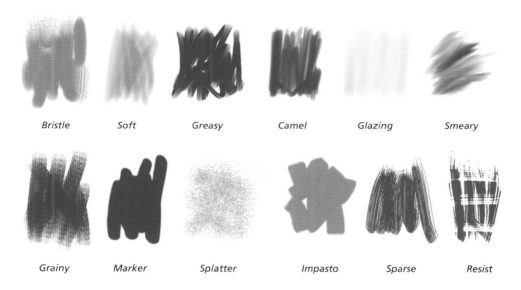

| Bristle | Soft | Greasy | Camel | Glazing | Smeary |

| Grainy | Marker | Splatter | Impasto | Sparse | Resist |

Blenders for smoothing and mixing

There are many diffusers and blenders in various categories and they each have different ways of mixing existing paint or imagery in your picture.

When the description says Grainy, then the mix will take on some characteristics of the paper texture currently selected, the Oily and Directional blenders also pull the paint in a particular direction. A soft finish will result from using blenders such as Just Add Water and ones with Soft in their name. For more information on Blenders refer to the detail later in this chapter and also in Chapter 11.

| Grainy | Oily | Soft | Rake | Directional | Add Water | Grainy Oils |

Acrylic brushes

The Acrylics range of brushes is ideal for making pictures that need to show the brush strokes clearly, the range is large and distinctive.

The Thick Acrylic variants use Impasto to give a stronger impression of depth to the brush strokes. Impasto is explained in more detail in the next chapter, but essentially it means that the brush strokes have a three-dimensional appearance.

The Wet variants blur the cloned image, this applies particularly to the larger brush sizes, but even with smaller brushes it is difficult to retain much detail.

The Dry Brush variant is a very useful brush for cloning as it paints quickly and gives an attractive brush texture.

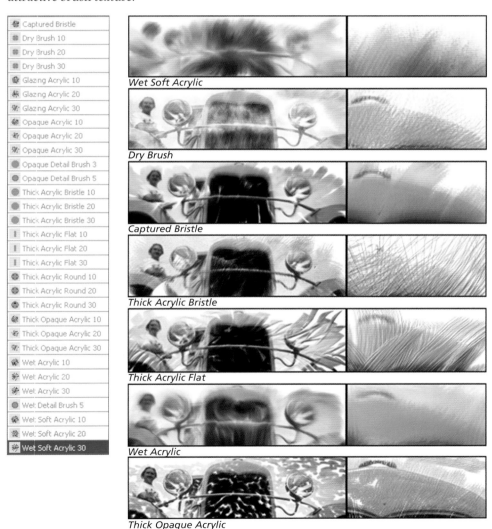

Captured Bristle
Dry Brush 10
Dry Brush 20
Dry Brush 30
Glazing Acrylic 10
Glazing Acrylic 20
Glazing Acrylic 30
Opaque Acrylic 10
Opaque Acrylic 20
Opaque Acrylic 30
Opaque Detail Brush 3
Opaque Detail Brush 5
Thick Acrylic Bristle 10
Thick Acrylic Bristle 20
Thick Acrylic Bristle 30
Thick Acrylic Flat 10
Thick Acrylic Flat 20
Thick Acrylic Flat 30
Thick Acrylic Round 10
Thick Acrylic Round 20
Thick Acrylic Round 30
Thick Opaque Acrylic 10
Thick Opaque Acrylic 20
Thick Opaque Acrylic 30
Wet Acrylic 10
Wet Acrylic 20
Wet Acrylic 30
Wet Detail Brush 5
Wet Soft Acrylic 10
Wet Soft Acrylic 20
Wet Soft Acrylic 30

Wet Soft Acrylic

Dry Brush

Captured Bristle

Thick Acrylic Bristle

Thick Acrylic Flat

Wet Acrylic

Thick Opaque Acrylic

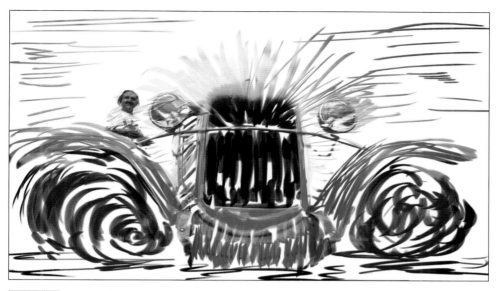

Figure 3.4 *The Proud Owner.*

The Thick Acrylic Flat 30 brush was used to make this clone picture and the flat brush gives strong directional strokes that stand out well.

The picture has a strong illustrative feeling rather than being purely photographic and emphasizes the exuberant impression of this car.

A pressure sensitive stylus is essential for this type picture in order to be able to get the elongated strokes, when the pen is held at an angle the shape of the strokes change.

Figure 3.5 *Detail of the acrylic brush strokes.*

Airbrushes

Many of the brushes in this category spray in the direction in which the tablet stylus is angled. These spray type airbrushes include Broad Wheel, Coarse Spray, Fine Spray, Fine Wheel and Finer spray, most of which give a fairly smooth finish.

Some of the smeary airbrushes, Digital, Detail, Fine Detail and Fine Tip Soft all move the underlying imagery and do not have the typical airbrush spray.

Variable Splatter, Tiny Splatter and Pepper Spray throw out a very coarse spray that looks very blotchy on a small file size.

The Soft Airbrush is one of the few to use paper textures.

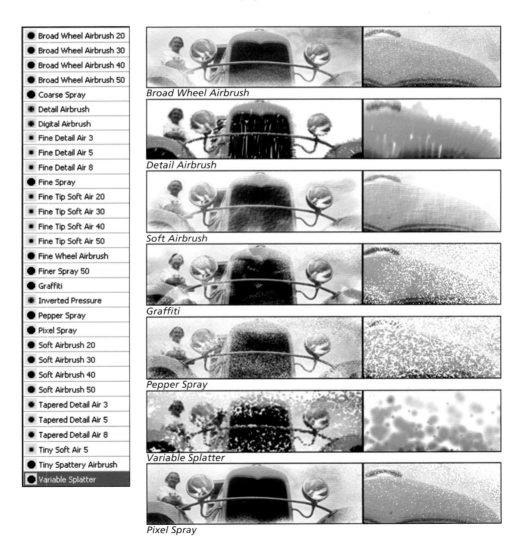

Broad Wheel Airbrush
Detail Airbrush
Soft Airbrush
Graffiti
Pepper Spray
Variable Splatter
Pixel Spray

List of brushes:
- Broad Wheel Airbrush 20
- Broad Wheel Airbrush 30
- Broad Wheel Airbrush 40
- Broad Wheel Airbrush 50
- Coarse Spray
- Detail Airbrush
- Digital Airbrush
- Fine Detail Air 3
- Fine Detail Air 5
- Fine Detail Air 8
- Fine Spray
- Fine Tip Soft Air 20
- Fine Tip Soft Air 30
- Fine Tip Soft Air 40
- Fine Tip Soft Air 50
- Fine Wheel Airbrush
- Finer Spray 50
- Graffiti
- Inverted Pressure
- Pepper Spray
- Pixel Spray
- Soft Airbrush 20
- Soft Airbrush 30
- Soft Airbrush 40
- Soft Airbrush 50
- Tapered Detail Air 3
- Tapered Detail Air 5
- Tapered Detail Air 8
- Tiny Soft Air 5
- Tiny Spattery Airbrush
- Variable Splatter

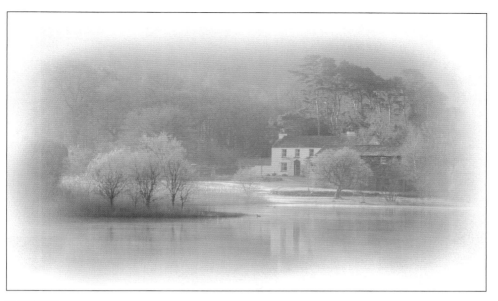

Figure 3.6 *Across the Lake.*

This photograph was taken early one morning looking across part of Derwentwater in the English Lake District. The atmosphere was placid and the only things moving were the ducks on the water.

The Broad Wheel Airbrush was used to paint over most of the picture, this is a very useful brush for covering large areas very lightly and gives the spray effect seen on the edges of the picture above. The density in the image was gradually increased, mainly in the central areas.

The Soft Airbrush was used to finish the picture and brought in more clarity to the central area. This brush has a much smoother texture and does not have the spray texture of the Broad Wheel Airbrush.

Figure 3.7 *Original photograph.*

Figure 3.8 *Detail showing textures.*

Art Pen Brushes

This brush category was added in the Painter IX. 5 upgrade and at the same time an art marker pen was added to the Wacom range, so to get the very best out of these brushes you may wish to purchase this additional pen. The examples shown here were created using the standard pen.

There are a range of different styles available, several will use the grain texture quite successfully, these include the ones with Grainy in their name. Grainy Calligraphy and Soft Flat Oils will smear the picture rather well giving a very attractive texture. Tapered Gouache is the only one which shows any significant brush marks, it sprays the brush marks outwards when the pressure sensitive pen is angled to one side.

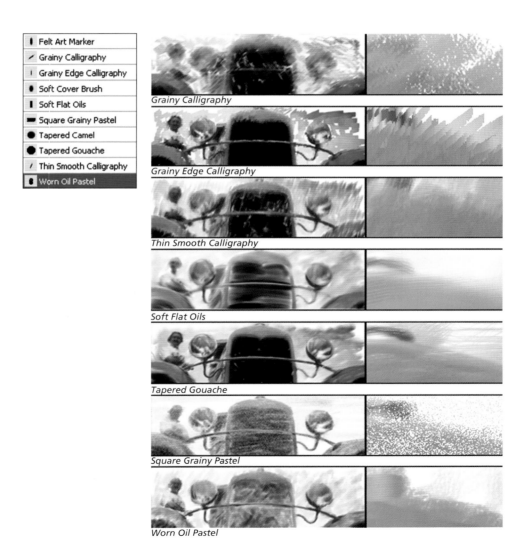

	Felt Art Marker
	Grainy Calligraphy
	Grainy Edge Calligraphy
	Soft Cover Brush
	Soft Flat Oils
	Square Grainy Pastel
	Tapered Camel
	Tapered Gouache
	Thin Smooth Calligraphy
	Worn Oil Pastel

Grainy Calligraphy

Grainy Edge Calligraphy

Thin Smooth Calligraphy

Soft Flat Oils

Tapered Gouache

Square Grainy Pastel

Worn Oil Pastel

Figure 3.9 *The old chair.*

The brush used for this picture was the Soft Flat Oils which has given it a very soft flowing appearance. The default brush has a high Bleed value of 70% which means that as the brush clones imagery from the original picture, it also smears and blends the new picture information with any imagery already on the canvas.

The brush has 70% Bleed but only 20% Resaturation which means that it smears more than it paints. By adjusting these two sliders on the Properties bar we can alter the amount of paint and smearing at any time.

The initial painting was created using the default settings, then the Bleed was increased and the Resaturation decreased to smooth out many of the irregular marks.

The picture was cloned with large brush sizes initially and then smaller ones to bring in more detail. To complete the picture the brush size was increased once again and was painted with a low opacity over the detail to blend it better with the less-defined areas.

Figure 3.10 *Detail.*

Artists' Oils

Artists Oils brushes replicate the use of real brushes much more closely than ever before; the paint can be taken directly from the Mixer palette and a blend of colors picked up on the brush. The brush only takes up a specific amount of paint so the brush stops painting when it runs out of paint. The brush also interacts with any paint already on the canvas, just as it would on a real oil painting.

When the brushes are used on photographs they do not work as cloners in the same way as many other brushes, they will pick up colors from the source image and continue to paint with those colors, disregarding what has changed. In the example on the next page the brush has been used as a cloner and the brush strokes have been kept very short, thereby retaining the shapes.

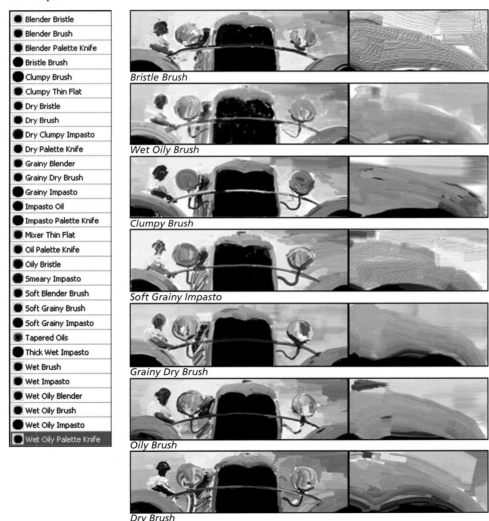

Blender Bristle
Blender Brush
Blender Palette Knife
Bristle Brush
Clumpy Brush
Clumpy Thin Flat
Dry Bristle
Dry Brush
Dry Clumpy Impasto
Dry Palette Knife
Grainy Blender
Grainy Dry Brush
Grainy Impasto
Impasto Oil
Impasto Palette Knife
Mixer Thin Flat
Oil Palette Knife
Oily Bristle
Smeary Impasto
Soft Blender Brush
Soft Grainy Brush
Soft Grainy Impasto
Tapered Oils
Thick Wet Impasto
Wet Brush
Wet Impasto
Wet Oily Blender
Wet Oily Brush
Wet Oily Impasto
Wet Oily Palette Knife

Bristle Brush

Wet Oily Brush

Clumpy Brush

Soft Grainy Impasto

Grainy Dry Brush

Oily Brush

Dry Brush

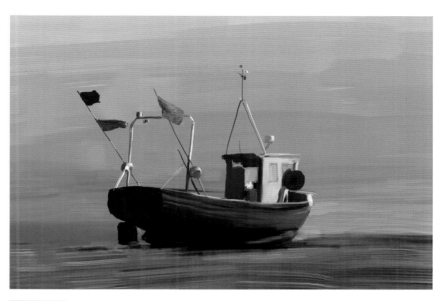

Figure 3.11 *Colorful boat.*

The technique used to create this picture of a colorful boat on the seashore was to make a clone copy and clear the image. A new layer was made and the Artists Oils Dry Bristle brush was used at a large size to paint over the background to establish the sky, sea and shoreline.

A new layer was made on the top of the layers stack and the Artists Oils Wet, brush size 20.0 and opacity 100% was used to paint in the boat. The brush was reduced to size 3.2 to paint the rigging and flags and to go over some of the detail of the boat.

Another new layer was created to give more emphasis to the line between sea and sky.

The various elements were blended together using the Artists Oils Grainy Blender at various sizes and opacities, this softened the transition between the background and the more detailed boat.

The technique of using multiple layers is dealt with in detail in Chapter 7, Layers and montage.

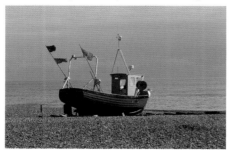

Figure 3.12 *Original photograph.*

Figure 3.13 *Detail.*

Artists

It is perhaps surprising that this set of what one might call curiosity brushes, all work perfectly well as cloners. All of the brushes except Tubism are able to use the Cloning Method while Tubism has to use Clone Color.

The final example titled Auto Van Gogh (on Auto) has been created in a different manner. The brush was set to Auto Van Gogh and the Cloning Method chosen. A clone copy was made and cleared then I went to Effects>Esoterica>Auto Van Gogh and immediately the 'Van Gogh' effect was applied. There are no controls, it just does the one clone. Try it and see.

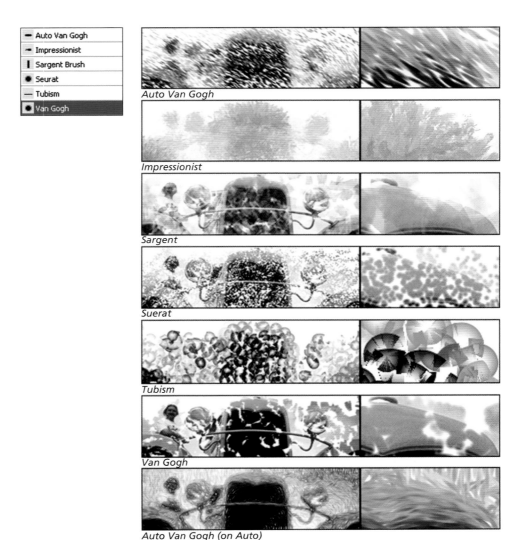

Auto Van Gogh

Impressionist

Sargent

Suerat

Tubism

Van Gogh

Auto Van Gogh (on Auto)

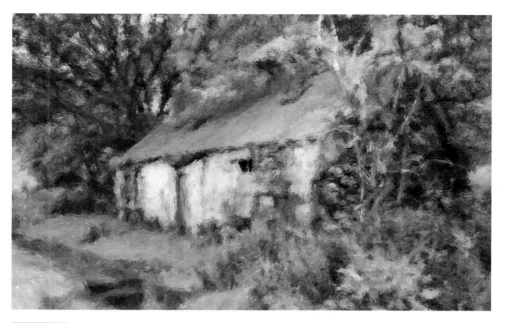

Figure 3.14 *Ruined cottage.*

The Impressionist brush can produce some very attractive textures and in many cases can be used to provide an underpainting before adding more details.

In this case the picture was created with the new Auto-Painting palette which was first introduced in Painter IX.5 and improved in Painter X.

The Smart Stroke Painting option was ticked so that the brush strokes would follow the lines in the picture. The brush size was 19 with 100% opacity. After the Auto-Painting was completed the remaining white holes were painted in with the same brush.

Check the enlarged detail picture and note the very distinctive brush marks which this variant makes.

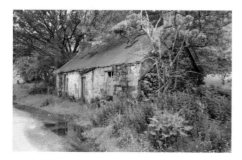

Figure 3.15 *Original photograph.*

Figure 3.16 *Detail of the finished picture.*

Blenders

Blenders are not brushes for cloning but they do have some very interesting and useful features. They can be used directly on photographs and also on finished clones to add a further dimension.

Several of the variants, such as Diffuse Blur and Round Blender Brush, smear the image and give it a furry look. Others, like the Detail Blender, smooth the image but retain the overall shape and color.

There is more detail on Blenders at the start of Chapter 11 as they are excellent for portraits. Many other brushes not in this category can be made to work as blenders by reducing the ReSat value to zero and increasing the Bleed value.

● Blur
✸ Coarse Oily Blender 10
✸ Coarse Oily Blender 20
✸ Coarse Oily Blender 30
● Coarse Smear
● Detail Blender 3
● Detail Blender 5
● Diffuse Blur
━ Flat Grainy Stump 10
━ Flat Grainy Stump 20
━ Flat Grainy Stump 30
❀ Grainy Blender 10
❀ Grainy Blender 20
❀ Grainy Blender 30
■ Grainy Water
■ Grainy Water 30
● Just Add Water
● Oily blender 20
● Oily blender 30
● Oily blender 40
■ Pointed Stump 10
■ Pointed Stump 20
■ Pointed Stump 30
● Round Blender Brush 10
● Round Blender Brush 20
● Round Blender Brush 30
● Runny
● Smear
● Smudge
● Soft Blender Stump 10
● Soft Blender Stump 20
● Soft Blender Stump 30
● Water Rake

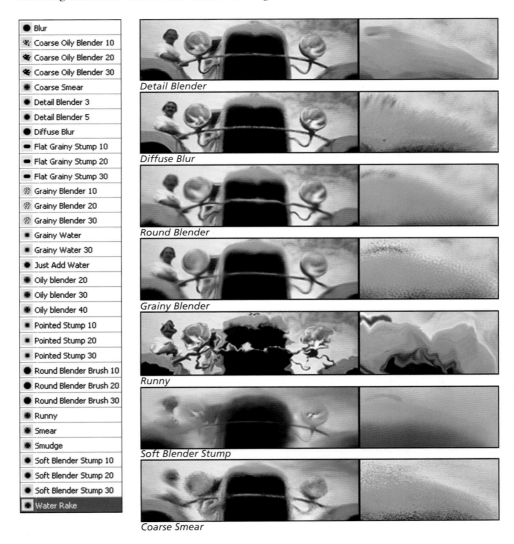

Detail Blender

Diffuse Blur

Round Blender

Grainy Blender

Runny

Soft Blender Stump

Coarse Smear

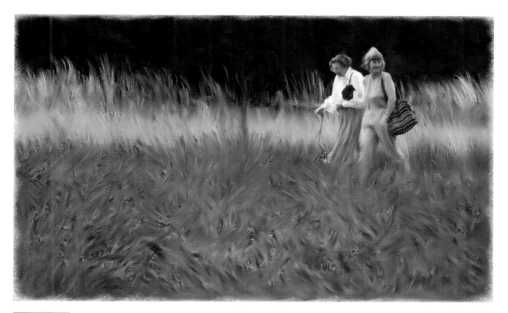

Figure 3.17 *The Lavender Walkers.*

The Coarse Smear Blender was used to make this picture. I painted all over the photograph making flowing lines in the lavender and streaking the grasses out against the dark background, look at the detail in Figure 3.19 to see the brush strokes.

The Coarse Smear Blender was used once again on the clothes but changed to the Detail Blender 3 to work on the faces and fine detail.

The picture was taken at the Lavender Farm in the Cotswolds, England.

The blender range of brushes create lovely textures and are well worth experimenting with.

It is usually better to make a clone copy and work on that, which gives you the opportunity to bring back detail from the original image.

Figure 3.18 *Original photograph.*

Figure 3.19 *Detail of brush strokes.*

Calligraphy

The major characteristic of the Calligraphy brushes is the sharp angle of the brush stroke, one edge narrow and the other broad.

All of these brushes use the Cloning method and are therefore very good for using with paper textures.

In the examples below the first three brushes have been used at their default settings and have the opacity and grain at high levels.

The other examples have had both the opacity and the grain reduced to around 20% and this gives them quite a different appearance. The strokes are very similar, however, it is the texture that is different.

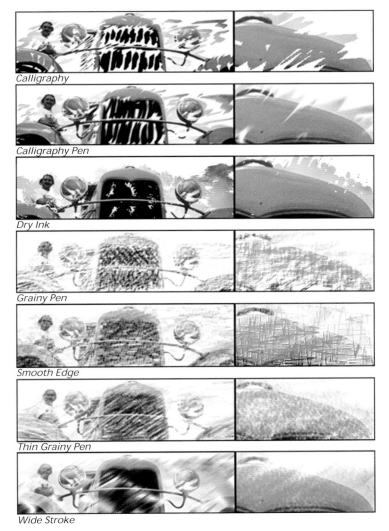

Calligraphy

Calligraphy Pen

Dry Ink

Grainy Pen

Smooth Edge

Thin Grainy Pen

Wide Stroke

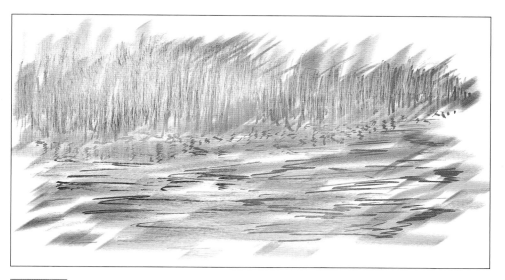

Figure 3.20 Lakeside reeds.

The Calligraphy Thin Smooth Pen 10 was used to make this picture. The brush grain setting was reduced to around 21% in order to emphasize the grain. The opacity varied between 5% and 100% and the brush size between 8.0 and 45.0.

The small brush was used at a high opacity to sketch in the lines of the reeds and add some lines in the water. You can still see the dark lines in the water where they were put at the start of the picture with more added at various opacities at the end. Washes of color were painted with the larger brush sizes at a low opacity.

The brush was used in a very definite calligraphic style to make full use of the thin and wide strokes that are characteristic of these brushes.

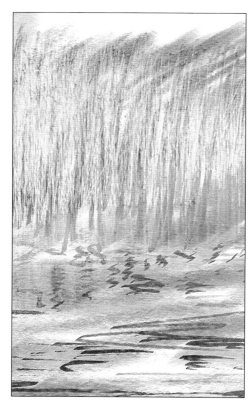

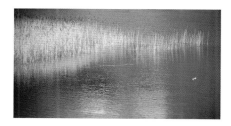

Figure 3.21 Original photograph.

Figure 3.22 Detail of brush strokes.

53

Chalk

The Chalk brushes are particularly good for using with paper textures, many of them use very rough captured dabs, which scrape over the paper surface and emphasize the grain. Some of the dabs are square and the icons in the list of brushes on this page gives an indication of the shape.

In most of these examples below the grain and the opacity settings have been reduced to emphasize the paper grain. The papers chosen vary and it is the differing papers that have changed the appearance of the texture.

The Tapered Artists Chalk is particularly smooth yet it also brings out the texture. The Sharp and Square Chalks give the roughest finish.

- ● Blunt Chalk 10
- ● Blunt Chalk 20
- ● Blunt Chalk 30
- ● Dull Grainy Chalk 10
- ● Dull Grainy Chalk 20
- ● Dull Grainy Chalk 30
- ● Large Chalk
- ● Sharp Chalk
- ■ Square Chalk
- ■ Square Chalk 35
- ● Tapered Artist Chalk 10
- ● Tapered Artist Chalk 20
- ● Tapered Large Chalk 20
- ● Tapered Large Chalk 30
- ● Tapered Large Chalk 40
- ■ Variable Chalk
- ● Variable Width Chalk

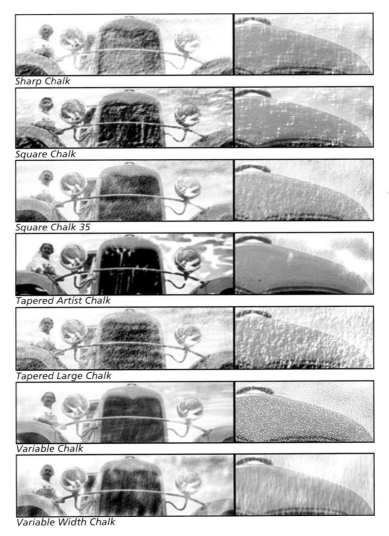

Sharp Chalk

Square Chalk

Square Chalk 35

Tapered Artist Chalk

Tapered Large Chalk

Variable Chalk

Variable Width Chalk

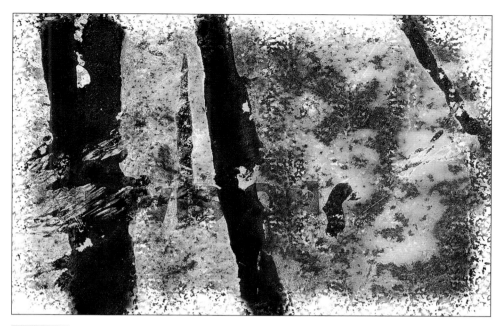

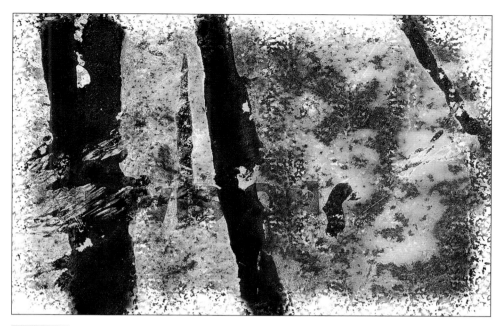

Figure 3.23 *Rust.*

The original picture of rust on the side of an old vehicle was very striking already and the clone has given it even more impact.

The Tapered Large Chalk variant was used to paint a very rough texture that reacted well to the strong colors and shapes.

Harsh Texturing paper from the Relief set of paper textures was the paper used, this additional brush library can be loaded from the Extras folder on the Painter program CD.

The brush size was initially 250.0 then using more opacity and less grain the colors and textures were gradually built up.

Figure 3.24 *Original photograph.*

Figure 3.25 *Rust detail.*

Charcoal

Like the Chalk variants, the Charcoal brushes are very hard and rough. They are excellent for interacting with grain textures, in most cases you will need to reduce both the grain and the opacity settings.

The Sharp Charcoal Pencil seems to work almost like an airbrush in the way it lays down clumps of clone image.

A variant that is quite different is the Soft Vine Charcoal which shifts around the cloned image and blurs it out of register with the original.

The Soft Charcoal Pencil also does this but to a much lesser extent.

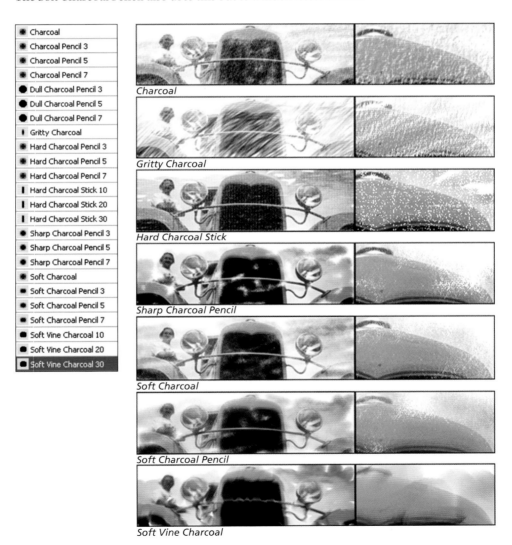

Charcoal

Gritty Charcoal

Hard Charcoal Stick

Sharp Charcoal Pencil

Soft Charcoal

Soft Charcoal Pencil

Soft Vine Charcoal

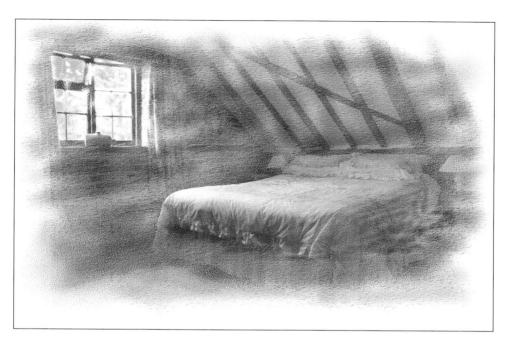

Figure 3.26 *The bedroom in the loft.*

The Sharp Charcoal Pencil was used to create this picture. A large brush size was used for the early stages and then various smaller sizes to bring in more detail.

The Method was Cloning> Hard Grainy Cloning and Pacific Laid was the paper, which produced the distinctive horizontal streaks.

To complete the clone the paper was changed to Basic Paper, which helped to even out the texture.

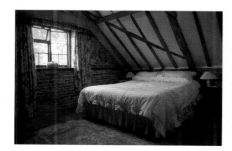

Figure 3.27 *Original photograph.*

Figure 3.28 *Detail of texture.*

Cloners

This set of brushes has been chosen specifically for cloning and brings together brushes from several other brush categories. All the brushes have been set up ready for cloning with no adjustments needed.

There is no sense of strong identity with this set as they have been presented together for convenience. Some, like the Splattery and Texture Spray cloners, are very rough while the Camel cloners are smooth and smear the original picture. The Water Color and Oil cloners use the Clone Color option and will smear the cloned image. The Soft Cloner is invaluable in bringing back detail to many pictures made with other brushes.

Most brushes in other brush categories can be made to work as cloners simply by clicking the Clone Color option in the Colors palette.

● Bristle Brush Cloner	
● Bristle Oils Cloner 15	
● Camel Impasto Cloner	
● Camel Oil Cloner	
● Chalk Cloner	
● Cloner Spray	
● Coarse Spray Cloner 50	
● Colored Pencil Cloner 3	
● Crayon Cloner	
\ Driving Rain Cloner	
● Felt Pen Cloner	
— Fiber Cloner	
● Fine Gouache Cloner 15	
● Fine Spray Cloner 35	
I Flat Impasto Cloner	
I Flat Oil Cloner	
● Furry Cloner	
● Graffiti Cloner 20	
- Impressionist Cloner	
● Melt Cloner	
● Oil Brush Cloner	
● Pencil Sketch Cloner	
● Smeary Bristle Cloner	
● Smeary Camel Cloner	
I Smeary Flat Cloner	
● Soft Cloner	
● Splattery Clone Spray	
● Straight Cloner	
● Texture Spray Cloner	
● Thick Bristle Cloner 20	
● Thick Camel Cloner 20	
I Thick Flat Cloner 20	
● Van Gogh Cloner	
O Watercolor Cloner	
● Watercolor Fine Cloner	
● Watercolor Run Cloner	
● Watercolor Wash Cloner	
● Wet Oils Cloner 10	

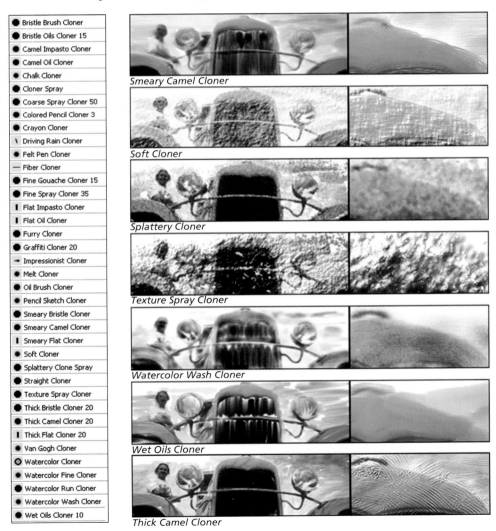

Smeary Camel Cloner

Soft Cloner

Splattery Cloner

Texture Spray Cloner

Watercolor Wash Cloner

Wet Oils Cloner

Thick Camel Cloner

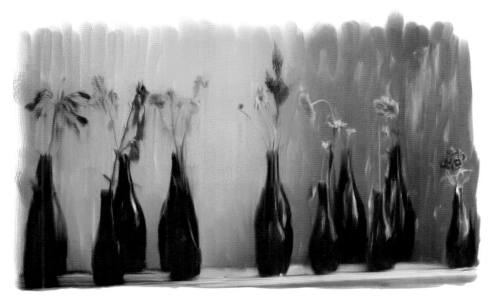

Figure 3.29 *Makeshift flower vases.*

The picture above was painted with the Smeary Bristle Cloner, this is an interesting brush as it gives a very pronounced bristle effect and is quite unusual in that it reacts differently depending on the speed the paint is applied. The faster the brush stroke is made the smearier the result. A very slow stroke will give complete clarity.

I used brush size 30 on a Quick Clone document with opacity 100%. I left the finished picture slightly rough in appearance to give a quick hand painted look.

Figure 3.30 *Original photograph.*

Figure 3.31 *Detail.*

Colored Pencils

This group of brushes are not very easy to use for cloning.

The first three examples can be used in the Cloning Method but they have a rather unique style. When you make a brush stroke, the brush picks up the color first clicked on and continues painting with that color and ignores the source image. Some variants gradually fade out while others continue with the same color.

The rest of the examples cannot be used for cloning at all, or at least, none that I have found. They can, however, be used to work directly upon a picture, so perhaps it might be best to think of them as a sort of blender.

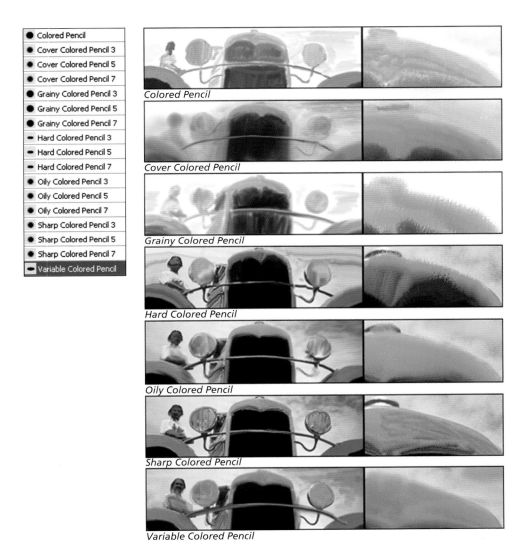

Colored Pencil

Cover Colored Pencil

Grainy Colored Pencil

Hard Colored Pencil

Oily Colored Pencil

Sharp Colored Pencil

Variable Colored Pencil

Figure 3.32 *Stone horse and dog.*

This picture was created using the Grainy Colored Pencils variant. The outlines of the statues were traced with a narrow brush at a low opacity then a larger brush size filled in the shapes. A medium brush integrated the two brush sizes.

To finish the picture the original image was selected and copied, then pasted into the clone document on top of the clone layer.

The Layer Composite Method of the top layer was changed to Luminosity and the opacity to 32%. More detail on using layers can be found in Chapter 7.

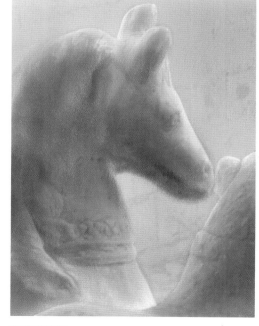

Figure 3.33 *Original photograph.*

Figure 3.34 *Detail.*

Conte

As you will notice from the list of variants on the left this is a very small section. When you remove the different sizes there are only three different variants of the Conte Brushes.

Like the Chalk and Charcoal categories, these brushes are excellent at picking up a paper texture as they have a very rough finish. They can all use the Cloning Method.

In the examples below the brushes have been shown using both the Cloning Method and the Clone Color option.

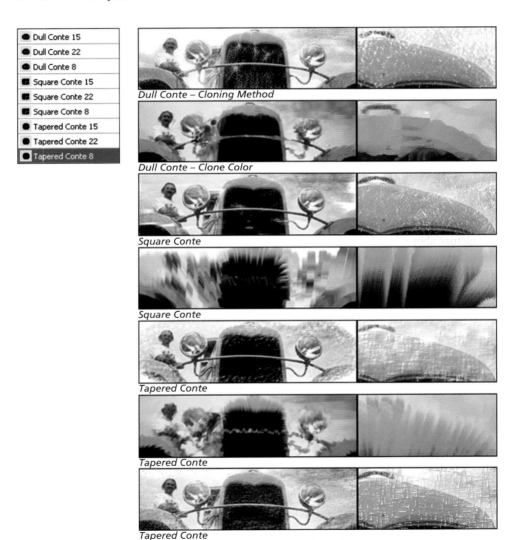

Dull Conte – Cloning Method

Dull Conte – Clone Color

Square Conte

Square Conte

Tapered Conte

Tapered Conte

Tapered Conte

Figure 3.35 Bark pattern.

This tree had a wonderful bark pattern and I was particularly attracted to the lovely range of colors.

The Tapered Conte brush was used to make the picture above, brush size 21.5 and opacity 75%. In the General palette the Method was changed to Cloning and the sub-category to Grainy Hard Cover Cloning.

After lightly cloning most of the picture the opacity was then increased to 100% to emphasize the main lines of the pattern.

The paper used was the Artists Rough Paper.

Figure 3.36 Original photograph.

Figure 3.37 Detail.

63

Crayons

Like the Chalk and Conte brushes the Crayon group takes up the paper texture very well as you can see from the examples below.

The two odd ones are the Grainy Hard Crayon and the Waxy Crayon, both of which smear the cloned image.

The second example of the Dull Crayon brush uses a paper called Crystalline Formation from the Molecular library, which is one of the paper libraries that can be loaded from the Extras folder on the Painter program CD.

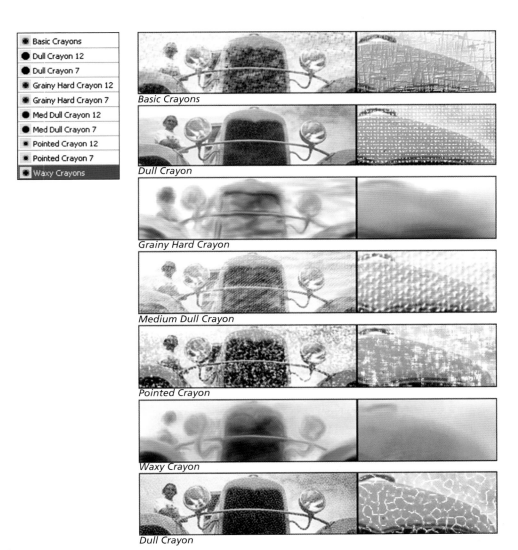

- Basic Crayons
- Dull Crayon 12
- Dull Crayon 7
- Grainy Hard Crayon 12
- Grainy Hard Crayon 7
- Med Dull Crayon 12
- Med Dull Crayon 7
- Pointed Crayon 12
- Pointed Crayon 7
- Waxy Crayons

Basic Crayons

Dull Crayon

Grainy Hard Crayon

Medium Dull Crayon

Pointed Crayon

Waxy Crayon

Dull Crayon

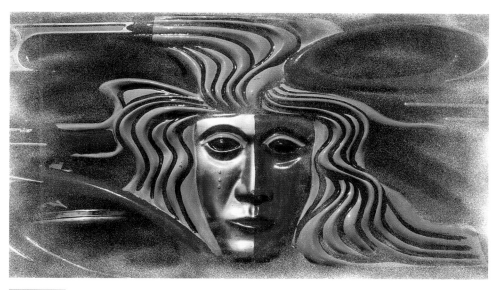

Figure 3.38 *Fairground decoration.*

The picture above was initially painted with the Painted Crayon, brush size 108.0, opacity 28% and grain 14%. This gave a light texture over all the photograph.

The Dull Crayon was then used to bring in more detail. Brush size 78.2, opacity 9% and grain 20%.

The settings for the Dull Crayon were changed to brush size 12.0, opacity 30% which brought in more detail.

Most of these brushes show the paper texture very well when used in the Grainy Hard Cover Cloning method, as these were here.

Figure 3.39 *Original photograph.*

Figure 3.40 *Detail.*

Digital Watercolor

Digital Watercolor offers an alternative to the standard Watercolor brushes. The main difference is that the brushes can be applied to a normal layer unlike Watercolor, which must have its own dedicated layer. This makes it more versatile as it is possible to use both Digital Watercolor and other brush categories on the same layer.

As can be seen below the brushes vary considerably from smooth strokes to very diffused ones. With the exception of the Flat Water Blender, all the examples below use the Clone Color option, which retains the impression of watercolor.

There is more information on the difference between the Digital Watercolor and Watercolor brush categories in Chapter 8 together with a step-by-step example using Digital Watercolor.

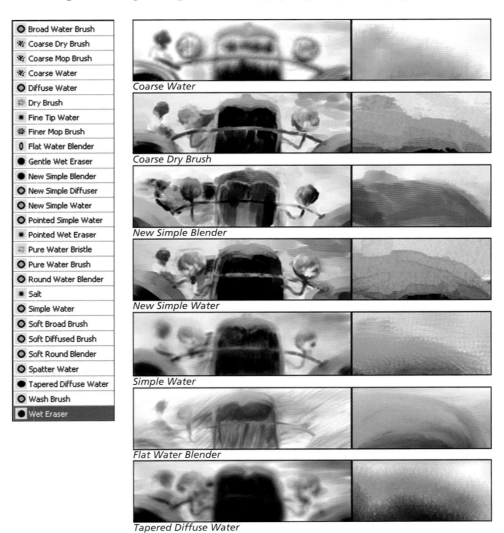

Coarse Water

Coarse Dry Brush

New Simple Blender

New Simple Water

Simple Water

Flat Water Blender

Tapered Diffuse Water

Figure 3.41 *Rock and grasses.*

The brush used for this picture was the Digital Watercolor Dry Brush.

When used in a medium or large brush size the result will be very diffused with no detail which is useful as a base color wash.

The brush size was 23.6, opacity 20% and grain 100%. The Clone Color option was ticked in the Colors palette.

To bring in some detail the brush size was reduced to 5.4 and the whole picture painted over at an enlarged size. It was useful to rotate the canvas so that the brush strokes followed the lines of the grasses and rock strata. Rotating the canvas is explained in Chapter 1.

Figure 3.42 *Original photograph.*

Figure 3.43 *Detail.*

Distortion

This brush category is not suitable for cloning but a great fun to play around with as the brushes move around and distort the original picture.

The brushes create spikes, swirls, circles and distortions of every type.

The Hurricane brush seems to send the image to another planet!

Although generally these brushes are not made for cloning, it is possible to use a few in this way. Marbling Rake and Water Drops can both be used as cloners.

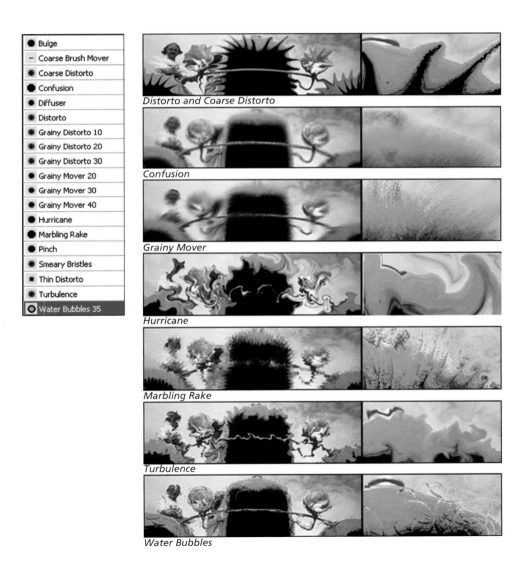

- ● Bulge
- − Coarse Brush Mover
- ✳ Coarse Distorto
- ● Confusion
- ✳ Diffuser
- ✳ Distorto
- ✳ Grainy Distorto 10
- ✳ Grainy Distorto 20
- ✳ Grainy Distorto 30
- ● Grainy Mover 20
- ● Grainy Mover 30
- ● Grainy Mover 40
- ● Hurricane
- ● Marbling Rake
- ● Pinch
- ✳ Smeary Bristles
- ✳ Thin Distorto
- ✳ Turbulence
- ◉ Water Bubbles 35

Distorto and Coarse Distorto

Confusion

Grainy Mover

Hurricane

Marbling Rake

Turbulence

Water Bubbles

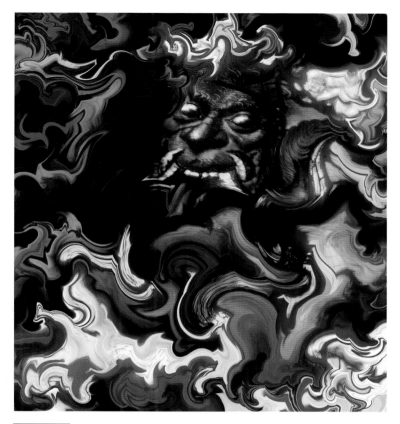

Figure 3.44 *The fiery furnace.*

The original photograph was of a stained glass church window and from the Distortion set of brushes the Hurricane brush was used to make these wild distortions.

I rather felt that it suited the idea of being thrown in the maelstrom, with the Devil waiting there for you!

Figure 3.45 *Original photograph.*

Figure 3.46 *The devil in close up.*

Erasers

When it is necessary to erase parts of a picture it is often better to change the Method to Erasers in order to retain the same brush stroke characteristics. There are times however when it is more convenient to use the Erasers in this category as you can then swap very easily between the cloning brush and the eraser.

There are several brushes that have uses other than as erasers. The darkener can be used to enhance modelling by darkening shadows.

The Gentle Bleach will do the opposite and brighten areas. When used with large brush sizes and a low opacity many erasers will lighten or darken whole areas.

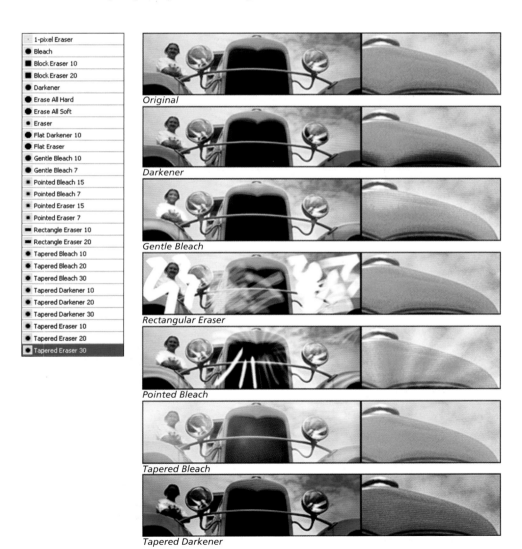

Original

Darkener

Gentle Bleach

Rectangular Eraser

Pointed Bleach

Tapered Bleach

Tapered Darkener

Figure 3.47 *Thoughtful.*

The photograph of this rather grotesque statue was taken on a very dull overcast day and the resulting picture was lacking in contrast.

Two of the Eraser brushes were used to improve the contrast and brightness.

The Darkener was used to paint in the background to remove the bright areas, then the Gentle Bleach to paint over the eyes and areas where the light would be expected to fall.

Various brush sizes and opacities were used and alternated until the picture was complete.

Figure 3.48 *Original photograph.*

F – X

The name F – X immediately tells us that this group of brushes is intended for special effects. Some of the brushes such as Graphic Paintbrush, Furry Brush and Piano Keys will also work well as cloners, they will all produce some very unusual pictures.

Other brushes work directly upon the picture. In the examples below Glow, for instance, lights up the headlights of the car, while Fire seems to set light to it.

Shattered imposes a broken structure over the original as though it is being seen through broken glass. The Furry Brush and Hair Spray both use the airbrush effect and shoot out the paint in the direction that the stylus is angled.

● Confusion
✳ Fairy Dust
♦ Fire
● Furry Brush
✳ Glow
🖌 Gradient Flat Brush 20
— Gradient String
— Graphic Paintbrush
— Graphic Paintbrush Soft
● Hair Spray
— Neon Pen
❘ Piano Keys
🔺 Shattered
❚ Squeegee

Graphic Paintbrush

Furry Brush

Glow

Fire

Shattered

Hair Spray

Piano Keys

Figure 3.49 *Original photograph.*

Figure 3.50 *Shattered and Fairy Dust.*

Figure 3.51 *Graphic Paintbrush Soft.*

Figure 3.52 *Furry Brush.*

The examples above show how brushes in this category may be used to create unusual abstract pictures. Figure 3.50 used the Shattered brush initially then the Fairy Dust brush added the stars over the top of the picture.

Felt Pens

Felt Pens are graphic tools and are best used for pictures that need a strong energetic style. One of the distinguishing characteristics of Felt Pens is that when you repeat brush strokes the density increases and the color builds quite quickly to black. Most of the Felt Pens in this category work on this same principle.

The Design marker is very rough and increases the contrast and color quite strongly.

In the last two examples the Method has been changed to Grainy Hard Cover Cloning and paper texture changed to a different pattern. Using this method the pens no longer build to black.

I	Art Marker
●	Blunt Tip 3
●	Blunt Tip 5
●	Blunt Tip 7
■	Design Marker 10
■	Design Marker 20
■	Design Marker 30
—	Dirty Marker
—	Dirty Marker 10
—	Dirty Marker 20
—	Felt Marker
■	Fine Point Marker 5
●	Fine Tip
●	Medium Tip Felt Pens
■	Thick n Thin Marker 10
■	Thick n Thin Marker 20
■	Thick n Thin Marker 30

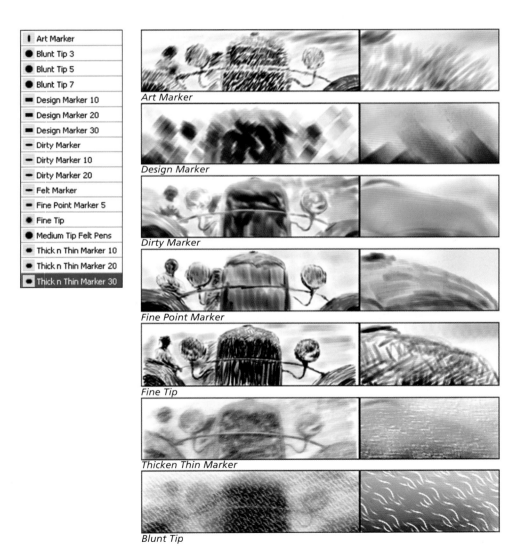

Art Marker

Design Marker

Dirty Marker

Fine Point Marker

Fine Tip

Thicken Thin Marker

Blunt Tip

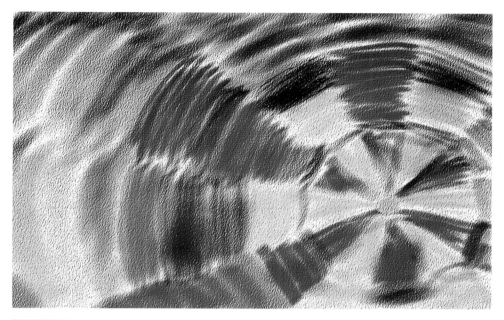

Figure 3.53 *Balloon canopy.*

The Art Marker was used for this picture which gave a rough unfinished look but with quite a lot of impact. The brush was on the default settings but with the Clone Color option selected. Brush sizes were between 8.0 and 24.0 and opacity 10%.

Figure 3.54 *Original photograph.*

The original photograph of the balloon canopy was shot from inside the balloon while it was being inflated. Once the first stage of the clone copy was finished as shown in Figure 3.55, a surface texture was added based on the paper pattern, which was Basic Paper.

Another layer of texture was applied this time based on the image luminance.

The textures added to the overall appearance of the finished picture and helped to harmonize together the brush strokes.

The procedure for adding surface textures is covered in Chapter 6.

Figure 3.55 *Before the texture was applied.*

Gouache

All the Gouache brushes have a very pronounced brush stroke and several have three-dimensional depth.

The first few examples below use an airbrush style and spray paint in the direction that the stylus is angled.

Most of the brushes use the Clone Color option but the Opaque Smooth brush can also change the Method to cloning and it is shown below in that mode using the Smooth Handmade paper.

The Wet Gouache Round brush smears the picture in a style reminiscent to watercolor.

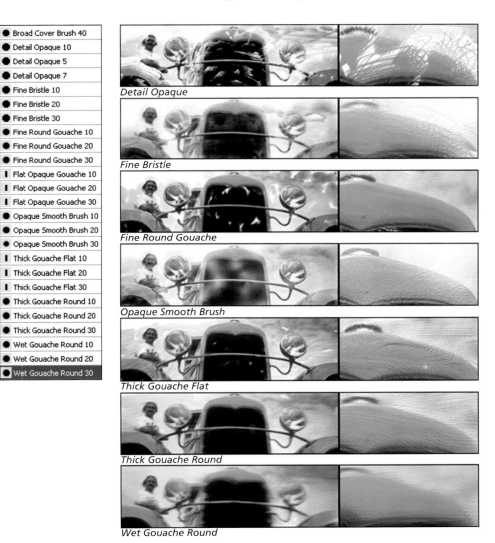

Broad Cover Brush 40
Detail Opaque 10
Detail Opaque 5
Detail Opaque 7
Fine Bristle 10
Fine Bristle 20
Fine Bristle 30
Fine Round Gouache 10
Fine Round Gouache 20
Fine Round Gouache 30
Flat Opaque Gouache 10
Flat Opaque Gouache 20
Flat Opaque Gouache 30
Opaque Smooth Brush 10
Opaque Smooth Brush 20
Opaque Smooth Brush 30
Thick Gouache Flat 10
Thick Gouache Flat 20
Thick Gouache Flat 30
Thick Gouache Round 10
Thick Gouache Round 20
Thick Gouache Round 30
Wet Gouache Round 10
Wet Gouache Round 20
Wet Gouache Round 30

Detail Opaque

Fine Bristle

Fine Round Gouache

Opaque Smooth Brush

Thick Gouache Flat

Thick Gouache Round

Wet Gouache Round

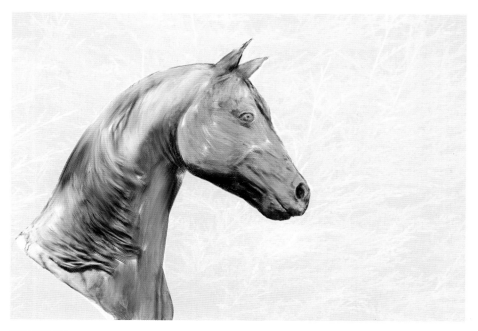

Figure 3.56 *Horse statue.*

The Wet Gouache Round brush was used for this statue of a Horse's head. The brush size was 30.0 initially then 10.0 for the more detailed areas with the opacity at 100% for most of the time.

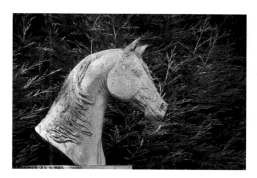

Figure 3.57 *Original photograph.*

Only the statue was cloned and not the background as the color was too strong and distracting.

When the head was finished the original image was copied and pasted into the cloned copy on the top of the layer stack.

The canvas was then copied and moved to the top of the layer stack and the Layer Composite method was changed to Gell, which removed the white around the head.

Finally the opacity of the layer underneath was reduced to just 11% to provide this very light background with just a hint of the original trees.

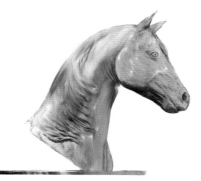

Figure 3.58 *Before the background was added.*

Image Hoze

The Image Hoze is quite unlike any other brush category as it cannot make clones or over paint pictures and does not resemble any traditional artists tool.

What it does is to spray out images which have previously been stored in the Image Hoze nozzle. There are many nozzles in Painter to choose from and some samples from the libraries that come with the program are shown below.

What is also very interesting is the ability to make Image Hoze nozzles from your own images. It is certainly a tool to explore and have fun with.

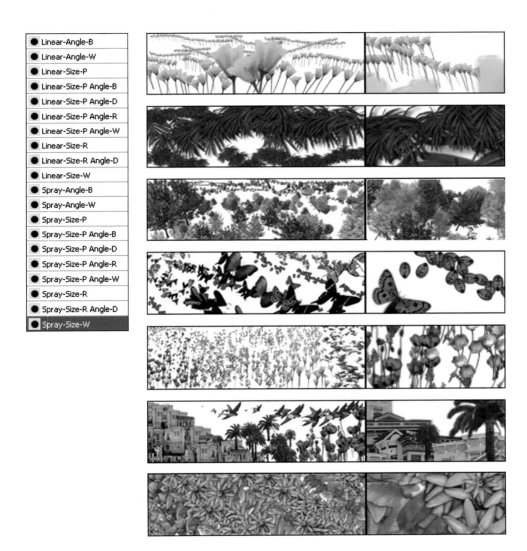

Figure 3.59 *Snakes and Ladders.*

Several Image Hoze nozzles have been applied over a photograph of a very old Snakes and Ladders board game.

The brush variants listed for this category refer to the manner in which the images are put on the paper, in lines or sprays and in what order.

To access the images to be sprayed, click on the bottom right icon in the toolbox and select the nozzle required. Image Hoze pictures can be used to make abstract patterns as the pictures below illustrate.

Figure 3.60 *Some other Image Hoze nozzle pictures.*

Impasto

Impasto is both the name given to this group of brushes and also the name of the style used for many other brushes particularly in the Acrylics and Oils categories.

Brush
● Acid Etch
● Clear Varnish
● Depth Color Eraser
● Depth Equalizer
● Depth Eraser
● Depth Lofter
● Depth Rake
● Depth Smear
● Distorto Impasto
— Fiber
● Gloopy
● Grain Emboss
— Graphic Paintbrush
— Impasto Pattern Pen
— Loaded Palette Knife
● Opaque Bristle Spray
❙ Opaque Flat
● Opaque Round
— Palette Knife
● Pattern Emboss
● Round Camelhair
● Smeary Bristle
● Smeary Bristle Spray
❙ Smeary Flat
● Smeary Round
● Smeary Varnish
● Texturizer-Clear
● Texturizer-Fine
● Texturizer-Heavy
● Texturizer-Variable
● Thick Bristle 10
● Thick Bristle 20
● Thick Bristle 30
● Thick Clear Varnish 20
● Thick Round 10
● Thick Round 20
● Thick Round 30
❙ Thick Tapered Flat 10
❙ Thick Tapered Flat 20
❙ Thick Tapered Flat 30
❙ Thick Wet Flat 20
❙ Thick Wet Round 20
❙ Variable Flat Opaque
● Wet Bristle

The Impasto effect is based on the traditional technique of painting with a very thick paint to create the impression of depth.

Painter re-creates the look of Impasto by using lighting effects to create a three-dimensional impression which is applied as the brush stroke is made.

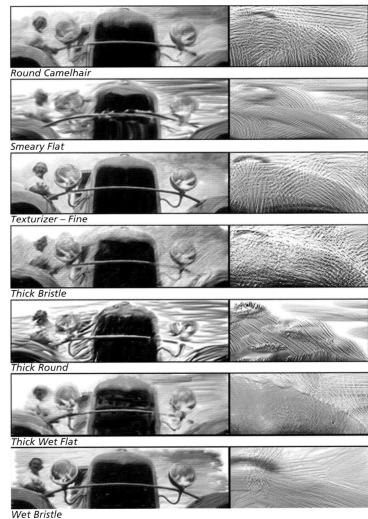

Round Camelhair

Smeary Flat

Texturizer – Fine

Thick Bristle

Thick Round

Thick Wet Flat

Wet Bristle

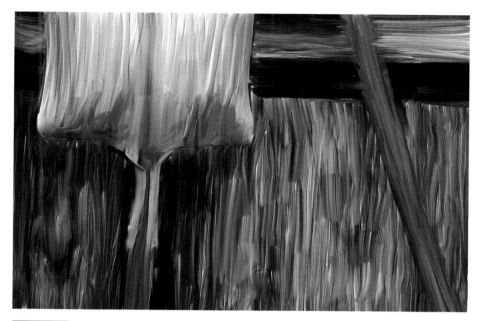

Figure 3.61 *Shovel.*

This old shovel and another tool were hanging on the side of an old boat and I liked the contrast between the metal and the wood.

The Smeary Flat brush was chosen for the clone picture to emphasize the textures of the wood and metal. The brush sizes were between 20.0 and 50.0 and opacity 63%. The Clone Color option was ticked in the Colors palette.

One useful technique is the ability to turn the canvas around to make it easier to paint in a particular direction. In this case I wanted to paint downwards to go with the wood grain but that way the flat brush was being used on its short edge while I wanted to use the wide edge.

With a traditional canvas you can just turn it around, so you will not be surprised that Painter also allows you to do this. Click and hold the hand symbol in the Toolbox until the circular

symbol appears. Click into the picture and drag until the canvas is in the position where it is most convenient to use and continue painting.

To revert to the normal upright position, simply double click in the picture.

You may also notice that the brush strokes appear different. That is to be expected, as you are now painting using the side of the brush and the brush strokes reflect that.

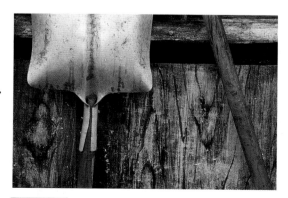

Figure 3.62 *Original photograph.*

Liquid Ink

Liquid Ink is a large group of brushes which replicate the use of ink-based artists materials. The ink flows very fast and covers the paper quickly and has a graphic appearance.

All Liquid Ink brushes use a special layer and a new Liquid Ink layer is created automatically when you use one of the brushes.

The Liquid Ink section in the Brush Creator has many controls for adjusting the brushes, in particular the amount of ink. If this slider is very high the ink spills over the paper in pools.

- Airbrush
- Airbrush Resist
- Calligraphic Flat
- Calligraphic Flat 15
- Clumpy Ink 4
- Coarse Airbrush
- Coarse Airbrush Resist
- Coarse Bristle
- Coarse Bristle Resist
- Coarse Camel
- Coarse Camel Resist
- Coarse Flat
- Coarse Flat Resist
- Depth Bristle
- Depth Camel
- Depth Flat
- Drops of Ink 4
- Dry Bristle
- Dry Camel
- Dry Flat
- Eraser
- Fine Point
- Fine Point Eraser
- Graphic Bristle
- Graphic Bristle Resist
- Graphic Camel
- Graphic Camel Resist
- Graphic Flat
- Graphic Flat Resist
- Pointed Flat
- Serrated Knife
- Smooth Bristle
- Smooth Bristle Resist
- Smooth Camel
- Smooth Camel Resist
- Smooth Flat
- Smooth Flat Resist
- Smooth Knife
- Smooth Rake
- Smooth Round Nib
- Smooth Thick Bristle 12
- Smooth Thick Flat 12
- Smooth Thick Round 12
- Soften Color
- Soften Edges
- Soften Edges and Color
- Sparse Bristle
- Sparse Bristle Resist
- Sparse Camel
- Sparse Camel Resist
- Sparse Flat
- Sparse Flat Resist
- Tapered Bristle 15
- Tapered Thick Bristle
- Thick Bristle
- Velocity Airbrush
- Velocity Sketcher

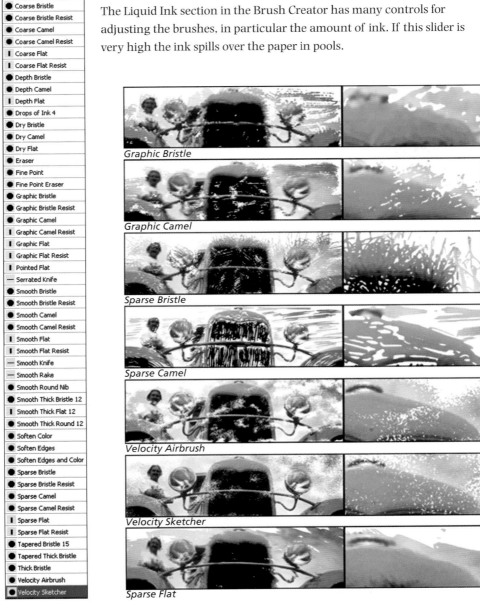

Graphic Bristle

Graphic Camel

Sparse Bristle

Sparse Camel

Velocity Airbrush

Velocity Sketcher

Sparse Flat

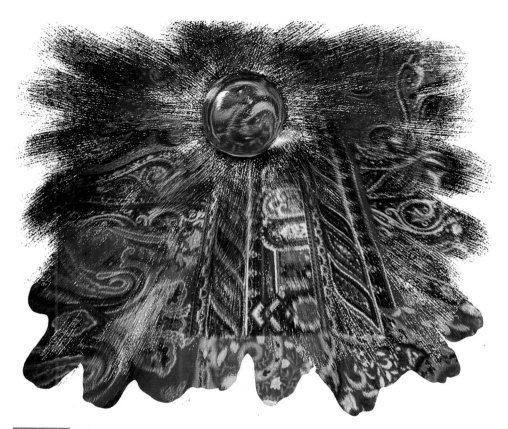

Figure 3.63 *Paperweight on colored cloth.*

This paperweight on a strongly patterned cloth was painted with the Graphic Camel liquid ink brush, size 66.0, opacity 5%. This brush gives a different result depending on whether the brush strokes are fast or slow.

The brush size was reduced when painting the paperweight in order to give it more clarity.

In order to break areas up where the picture had become too dense, white streaks were painted using the Sparse Bristle brush, size 84.0, opacity 1%, volume 6%.

Finally the Soften Edges and the Soften Edges and Color brushes were used on the bottom edges of the picture to create the impression of pooled ink.

Figure 3.64 *Original photograph.*

Oil Pastels

The brushes in the Oil Pastel category all use a very loose chunky style of applying paint but when the brush size is reduced down to a small size the detail can be brought back into the picture.

Oil Pastel brushes will show paper texture if the opacity and grain sliders are reduced considerably, compare the two examples of the Chunky Oil Pastel shown below, the default setting at the top and the reduced grain setting at the bottom.

Some brushes will use the Cloning Method and the Oil Pastel is shown in its default version below and also at the bottom of the examples using the Cloning Method. This does not show the grain at all but smears the original image.

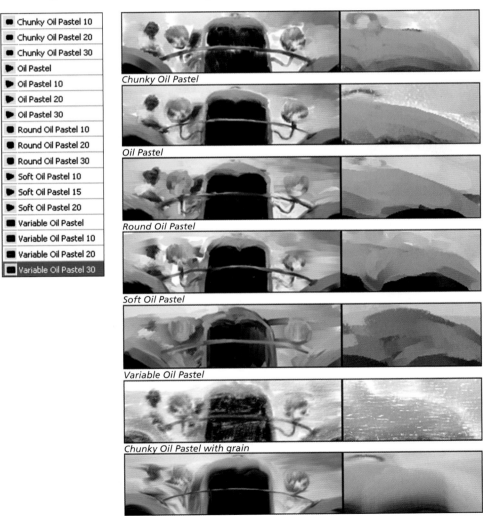

Chunky Oil Pastel

Oil Pastel

Round Oil Pastel

Soft Oil Pastel

Variable Oil Pastel

Chunky Oil Pastel with grain

Oil Pastel – Cloning Method

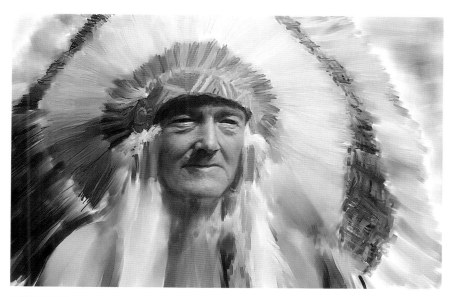

Figure 3.65 *The Chief.*

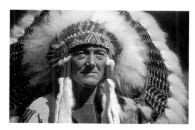

Figure 3.66 *Original photograph.*

Figure 3.67 *Stage 1.*

A Variable Oil Pastel was used to make a clone of this photograph of a man with a splendid feather head dress.

The first step was to roughly block out the main shapes with brush size 30 and opacity 100%.

The same brush and one slightly larger but with reduced opacity was used to paint all over the picture, softening and merging the brush strokes together. In stage three a smaller brush brought out more detail and the opacity was increased to enhance the color and contrast.

Finally the original image was pasted back into the clone and using a layer mask some of the face was brought back to add more realism and detail.

The use of Layer Masks is explained in Chapter 7 which deals with all aspects of the Layers palette.

Figure 3.68 *Stage 2.*

Figure 3.69 *Stage 3.*

Oils

None of these Oil brushes use the paper texture but nearly all have a lovely brush texture. The majority of them use the Clone Color option with just a few able to switch to the Cloning Method.

These brushes are really useful for creating a painterly look, they can be used initially as large brushes to create a textured background and then, by reducing the brush size, more detail can be brought into the clone picture.

The Glazing Round brush has a fine gentle texture which is unusual in this category.

● Bristle Oils 20
● Bristle Oils 30
● Detail Oils Brush 10
● Detail Oils Brush 15
● Detail Oils Brush 5
● Fine Camel 10
● Fine Camel 20
● Fine Camel 30
● Fine Feathering Oils 20
● Fine Feathering Oils 30
● Fine Soft glazing 20
● Fine Soft glazing 30
❘ Flat Oils 10
❘ Flat Oils 20
❘ Flat Oils 30
❘ Flat Oils 40
❘ Glazing Flat 20
❘ Glazing Flat 30
● Glazing Round 10
● Glazing Round 20
● Glazing Round 30
✳ Meduim Bristle Oils 15
✳ Meduim Bristle Oils 25
● Opaque Bristle Spray
❘ Opaque Flat
● Opaque Round
● Round Camelhair
● Smeary Bristle Spray
❘ Smeary Flat
● Smeary Round
❘ Tapered Flat Oils 15
● Tapered Round Oils 15
● Thick Oil Bristle 10
● Thick Oil Bristle 20
● Thick Oil Bristle 30
❘ Thick Oil Flat 10
❘ Thick Oil Flat 20
❘ Thick Oil Flat 30
● Thick Wet Camel 10
● Thick Wet Camel 20
● Thick Wet Camel 30
● Thick Wet Oils 10
● Thick Wet Oils 20
● Thick Wet Oils 30
❘ Variable Flat
● Variable Round

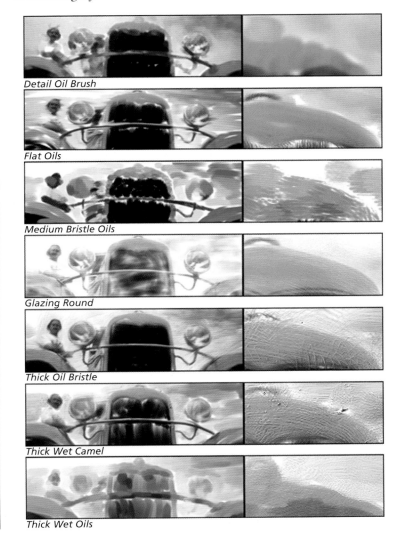

Detail Oil Brush

Flat Oils

Medium Bristle Oils

Glazing Round

Thick Oil Bristle

Thick Wet Camel

Thick Wet Oils

Figure 3.70 *Hello there!*

This charming scene of a child watching the pigeons bathing in the fountain was photographed in Venice and I loved the delight that showed in her face and in the way her hands were clasped together.

The Thick Wet Oils brush was used to block in the main areas, then the Thick Wet Camel to bring in more detail and texture.

It was quite difficult to get good detail into the face and hands of the child, so when the clone was finished the original was pasted back into the clone copy.

A layer mask (see Chapter 7 on how to apply and use Layer masks) hid most of the original picture and just the face and hands were revealed. This gave the clarity and definition that the picture needed.

Figure 3.71 *Detail of finished picture.*

Palette Knives

The Palette Knife brushes are not the easiest to use as clone brushes as they jump around and are quite difficult to control. The Loaded Palette Knife shown below is a good example. The Tiny Palette Knifes are easier to handle, probably because they are so much smaller.

Another way of using these brushes is to work directly on the original and not use the cloning option. The brushes then push the picture around like the Blenders and this can be very successful with the right picture. The examples below for the Subtle Palette Knife and Tiny Subtle Knife have both been used directly upon the image.

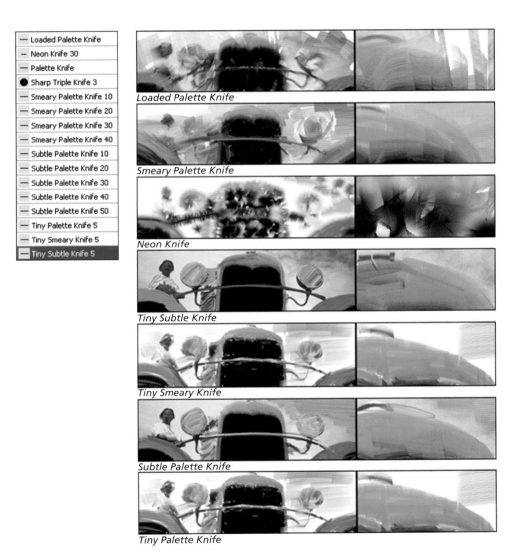

Loaded Palette Knife

Smeary Palette Knife

Neon Knife

Tiny Subtle Knife

Tiny Smeary Knife

Subtle Palette Knife

Tiny Palette Knife

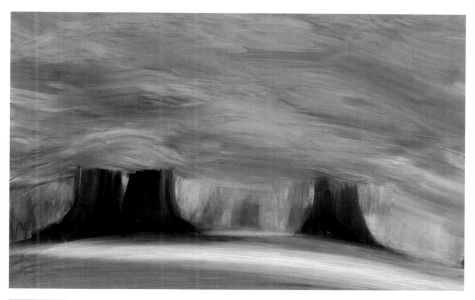

Figure 3.72 *Autumn gales.*

The Subtle Palette Knife was used on these trees in their Autumn colors, the brush was used on a clone copy but with the image not cleared. The brush smeared the photograph as it recreated the picture, treating the imagery as though it was wet paint.

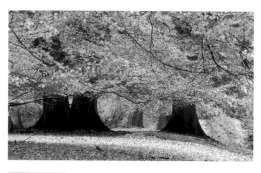

The brush size was mainly 40.0 and opacity 77.0. It was necessary to rotate the photograph in order to have the knife painting in the desired direction.

Figure 3.73 *Original photograph.*

These brushes work in a similar manner to the Blender brushes and Figure 3.74 shows an alternative version using the Grainy Blender brush. This is actually a much easier brush to use, the brush size was 66.60, opacity 80%.

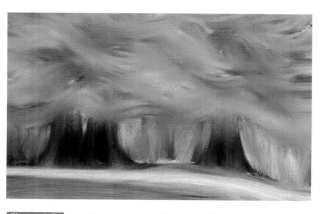

It's fun doing this sort of picture. The brush is fast to use and you can easily make several versions and decide later which the better one is.

Figure 3.74 *Another version made with a blender brush.*

Pastels

The Pastel brush category has a rather loose smeary finish when used at a large brush size but more detail can be brought back when the brush size is reduced.

Most variants can be used in Cloning Method but to get the distinctive pastel finish it is generally more useful to use the Clone Color option.

The Blunt Hard and the Square Hard Pastel uses the paper textures very successfully without any brush modification. The various Soft Pastels all smear the picture, some very substantially.

Pastels are very useful for painting portraits and there are some examples of their use in the chapters on portraits.

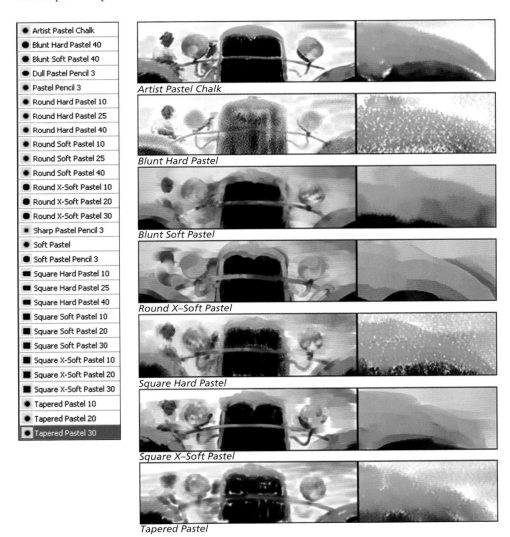

- Artist Pastel Chalk
- Blunt Hard Pastel 40
- Blunt Soft Pastel 40
- Dull Pastel Pencil 3
- Pastel Pencil 3
- Round Hard Pastel 10
- Round Hard Pastel 25
- Round Hard Pastel 40
- Round Soft Pastel 10
- Round Soft Pastel 25
- Round Soft Pastel 40
- Round X-Soft Pastel 10
- Round X-Soft Pastel 20
- Round X-Soft Pastel 30
- Sharp Pastel Pencil 3
- Soft Pastel
- Soft Pastel Pencil 3
- Square Hard Pastel 10
- Square Hard Pastel 25
- Square Hard Pastel 40
- Square Soft Pastel 10
- Square Soft Pastel 20
- Square Soft Pastel 30
- Square X-Soft Pastel 10
- Square X-Soft Pastel 20
- Square X-Soft Pastel 30
- Tapered Pastel 10
- Tapered Pastel 20
- Tapered Pastel 30

Artist Pastel Chalk

Blunt Hard Pastel

Blunt Soft Pastel

Round X–Soft Pastel

Square Hard Pastel

Square X–Soft Pastel

Tapered Pastel

Figure 3.75 Window model.

A Clone copy was made of the photograph of the window model and the image was not cleared. The hair and neck and shoulders were painted over with the Round Hard Pastel, brush size 40, opacity 100% and grain 12%.

The paper chosen was Sandy Pastel Paper which added a fine texture to the picture and gave it the distinctive look of pastel.

The face was painted with the same pastel and a reduced opacity of 65% which gave it a lighter and more detailed texture.

Smaller sizes and varying opacities were necessary to complete the details of the face.

Figure 3.76 Original photograph.

Pattern Pens

Well, what are we to make of this brush category? It is very different and definitely not designed for accurate cloning.

The name of the brush category says it all, Pattern Pens are designed to make patterns out of images. Some of the brush variants can use the Cloning method but the result is much the same, an unusual sampling and mixing of the original picture.

The pens vary slightly. The Pattern Marker mutes the colors and gives a pastel finish while the Pattern Pen is strident and full of bold colors. The Soft Edge and Transparent Pens both have softer and slightly veiled looks.

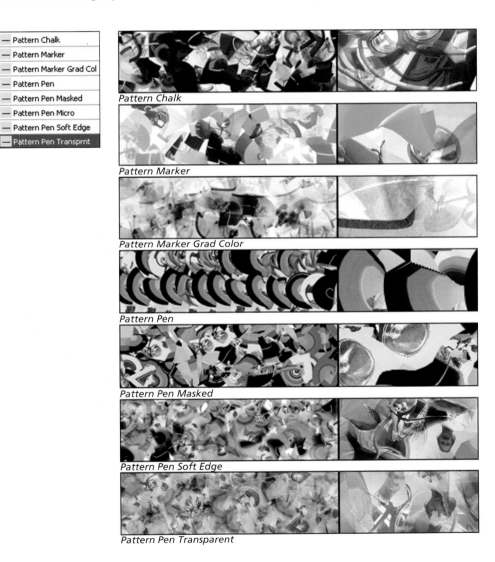

Pattern Chalk

Pattern Marker

Pattern Marker Grad Color

Pattern Pen

Pattern Pen Masked

Pattern Pen Soft Edge

Pattern Pen Transparent

Figure 3.77 *Interleaved.*

Figure 3.78 *Original photograph.*

Figure 3.79 *Swirl.*

Various brushes from the Pattern Pen category were used to make the abstract patterns on this page. Figure 3.78 shows the original photograph.

Figure 3.80 *Eyes.*

Pencils

The Pencil brush category, not surprisingly, consists of thin brushes suitable for sketching. Here I have used them all as cloners but they may be more successful to use as simple pencils.

Several of the variants use the Build-up method so they will get darker as the brush continues to paint. If you want to avoid this you could use the Grainy Cover Pencil as this works differently.

Both the Greasy Pencil and the Oily Variable Pencil smear the image so are less accurate in making clones. All the Pencils interact well with the paper grain.

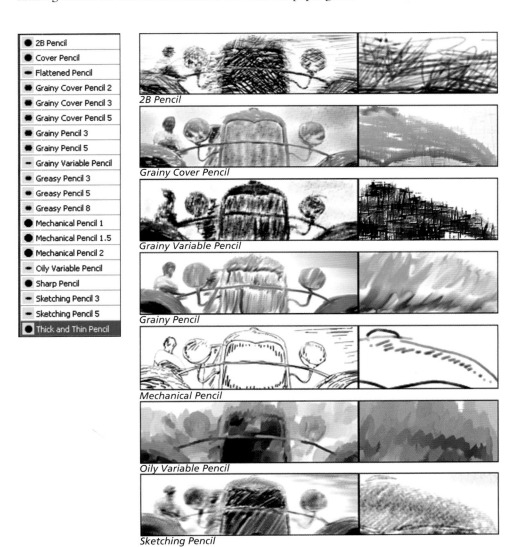

- ● 2B Pencil
- ● Cover Pencil
- ━ Flattened Pencil
- ◼ Grainy Cover Pencil 2
- ◼ Grainy Cover Pencil 3
- ◼ Grainy Cover Pencil 5
- ◼ Grainy Pencil 3
- ◼ Grainy Pencil 5
- ━ Grainy Variable Pencil
- ◼ Greasy Pencil 3
- ◼ Greasy Pencil 5
- ◼ Greasy Pencil 8
- ● Mechanical Pencil 1
- ● Mechanical Pencil 1.5
- ● Mechanical Pencil 2
- ━ Oily Variable Pencil
- ● Sharp Pencil
- ━ Sketching Pencil 3
- ━ Sketching Pencil 5
- ◉ Thick and Thin Pencil

2B Pencil

Grainy Cover Pencil

Grainy Variable Pencil

Grainy Pencil

Mechanical Pencil

Oily Variable Pencil

Sketching Pencil

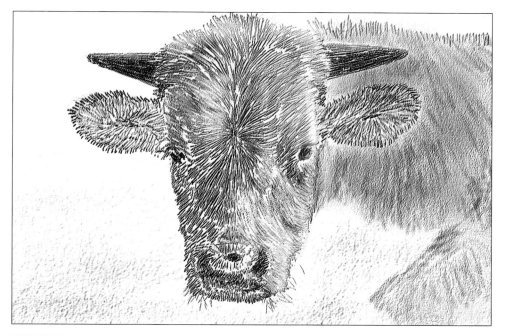

Figure 3.81 *Bullock.*

This picture was painted with the Grainy Cover Pencil variant, the brush size was around 3.0–5.0 for most of the picture, with the opacity at 100%.

The picture was intended to look like a pencil sketch and this brush gave a hard finish to the brush strokes. The Clone Color option was used with the other settings on default.

When the head was finished a larger brush size, around 10.0 with a lower opacity of 10% was used for the body of the bullock.

Light texture was added to the bottom of the picture to give the impression of ground for the animal to lie on, this was cloned using Rough Charcoal as the paper grain.

Finally Surface Texture was added based on the image luminance and in addition another texture using three-dimensional brush strokes, which gave the picture more body.

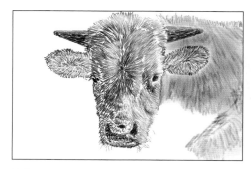

Figure 3.82 *An early stage.*

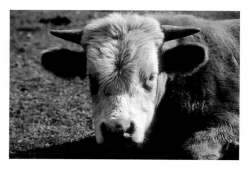

Figure 3.83 *Original photograph.*

Pens

As you may expect, the Pens brush category includes a fair selection of thin brushes, which give a ball pen style of painting. There are, however, some rather unusual and interesting variants. The barbed wire pen, for example, which spreads random lines around the brush stroke.

The Nervous pen is great fun, it might also be described as a drunken pen as the brush stroke is so irregular. The Scratchboard Rake is also quite different, painting everything with multiple separate brush strokes.

Variants like the Smooth Ink Pen and the Round Tip Pen both give strong colorful strokes and smear the original clone information around to some extent.

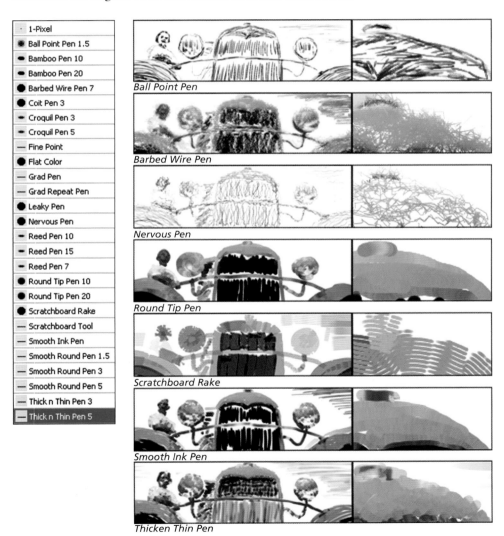

1-Pixel
Ball Point Pen 1.5
Bamboo Pen 10
Bamboo Pen 20
Barbed Wire Pen 7
Coit Pen 3
Croquil Pen 3
Croquil Pen 5
Fine Point
Flat Color
Grad Pen
Grad Repeat Pen
Leaky Pen
Nervous Pen
Reed Pen 10
Reed Pen 15
Reed Pen 7
Round Tip Pen 10
Round Tip Pen 20
Scratchboard Rake
Scratchboard Tool
Smooth Ink Pen
Smooth Round Pen 1.5
Smooth Round Pen 3
Smooth Round Pen 5
Thick n Thin Pen 3
Thick n Thin Pen 5

Ball Point Pen

Barbed Wire Pen

Nervous Pen

Round Tip Pen

Scratchboard Rake

Smooth Ink Pen

Thicken Thin Pen

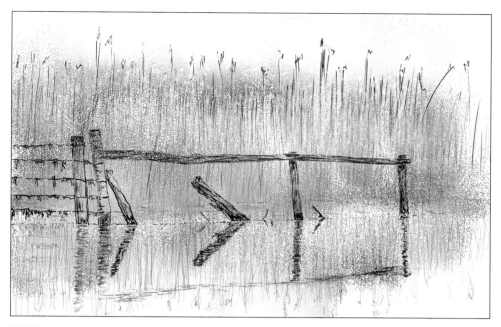

Figure 3.84 *Lakeside reeds.*

This clone was painted with the Smooth Ink Pen. The outlines of the posts were sketched first using the Tracing Paper as a guide, the brush size was 5.0 and the opacity 100%.

The reeds at the top were painted using brush sizes of between 1.0 and 3.0 and 50% and 100% opacities.

The reflections of the reeds were made with the Nervous Pen. This was ideal as the nervous movement of the pen was perfect for indicating the subtle movement of the reflections in the water. The picture showing this stage can be seen in Figure 3.85.

To complete the picture shown at the top of the page an empty layer was placed on the top of the layer stack and using the Coarse Spray Airbrush, color was cloned back in. Some of the color was later partially removed with an eraser to keep the picture very light and delicate.

Figure 3.85 *Stage 1.*

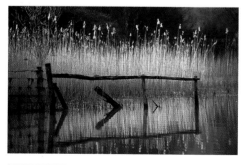

Figure 3.86 *Original photograph.*

Photo

The Photo category of brushes is intended to give easy access to tools which photographers typically use to fine-tune their photographs. They include sharpen, blur, dodge and saturation and are applied directly on the photograph with brushes rather than by making selections.

The Add Grain Brush is interesting as texture is copied from the Papers palette and painted directly on the photograph.

The diffusers are very similar to those in the Diffusers brush category.

In the examples below I have been rather heavy handed to enable the result to be seen in a small picture. Normally the effect would be done with more subtlety.

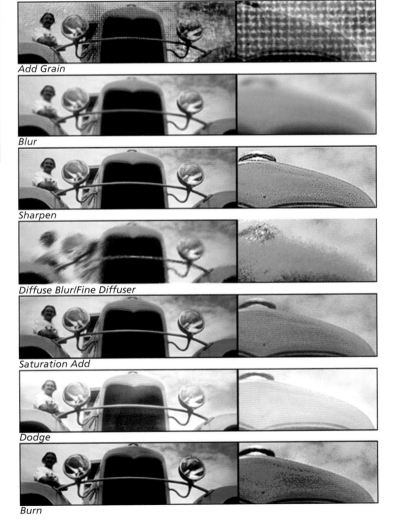

Add Grain

Blur

Sharpen

Diffuse Blur/Fine Diffuser

Saturation Add

Dodge

Burn

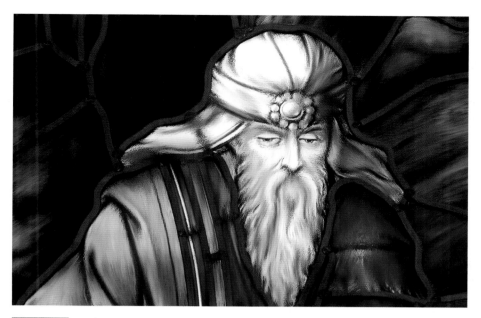

Figure 3.87 *Prophet.*

The stained glass window in a local church featured this very impressive religious figure and I have used the tools in the Photo brush category to illustrate how they can be used to alter a picture.

I painted over the photograph with the Diffuse Blur brush, which broke up the detail and made it less of a record picture. All the brushes were used at their default settings. The Burn brush darkened the background. I also ran over the top of the background with the Blur brush to soften the detail more. I gently sharpened the face at the end.

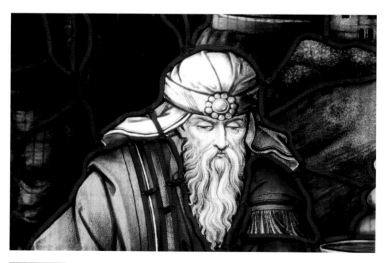

Figure 3.88 *Original photograph.*

RealBristle Brushes

RealBristle Brushes are new in Painter X and are a wonderful addition to the existing brush categories. They are already fast becoming some of my favorite brushes. What I like about them is the beautiful bristle marks which they make, it has been hard to achieve this effect previously. They are also excellent for cloning and very easy to use.

The Real Blender Round will clone very well, it slightly smears the existing colors and is excellent for portraits. The Real Flat Opaque is the odd one out in that it continues to paint with the first color sampled, rather like the Artist Oils category, this can be hard to use for cloning but is worth persevering with as the effect can be very interesting.

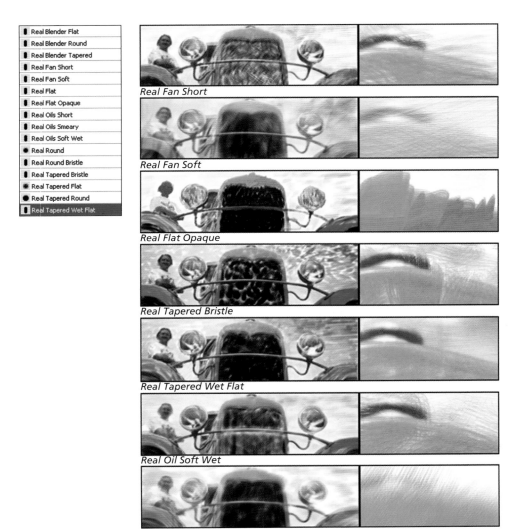

Real Blender Flat
Real Blender Round
Real Blender Tapered
Real Fan Short
Real Fan Soft
Real Flat
Real Flat Opaque
Real Oils Short
Real Oils Smeary
Real Oils Soft Wet
Real Round
Real Round Bristle
Real Tapered Bristle
Real Tapered Flat
Real Tapered Round
Real Tapered Wet Flat

Real Fan Short

Real Fan Soft

Real Flat Opaque

Real Tapered Bristle

Real Tapered Wet Flat

Real Oil Soft Wet

Real Blender Round

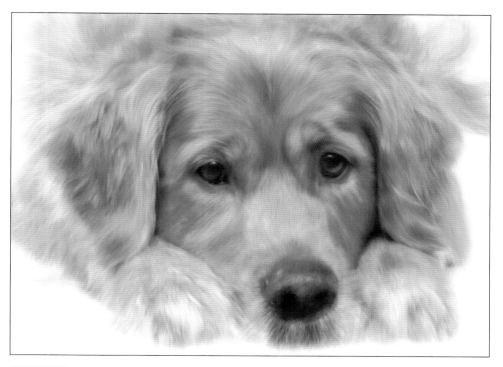

Figure 3.89 *Retriever.*

This very appealing Retriever was painted with the Real Blender Round brush. Starting from a clone copy (Quick Clone) the picture was gradually painted back using brush size 49 and opacity 12%, all other settings were as default. Figure 3.91 below shows an early stage, the density was gradually built up until all the central areas were fully painted. This brush subtly blends as it clones which leaves a very soft yet detailed finish.

When the cloning was complete the brush was used to paint and sampling the color from various parts of the picture I painted over areas of the painting to give a more painterly finish. I used brush size 10 with 100% opacity for the final painting.

My thanks to June Cook for loaning me her original photograph for this picture.

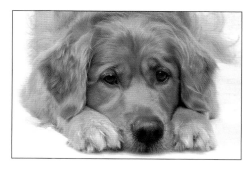

Figure 3.90 *Original photograph.*

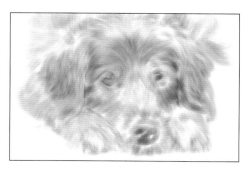

Figure 3.91 *Interim stage.*

Smart Stroke Brushes

Smart Stroke Brushes are the other brush category new to Painter X. They are designed to work with the new Auto-Painting palette and cover a wide range of traditional media techniques. They can be used for cloning and work very well, I particularly like the Acrylics Captured brush which gives a very rich texture and is quick and easy to use.

The examples shown below for Sponge Soft and Watercolor Broad brush have been made using the Auto-Painting palette. This palette is very useful as it can create the overall texture as an underpainting and then detail can be painted in by hand.

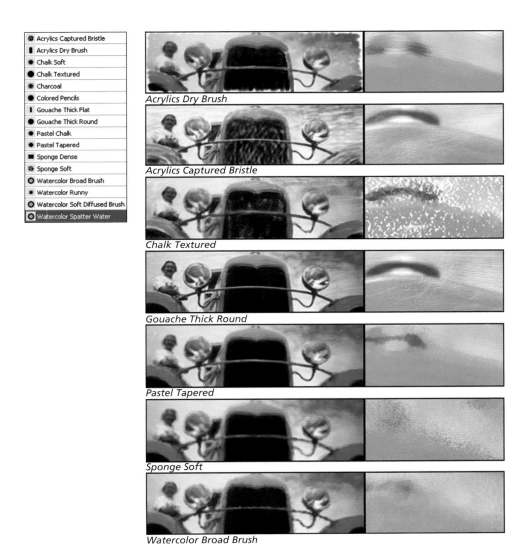

Acrylics Captured Bristle
Acrylics Dry Brush
Chalk Soft
Chalk Textured
Charcoal
Colored Pencils
Gouache Thick Flat
Gouache Thick Round
Pastel Chalk
Pastel Tapered
Sponge Dense
Sponge Soft
Watercolor Broad Brush
Watercolor Runny
Watercolor Soft Diffused Brush
Watercolor Spatter Water

Acrylics Dry Brush

Acrylics Captured Bristle

Chalk Textured

Gouache Thick Round

Pastel Tapered

Sponge Soft

Watercolor Broad Brush

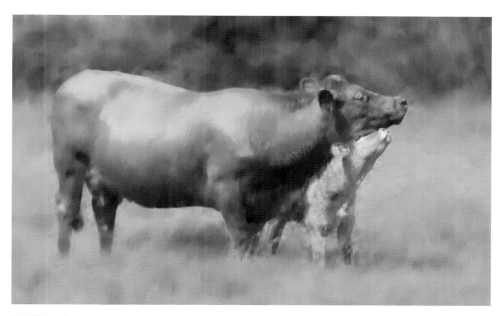

Figure 3.92 Cow and calf.

This pastoral photograph of a cow and her calf has been painted with the Smart Stroke, Acrylics Captured Bristle. The first stage was completed by using the Auto-Painting palette with the Smart Stroke Painting option ticked. This resulted in the picture seen in Figure 3.94, and the next step was to paint over the white areas. There are unsightly contour lines on the cow and these were painted over with the same brush size 20, opacity 100%, and the brush strokes followed the lines of the hair.

Reducing the brush size down to 10 and later to 5 and using an opacity of 50% the details on the head and coat of both cow and calf were gradually painted in.

The background was rather distracting, so taking the brush out of cloning method this was painted over with brush size 35 and opacity 50%.

Finally any unfinished areas were dealt with, rough areas smoothed over with a low opacity brush and the picture was cropped slightly.

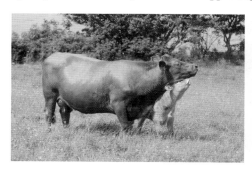

Figure 3.93 Original photograph.

Figure 3.94 After the Auto-Painting.

Sponges

In traditional painting sponges are often used to dab on wet paint and add a textured finish so they are not obvious candidates for cloning pictures. Most of these brushes can be used either in Cloning Method which gives a patchy, but fairly realistic, picture or using Clone Color where the image is reduced to dabs of color with little or no detail. The two Grainy Wet Sponge examples below illustrate the differences between the two methods.

As its name implies, the Smeary Wet Sponge smears the picture quite strongly.

Another way in which these brushes can be used very successfully is to apply them directly to the photograph and this is shown in the Wet Sponge example below.

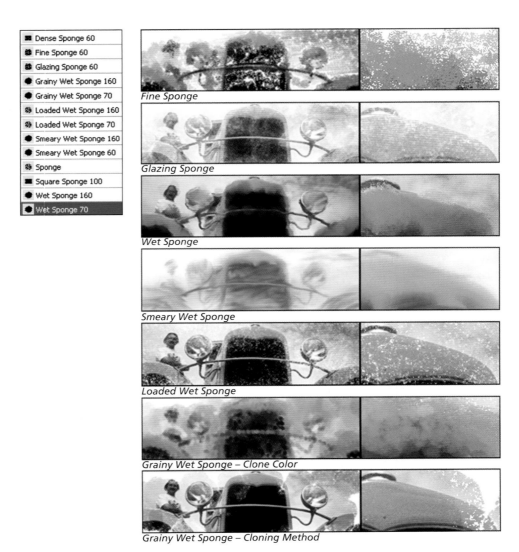

| Dense Sponge 60 |
| Fine Sponge 60 |
| Glazing Sponge 60 |
| Grainy Wet Sponge 160 |
| Grainy Wet Sponge 70 |
| Loaded Wet Sponge 160 |
| Loaded Wet Sponge 70 |
| Smeary Wet Sponge 160 |
| Smeary Wet Sponge 60 |
| Sponge |
| Square Sponge 100 |
| Wet Sponge 160 |
| Wet Sponge 70 |

Fine Sponge

Glazing Sponge

Wet Sponge

Smeary Wet Sponge

Loaded Wet Sponge

Grainy Wet Sponge – Clone Color

Grainy Wet Sponge – Cloning Method

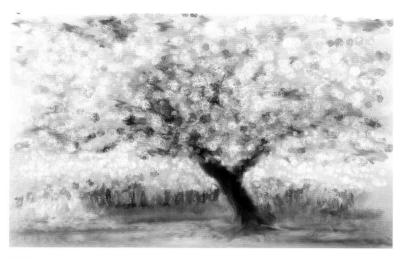

Figure 3.95 *Springtime blossom.*

The stages of painting Springtime Blossom are shown below.

Stage 1 was a quick wash with the Smeary Wet Sponge using the Clone Color option. Stage 2 used the same brush, Clone Color was clicked off and the Method changed to Cloning to bring in more detail. The brush was then changed to Fine Sponge using the Clone Color option to add to the texture.

Stage 3 used the Smeary Wet Sponge, dabbing all over the picture to soften some of the detail. In Stage 4 the Fine Sponge was used again and more dabs of color created.

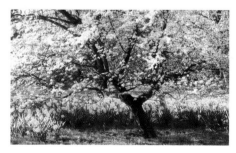

Figure 3.96 *Original photograph.*

Figure 3.97 *Stage 1.*

Figure 3.98 *Stage 2.*

Figure 3.99 *Stage 3.*

Sumi-e

Sumi-e is an unusual, distinctive brush that uses the rake stroke in most of its variants.

The Digital Sumi-e has the most pronounced rake style but apart from the Flat Wet Sumi-e all the others display this feature in varying degrees depending on the brush type. All the examples have been used with the Clone Color option. The fine Sumi-e is one of the few variants that can resolve fine detail.

The Flat Wet Sumi-e makes a very vivid colorful clone and, because it uses the Build-up Method, the colors intensify very quickly and will build up to black with over painting.

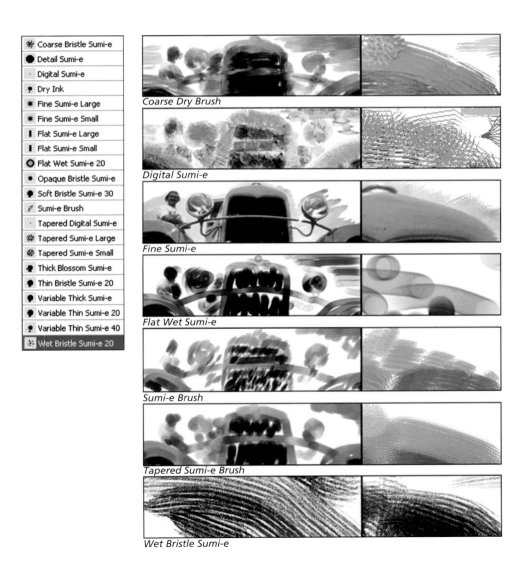

Coarse Bristle Sumi-e
Detail Sumi-e
Digital Sumi-e
Dry Ink
Fine Sumi-e Large
Fine Sumi-e Small
Flat Sumi-e Large
Flat Sumi-e Small
Flat Wet Sumi-e 20
Opaque Bristle Sumi-e
Soft Bristle Sumi-e 30
Sumi-e Brush
Tapered Digital Sumi-e
Tapered Sumi-e Large
Tapered Sumi-e Small
Thick Blossom Sumi-e
Thin Bristle Sumi-e 20
Variable Thick Sumi-e
Variable Thin Sumi-e 20
Variable Thin Sumi-e 40
Wet Bristle Sumi-e 20

Coarse Dry Brush

Digital Sumi-e

Fine Sumi-e

Flat Wet Sumi-e

Sumi-e Brush

Tapered Sumi-e Brush

Wet Bristle Sumi-e

Figure 3.100 *The Rialto bridge, Venice.*

This picture of the well-known Rialto Bridge in Venice was made using the Digital Sumi-e brush.

This brush variant gives a distinctive rake-type appearance and the enlarged detail shown in Figure 3.101 shows the brush strokes clearly.

The clone was made using a fairly large brush size with medium opacity, and cloning repeatedly until the image built up sufficient density.

It is on the outer parts of the picture where the brush marks are most evident. In the centre the picture has become much clearer by the overlapping of the brush strokes.

Figure 3.101 *Detail of Sumi-e brush strokes.*

Tinting

This set of brushes is designed for tinting photographs. They all work in a similar way and their names indicate the differences, oily, grainy, bristle, etc. In the illustrations below the differences are not very apparent and I have rather arbitrarily chosen to repaint this car in some vivid colors.

The original monochrome photograph was kept on the Canvas, a new empty layer was created on top and the brush strokes painted onto that layer. It is essential to change the layer composite method to Color to avoid obscuring the original image beneath.

In addition to the Tinting brushes there are several diffusing brushes and three are shown below. These are very useful for creating a texture over areas of a picture and they are explained in more depth in the later chapters which cover portraits.

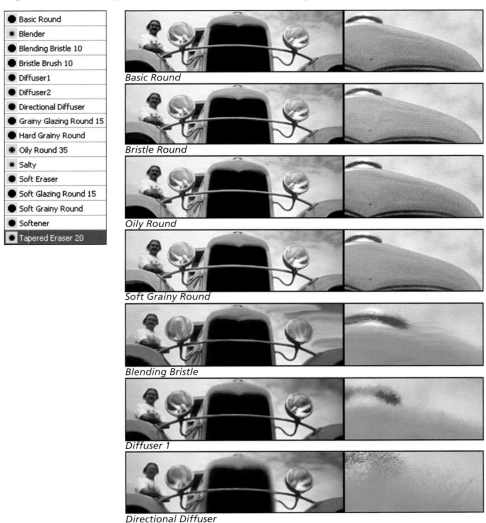

Basic Round

Bristle Round

Oily Round

Soft Grainy Round

Blending Bristle

Diffuser 1

Directional Diffuser

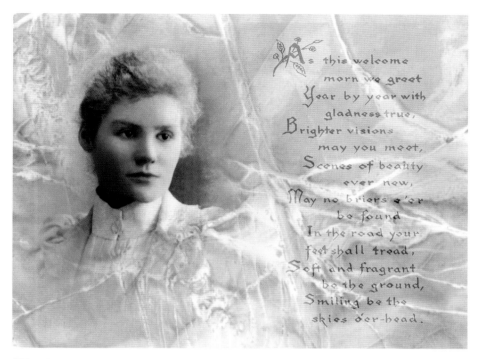

Figure 3.102 Ellen.

A Soft Glazing Round brush from the Tinting brush category was used to tint this old family photograph.

The brush opacity was only 1% or 2% but the color was still too strong, however as each section of tinting was put on a separate layer this allowed the opacity of the relevant layers to be reduced where necessary. The Mixer palette was very useful in selecting the colors.

For a more detailed, step-by-step guide to hand coloring refer to Chapter 10, Hand coloring and toning.

Figure 3.103 Original photograph.

Figure 3.104 The layers palette.

Watercolor

As can be seen from the list of brushes on the left, the Watercolor category contains a huge range of variants, which cover many types of watercolor painting.

The Runny brushes use the traditional wet on wet style and run down the page leaving a highly diffuse picture.

The Dry Camel and Fine Camel give quite a clear clone with the brush stroke visible. The Dry Bristle brush is a good quick brush for a beginner to try. All the examples below use the Clone Color option.

Generally Watercolor is a difficult group of brushes to use for cloning photographs, the special characteristics of Watercolor are explained in more detail in Chapter 8.

- Bleach Runny
- Bleach Splatter
- Diffuse Bristle
- Diffuse Camel
- Diffuse Flat
- Diffuse Grainy Camel
- Diffuse Grainy Flat
- Dry Bristle
- Dry Camel
- Dry Flat
- Eraser Diffuse
- Eraser Dry
- Eraser Grainy
- Eraser Salt
- Eraser Wet
- Fine Bristle
- Fine Camel
- Fine Flat
- Fine Palette Knife
- Grainy Wash Bristle
- Grainy Wash Camel
- Grainy Wash Flat
- Runny Airbrush
- Runny Wash Bristle
- Runny Wash Camel
- Runny Wash Flat
- Runny Wet Bristle
- Runny Wet Camel
- Runny Wet Flat
- Simple Round Wash
- Smooth Runny Bristle 30
- Smooth Runny Camel 30
- Smooth Runny Flat 30
- Soft Bristle
- Soft Camel
- Soft Flat
- Soft Runny Wash
- Splatter Water
- Sponge Grainy Wet
- Sponge Wet
- Wash Bristle
- Wash Camel
- Wash Flat
- Wash Pointed Flat
- Watery Glazing Flat 30
- Watery Glazing Round 30
- Watery Pointed Flat 30
- Watery Soft Bristle 20
- Wet Bristle
- Wet Camel
- Wet Flat
- Wet Wash Flat 35

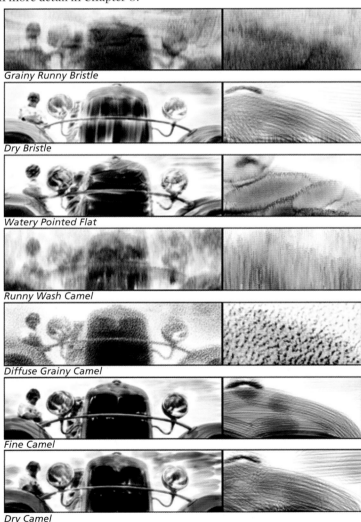

Grainy Runny Bristle

Dry Bristle

Watery Pointed Flat

Runny Wash Camel

Diffuse Grainy Camel

Fine Camel

Dry Camel

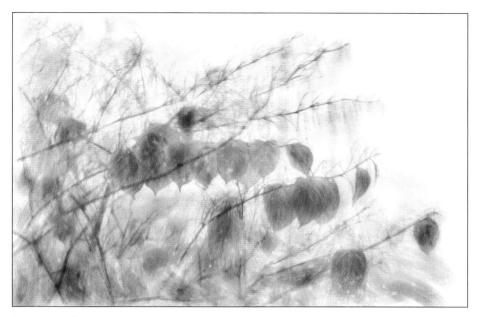

Figure 3.105 *Leaves in the mist.*

Leaves in the Mist was made with the Dry Bristle Watercolor brush, which is a good brush for pictures where the brush texture will enhance the image.

The paper used is Basic paper from the Painter default set.

As you can see from the detail shown in Figure 3.107, the brush strokes are clearly visible and add to the overall texture.

When the clone was completed, the original image was copied and pasted on the top of the clone copy.

The blur filter was applied to the layer and the composite method changed the layer to Screen at 30% opacity.

This gave a luminous quality to the finished picture.

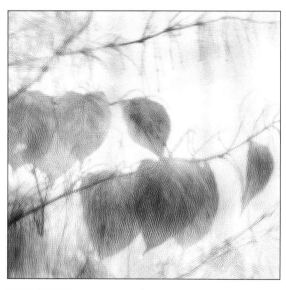

Figure 3.106 *Original photograph.*

Figure 3.107 *Detail showing dry bristle brush strokes.*

Figure 4.1 Red Rose.
This picture was made with the Coarse Oily Blender from the Blenders brush category

4

Customizing Brushes

113

Chapter 3 looked at the wide range of ready-made brushes available in Painter X, but even with all these varieties it is still often necessary to customize them to get exactly the brush strokes required. The Brush Creator contains all the controls for customizing brushes and this chapter explains this in detail together with many of the key controls that you will need to understand.

It is worth remembering that often the only difference between one brush and another is just a few settings in the Brush Creator. The brushes are, after all, just presets made by the creators of Painter for our convenience. In theory you could use just one standard brush and by changing the relevant options in the Brush Creator, have everything from a pencil to a watercolor brush. In practice, it is more convenient to use the standard brushes and change a few of the options to fine-tune the brush.

Figure 4.2 *Crocosmia.*

The Brush Creator

The Brush Creator is the powerhouse for customizing brushes as it brings together all the various palettes and commands into one easily accessible place.

Bring the palette on screen by Window> Show Brush Creator or by the shortcut Ctrl/Cmd + B. When you click back into the image the Brush Creator drops back behind the document you are working on which is a nice touch and saves time. Figure 4.3 shows the Brush Creator with the Stroke Designer tab active. This is where the many sub palettes are stored.

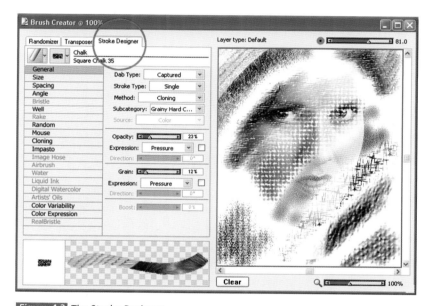

Figure 4.3 *The Stroke Designer.*

In the Brush Creator, click the palette names on the left and the controls for that particular palette will appear to the right. Some of the palettes refer to specific types of brush and are grayed out if that brush is not in use.

At the bottom left is the Preview Grid, this shows a visual representation of the selected brush in both profile view (end on) and as a brush stroke.

The area on the right is the Scratch Pad, this is where you can try out various brushes and options before making a final decision. This scratch pad reflects the paper texture in use and if you have a clone document active the brush will work in cloning mode. Remember that the clone is taken from the top left corner of the original, so nothing much will show if you have a blank area there!

The slider beneath the Scratch Pad will change the magnification, click the Clear button to delete the pad display. The slider above the Scratch pad changes the brush size.

The Stroke Designer Palettes

Stroke Designer Palette – General

The General palette is the most regularly used of all the brush palettes.

It is worth knowing that all the individual palettes of the Brush Creator can be brought on screen separately in Painter X, go to Window> Brush Controls and they will be listed separately there. Because the General palette is used so much I have this on screen permanently, other palettes like the watercolor palette are on screen just when a watercolor brush is being used.

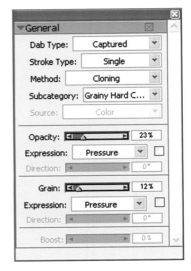

Figure 4.4 *General palette.*

Dab types

The Dab is the mark that the brush makes when a single mark is made using the brush completely vertical. Figure 4.5 shows the long list of dab types, those grayed out are not available for the chosen brush.

Figure 4.5 *Dab types.*

Making alterations in this section will make a fundamental change to the brush so do try out some of these types for yourself. Don't worry if you mess the brush settings up as you can easily revert the brush back to the default setting by clicking the brush icon on the left of the properties bar when the brush is active. The chief dab types are as listed below.

Circular dab types have a very smooth finish, and despite their name the brushes are often long and narrow. Soft clones use circular dab types so this is a good option if you want a smooth clear picture.

Static Bristle brushes are made up of individual bristles and therefore the brush lines are usually visible. This is the dab type to use if you want to emphasize the brush strokes.

116

Captured means that the shape has been made from a design or image rather than using individual bristles. When you make your own dab type this is called Captured. The dab illustrated comes from a Chalk variant. How to create your own captured dab is covered later in this chapter.

Camel Hair and Flat dab types use what are called Rendered dabs, which means that the brush is made up of individual bristles all computed separately. The brushes are often slow to operate, especially when smooth strokes are chosen. The Feature Slider in the Size palette controls the spread of the bristles. The illustration shows the Camel Hair brush with the Feature slider set at 2.1, 5.4 and 10.4.

Palette Knife has an elongated shape and can be used to move imagery around directly on a picture. When using this dab for cloning the imagery will appear with the very distinctive knife-like shape.

The Rendered dab is rather like the Palette Knife in shape and it is difficult to clone with this brush as the image is very distorted.

The Airbrush and the Pixel Airbrush both spray in the direction that the stylus is pointed, just like a real airbrush in fact. These two dab types are very similar with a slightly different texture. The Pixel Airbrush is shown in red in the example.

The Line Airbrush sprays imagery and also severely distorts it. The Furry Clone uses this dab type.

The Liquid Ink series of brush dabs are very smooth and dense, similar to pools of liquid ink on an even surface.

The Watercolor range of brush dabs varies depending on the type of brush, but all paint in the wet method and will distort the cloned image to varying degrees.

Method

The Method controls how the paint is laid on the paper.
Many of the choices are easy to imagine as they are
descriptive, Cover will cover anything previously painted
but will not become darker than the chosen color. Build-up
will get darker as more brush strokes are added, eventually
going to black. Cloning is available on some but not all of
the brushes, those which do use the Cloning method will
produce clear and accurate clones. There are two ways of
making brushes into cloners, one is by using the option in this
palette if available, the other is by clicking the clone icon in the
Colors palette. The option in the General palette will generally
make the brush copy the original picture more accurately than
the Clone Color option.

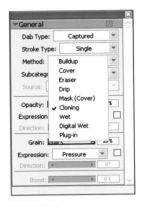

Figure 4.6 Choosing the
Method.

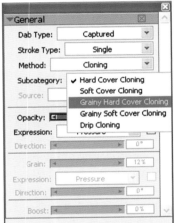

Figure 4.7 Choosing the
sub-category.

Sub-Category

This section refines the chosen Method and in the case
of the Cloning offers four choices. The two that are used
regularly for Cloning are Soft Cover Cloning, which has
a smooth even finish with soft edges, and Grainy Hard
Cover Cloning, which has a rough finish that shows
paper grain.

Grain

This slider controls the amount of grain that is revealed
when brush strokes are applied to the paper.

The amount that is needed depends on the combination
of brush and paper being used. Generally the control
needs to be set at a very low level, sometimes
as low as 1 or 2. It seems strange to be
reducing the slider control to increase the
amount of grain, but the slider really
controls how much paint goes into the grain,
so the higher the setting the less grain will be
visible.

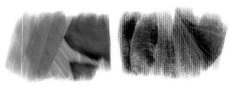

Figure 4.8 Altering the Grain slider.

Stroke Designer Palettes – Size

The size of the brush is usually set either on the Properties bar or in the Brush Creator, so the main reason for going to this section is to alter the shape of the brush tip. The top two rows are available for most brushes while the rows below are for the Artists Oils category.

The shape in the centre of the second row is the watercolor brush tip, the raised edges will give the wet edge that characterizes watercolor painting.

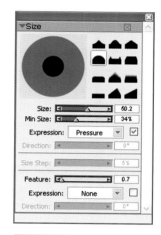

Figure 4.9 Size palette.

Stroke Designer Palettes – Well

The sliders in this section control whether or not the brush smears the existing artwork, or in the case of a clone, whether the clone is clear or completely blurred. The two sliders that control the level of diffusion are Resaturation and Bleed. Figure 4.11 shows, from top to bottom, brush strokes with the Resaturation slider at 12%, 50% and 100%.

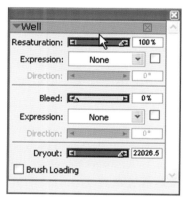

Figure 4.10 Well palette.

Figure 4.11 Resaturation and bleed controls.

Stroke Designer Palettes – Spacing

Brush strokes usually appear to be continuous, but are really a series of individual brush dabs spaced very closely so that they overlap. This palette adjusts the spacing between the dabs and Figure 4.12 shows the Wet Acrylic brush with spacing at 8%, 100% and 200%.

Figure 4.12 Brush spacing.

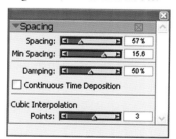

Figure 4.13 The Spacing palette.

Stroke Designer Palettes – Random

Computer brush strokes can often be too precise and accurate, unlike when we paint traditionally and our hands flex and the stroke varies. The Random section gives us some controls which will reduce the regularity of the brush strokes. Figure 4.15 shows how the sliders affect the picture from the left.

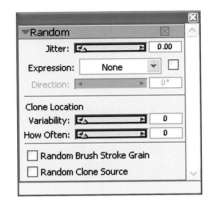

1 Using Square Chalk, the first is a normal stroke.
2 The Jitter slider is at 2.67, which places brush dabs at random places, the picture is still in register with the original clone source.
3 Clone Variability is set at 34. This control offsets the place from which the clone is taken. Moving the How Often slider changes the source more often.

Figure 4.14 The Random palette.

4 Random Clone Source has been ticked which takes each brush dab from a different part of the original clone but in a totally random manner. The result is a collage of elements from all over the picture.

Figure 4.15 Random brush stroke grain.

Figure 4.16 Changing the settings in the Random palette.

Random Brush Stroke Grain reduces the strength of the paper grain. Figure 4.16 illustrates this effect, the option has been ticked in the illustration on the right.

Stroke Designer Palettes – Impasto

Impasto is a very thick viscous paint and in this palette the Impasto effect can be added or removed from brush strokes.

To add Impasto to your brush, open the Impasto palette and change the Draw To box to Color and Depth and the Depth Method to Original Luminance. The amount of the depth is controlled by the Depth slider and this will give the brush stroke a three-dimensional appearance.

Figure 4.17 shows the Grainy Cover Pencil with Impasto applied in the strokes on top and the default setting beneath. This effect will work with most brushes except Watercolor and Liquid Ink.

Figure 4.17 Applying the Impasto effect.

The Randomizer

The Randomizer is available from within the Brush Creator and allows us to take a brush that is close to what we are looking for and to generate variations of the brush type so that we can consider the options suggested.

Click on the Randomizer tab to bring up the palette and select the brush you want to use as a starting point. Click on the cogwheels and Painter will generate a set of alternatives and show them in the preview area on the left, now try out some of them to see how the original brush has altered. To get a greater variation move the slider at the bottom to the right, to get small variations move the slider to the left.

Figure 4.18 shows a set of variations based on the Square Chalk brush and in the scratch pad I have made one brush stroke of each variation in order to show them more clearly.

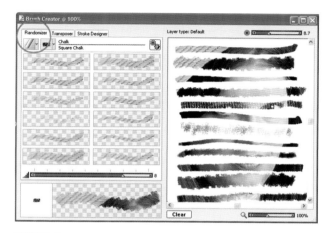

Figure 4.18 The Randomizer.

The Transposer

The Transposer is another tool for creating alternative brush variants. In this case Painter starts with your current brush, which is shown at the top of the display and changes it to a completely different brush in a series of steps. Figure 4.19 shows how an Airbrush is changed to a Digital Watercolor brush, the Scratch Pad showing how the distinctive light spray of the

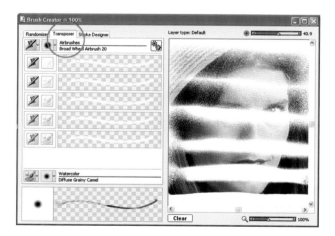

Figure 4.19 The Transposer.

airbrush changed to become much denser. Click the cogwheels to generate the transpositions. Try changing the starting and ending brushes to get a completely different result.

Creating a captured dab

By creating your own captured dab you can further customize favorite brushes. The dab can be made from a specially designed pattern as shown below or could be created from a photograph by starting at step 4 below. Before you start this you need to be careful that you do not replace the captured variant for the default brush you are using. In theory you can click on Replace Default Variant in the Brush selector menu and it should do what it says, however there are many brushes when this does not work and the captured dab stubbornly refuses to change. Look at the section in Chapter 1 titled 'Returning to default settings' to check the recommended steps to avoid this. However a simple way of avoiding this is included in Step 6.

Step 1 File> New to make a new empty document.
Step 2 Choose a brush to make the dab, try the Leaky Pen variant which spreads around marks in a random way.
Step 3 Make some marks on the paper as in Figure 4.20.
Step 4 Select the Marquee tool and, holding down the shift key to keep it square, make a selection of the marks.

Figure 4.20 Brush dab in the making

Figure 4.21
Capturing the dab.

Step 5 Choose an existing brush variant on which you want to base the new brush dab. When you choose the brush the characteristics of the original brush will be retained and only the brush dab will be changed.

Step 6 In the Brush Selector menu select Save Variant and give it a temporary name then select this brush to use for your trial dab captures. This will avoid the issue of losing your default setting.

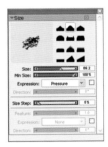

Figure 4.22 Size palette showing dab shape.

Step 7 Click the arrow on the Brush Selector bar to access the palette menu and select Capture Dab.
Step 8 Open the Size palette and try out the brush, adjust the size sliders as necessary.
Step 9 To keep the variant for future use you can either keep the name you gave it or save it again with a new name and delete the trial brush.

Figure 4.25 shows a brush dab made from the photograph in Figure 4.23, the dab was based on the Sharp Chalk variant.

Figure 4.23 Original photograph.

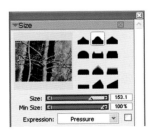

Figure 4.24 Size palette.

Figure 4.25 New dab in use.

Saving brush variants

Customizing a brush for a particular use can take some time, so it is sensible to save it for future use and Painter allows us to save brushes and also to make our own brush category.

The process is very easy, when you have customized the brush and are ready to save it, open the Brush Selector palette menu and click on Save Variant. Figure 4.26 shows the dialog box.

Give it a name different from the original and click OK. The new variant will be saved in the same brush category as the original.

If you want to delete the variant, select the same brush and choose Delete Variant. Painter will ask you to confirm that you really want to delete the brush if so click OK.

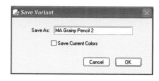

Figure 4.26 *Saving the brush variant.*

Making a new brush category

It is a good idea to make a new brush category for your own saved brushes, it helps to organize them and keeps them all in one place.

To make a new brush category and add brushes to it follow the next set of instructions.

Step 1 The first step is to create an icon which will be used for the brush category. This can be an image or text, whatever you will recognize. For this example it will be an image with a single letter. Open an image or make a new document and using the type tool type a single letter in capitals as in Figure 4.27, then Drop all the layers.

Step 2 Make a small square selection of the area with the Rectangular marquee (hold down the shift key to keep it square).

Step 3 Open the Brush Selector pop-up menu and click on Capture Brush Category. A dialog box will appear and here you can type in a name for the category, click OK and the new category will appear in the brush category list (Figure 4.28).

Figure 4.27 *Category icon.*

Step 4 To add a brush variant to your new category, open an existing brush in any category, make the changes to the brush variant and save the brush under a different name.

Figure 4.28 *The new category in the Brush Selector bar.*

Step 5 To move it to your own brush category, go to the palette menu again and select Copy Variant. In the dialog box that appears select your brush category from the drop down list and click OK. Finally go back to the original category and delete the entry there.

Another advantage with saving all your customized brushes in a new category is that you can save a copy in case you have to re-install the program. You will find that categories are not saved in the Program files section as you might expect but in the Application Data or Application Support folder. This is also the only place where you can delete a brush category.

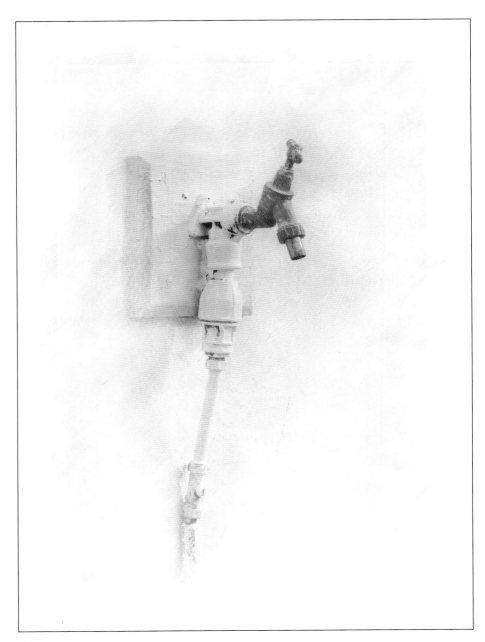

Figure 5.1 The old water tap.

5

Exploring paper textures

The huge range of paper textures is one of the reasons that Painter is so attractive to photographers and choosing the right texture can transform a picture quite dramatically.

In this chapter you will explore the library of paper textures that come as the default set, altering the size of the texture and also the contrast and brightness, all of which will change the appearance of the finished picture.

In addition to the default paper library there are many more papers available to load into the Painter program. You can also make your own paper and this is explained later in the chapter.

The picture below has had a canvas texture applied.

Figure 5.2 *Original photograph.*

Figure 5.3 *Manor house.*

Making a paper texture test print

To illustrate how different textures will change the appearance of your picture, this step-by-step example explains how to make a test print from one of the images on the DVD using sample papers from the default range which are loaded with Painter X program.

To access the Papers palette go to Window> Library Palettes> Show Papers.

Step 1 File> Open> DVD> Step-by-step files > 03 Manor House.
Step 2 File> Quick Clone.
Step 3 Select the Brush icon in the Toolbox.
Step 4 Select Chalk> Square Chalk 35 from the Brush Selector.
Step 5 Open the General palette, if it is not on screen go to Window >Brush Controls> Show General. Change the Method to Cloning and the Subcategory to Grainy Hard Cover Cloning. Move the opacity slider to 32% and the grain to 9%. The dialog box will change slightly depending on which brush is currently selected.
Step 6 Change the brush size to about 99.6.
Step 7 Open the Papers palette and select Italian Watercolor Paper.
Step 8 Turn off the tracing paper and paint a few brush strokes down the left side of the paper. If you want to keep the test

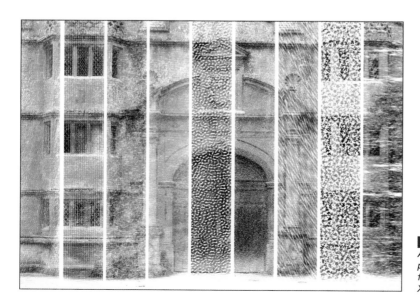

Figure 5.4 The General palette.

panels separate as in Figure 5.5, make a tall narrow selection with the Rectangular Selection tool and paint inside the selection area. When you have completed the first panel, go back to the Selection tool and click and drag inside the selection to move to the right.
Step 9 Change the paper to Artists Canvas and make more strokes next to the original one. Note how different the texture looks. Try some more papers and see how the texture changes.

Figure 5.5
A selection of paper textures from the Painter X default set.

Changing the paper scale

The Paper Scale slider controls the size of the texture on the paper. This is particularly useful when different file sizes are used. Generally speaking the larger the file size, the larger the paper scale needs to be to show a significant effect. The size to suit the particular picture is of course an artistic decision.

Step 1 Use the same photograph as in the last example.

Step 2 File> Quick Clone and hide the tracing paper.

Step 3 Select Chalk> Square Chalk 35 from the Brush Selector.

Step 4 In the General palette change the Method to Cloning and the Subcategory to Grainy Hard Cover Cloning. Move the opacity slider to 32% and the grain to 9%.

Step 5 Change the brush size to about 99.6.

Step 6 Select Simulated Woodgrain from the Papers palette.

Step 7 The top slider of the three in the papers palette controls the scale of the paper grain. Move the slider to the far left (25%) and draw a few brush strokes on the left-hand side of the picture. You will notice that the texture is finer than the picture you did earlier.

Figure 5.6 *The sliders in the Paper palette.*

Step 8 Move the slider to 50% and make more brush strokes next to the original one.

Step 9 Continue to make more brush strokes with the slider at 100%, 200%, 300% and 400%.

You will see from your own example, and from Figure 5.7, that the paper texture becomes much larger and coarser as you increase the scale.

Figure 5.7 *The Paper Scale slider at 25%, 50%, 100%-, 200%, 300% and 400%.*

Changing the paper contrast

Beneath the scale slider is the paper contrast control which increases or decreases the amount of contrast present in the texture. The higher the setting, the more pronounced the texture appears relative to the picture.

Step 1 Use the same photograph as in the last example.
Step 2 File> Quick Clone and remove the tracing paper.
Step 3 Select Chalk> Square Chalk 35 from the Brush Selector.
Step 4 In the General palette change the Method to Cloning and the Subcategory to Grainy Hard Cover Cloning. Move the opacity slider to 32% and the grain to 9%. Brush size 99.6.
Step 5 Select Thick Handmade paper from the Papers palette.
Step 6 Move the paper contrast slider to the far left (0%) and make some brush strokes down the left side of the picture. You will notice that the texture is very smooth.

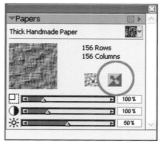

Continue with more test stokes, using 50%, 100%, 200% and 400%. The later ones will have a very hard contrasty appearance and the grain texture is emphasized. At the highest settings the texture is very strong. Different sizes and different paper textures can be mixed within one picture if that is appropriate.

Figure 5.8 *Inverting the paper grain.*

In the papers palette the small square icon highlighted in Figure 5.8 will invert the paper texture and make the paint go into the hollows of the paper. This will have the effect of removing the texture, which is useful if you want to bring back more of the original picture.

Figure 5.9 *The Paper Contrast slider at 0%, 25%, 50%, 100%, 200% and 400%.*

Changing the paper brightness

The last of the three sliders in the Papers palette controls the brightness of the paper texture. The brightness is effectively the depth of the paper grain, the shallower the grain the less texture is visible. In common with the other two controls, as the brightness level is raised the texture becomes more pronounced. At very low levels the texture is hardly visible while at 100% the picture is only just discernible and the texture itself dominates the picture.

Step 1 Use the same photograph as in the previous examples.
Step 2 File> Quick Clone and remove the tracing paper.
Step 3 Select Chalk> Square Chalk 35 from the Brush Selector.
Step 4 In the General palette change the Method to Cloning and the Subcategory to Grainy Hard Cover Cloning. Make the opacity 100% and the grain 13%. Brush size 206.0.
Step 5 Select Thick Handmade Paper from the paper palette.
Step 6 Move the Brightness slider to the far left (0%) and make some brush strokes down the left side of the picture. Continue with more test stokes, using 25%, 50%, 75% and 100%. By combining the effects of the three sliders the original paper texture can be changed from a very smooth finish to an extremely rough worn texture in different parts of the picture.

Figure 5.11 shows an alternative way of viewing the papers in the Papers palette. Click the paper icon to show the drop down list of papers, then click on the next tiny arrow in that menu (highlighted in Figure 5.10) and select Thumbnails.

Figure 5.10 The thumbnails arrow.

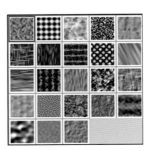

Figure 5.11 The thumbnails view of the papers.

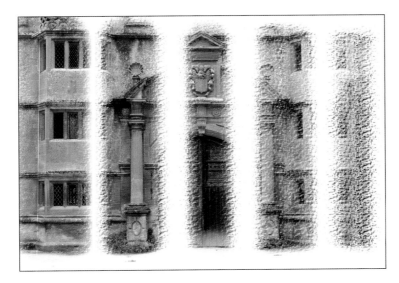

Figure 5.12 The Paper Brightness slider at 0%, 25%, 50%, 75% and 100%.

Using extra paper libraries

Painter X contains many extra paper texture libraries which are not automatically loaded with the program.

You will need to copy the folder containing these files and place them within the Painter program on your computer, they can be found in the Extras folder on the Painter X CD. These papers are not included on the DVD which accompanies this book. Once you have done this follow the instructions below.

Step 1 On the far right of the papers palette, click the small right facing triangle to reveal the drop down palette menu.

Step 2 Click on Open Library and a warning message will appear asking whether you want to Append or Load the new library, click on Load. The Choose Papers dialog box will appear as in Figure 5.13, go to the Corel Painter program files and open the Paper Textures folder.

Step 3 Highlight the Library you want to load and click Open. The selected library will appear in the papers palette, replacing the existing default library.

Step 4 Try out the papers in that library and make a note of any that look interesting so that you can find them in future. Repeat the process with some of the other libraries.

Step 5 To return to the original paper library, click on Load Library again and in the Choose Papers dialog box,

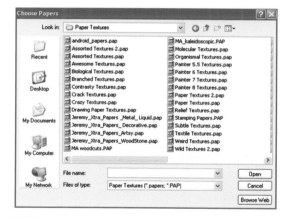

Figure 5.13 *Loading additional paper libraries.*

go up one level out of the Paper Textures folder and you will see a solitary file named Painter.pap amongst the folders. Select this file and click on open to reinstate the default paper set.

Painter does not offer an easy way to view all these papers as each paper library has to be loaded into the program before it can be viewed. A printed copy of all the paper textures available is included in Chapter 15. The thumbnails should prove very useful to help you decide which paper to choose and therefore which library you will need to load.

Creating your own paper texture

In addition to the many paper textures supplied with Painter, paper textures can also be made from a pattern or a photograph of your own.

Step 1 Use the same photograph of the Manor house for this exercise.

Step 2 Click on the Rectangular Selection tool in the Toolbox.

Step 3 Make a rectangular selection of the wall just under the top left window in the image as shown in Figure 3.14. The selection can be rectangular or square.

Step 4 Select Capture Paper in the Papers palette menu and in the dialog box that appears, type in a name for the paper and click OK. Go to Select> None to remove the selection.

Step 5 Your new paper texture will appear at the bottom of the papers palette, click the name to make it ready for use.

Step 6 File> Quick Clone.

Step 7 Select the Square Chalk 35 brush from the brush selector, it should still be set up for cloning from the last example. If not, change the Method and Subcategory in the General palette as previously.

Step 8 On the properties bar set the brush size 60.0, opacity 26%, grain 10%.

Step 9 In the papers palette, move the size slider to 400%, the contrast slider to 179% and the brightness slider to 25%.

Step 10 Clone the right half of the picture using these settings, then change the size slider to 25% and clone the other half.

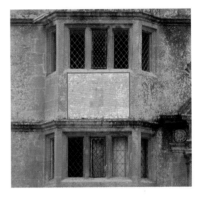

Figure 5.14 *Making a selection from the photograph.*

Using these two very different size settings will illustrate how the captured pattern reacts when used on a picture, this can be seen in Figure 5.15. The 25% setting reduces the selected area to a small tile that is repeated across the entire picture resulting in a strong pattern, contrast this with the 400% setting that creates a very rough texture where the pattern effect is much larger and broken up. These tiling effects can be reduced significantly if the tile has a very even texture. These are extreme settings and usually a more moderate size is used, but they clearly illustrate the effect of the slider settings.

Figure 5.15 *Two examples using a captured brush at different paper scales.*

Figure 6.1 Mountain Triptych.

6

Applying surface texture

Chapter 5 explained how textures could be applied when using a clone brush. This chapter takes this a stage further and you will discover how to apply these textures to your picture after it has been finished. The textures that you can apply are not confined to paper patterns and the examples show how to apply textures based on both the clone picture and the original source image.

The picture shown in Figure 6.1 illustrates how different textures can be applied to the same image. A rough paper texture was applied to the insets while the surround has received a canvas texture. This has helped to separate the elements and has made a more interesting design.

The picture of the mannequin shown below has had two applications of surface texture: one based on the image luminance, the other based on a paper pattern.

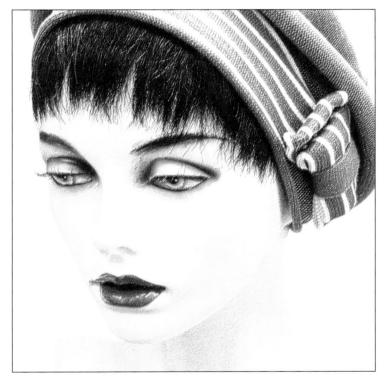

Figure 6.2 *Mannequin.*

Apply Surface Texture – dialog box

Surface texture is usually applied at the last stage of creating a picture. There are several ways of applying texture and the dialog box, which is shown in Figure 6.3, where all the adjustments are made. Before you start the step-by-step examples in this chapter read through the explanations of the various controls, which are given below.

Open a picture first, one of your own or use '6 Vase of Grasses' from the DVD.

File> Clone.

To open the dialog box go to Effects> Surface Control> Apply Surface Texture.

Using

The four ways of using the Apply Surface Texture command are found in the Using drop down menu in the dialog box. They allow the texture to be based on several different sources.

Paper uses the current paper texture.

Image Luminance bases the texture on the cloned image.

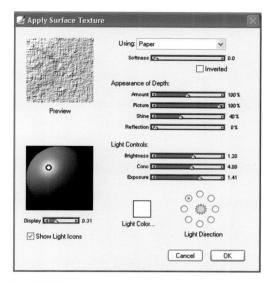

Figure 6.3 Apply Surface Textures dialog box.

Original Luminance takes the texture from the original source image.

Three-dimensional Brush Strokes calculates the difference between the original and the clone copy.

Softness and Inverted

The Softness slider controls how sharp the texture will appear, in most cases the slider is best left on zero to keep the detail.

The Inverted option changes the appearance of the texture from positive to negative. Figure 6.4 shows the normal texture and Figure 6.5 the texture after being inverted.

Figure 6.4 Normal texture.

Figure 6.5 Inverted texture.

Appearance of Depth

The Amount slider does just what is says, it controls the strength of the applied texture. Larger file sizes will need a higher setting and vice versa. In most cases the default amount

is too strong, I suggest you try 50% and use the Edit> Fade command to fine-tune if necessary. Figures 6.6, 6.7 and 6.8 show three settings of the Amount slider.

Picture, controls the balance of the picture in relation to the texture. At the minimum setting the picture is virtually hidden by the texture. You can usually leave this on the default 100%.

The Shine slider increases or decreases the amount of the highlights. Use this if the picture looks a bit dull after the texture has been applied.

The Reflection slider moves the picture towards gray at the centre point, at the far end only the texture is visible. You can usually leave this on the default setting of zero.

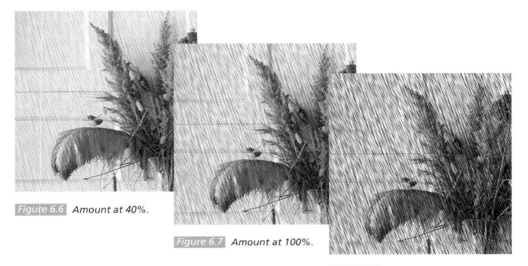

Figure 6.6 *Amount at 40%.*

Figure 6.7 *Amount at 100%.*

Figure 6.8 *Amount at 200%.*

Light Controls

Surface Texture is represented by light and shadow based on the image luminosity and the Light controls will change the direction, intensity, color, exposure and balance of the lighting. Figure 6.9 shows the light direction coming from the top left while in Figure 6.10 it is coming from the bottom right, which gives the frame a very different appearance.

Figure 6.9 *Light direction top left.*

Figure 6.10 *Light direction bottom right.*

Using – Paper

The first option in the Using box uses Paper as the source of the texture. Paper textures can be used from any of the many paper libraries, so the choice of texture is huge.

Step 1 File> Open> DVD> Step-by-step files> '06 Vase of Grasses'.
Step 2 Select Artists Canvas from the Papers palette.
Step 3 Effects> Apply Surface Texture.
Step 4 Select Paper in the Using box and 68% in the Amount slider.

In the Preview square you will see the effect on the picture, click in the square to compare the before and after view. Before you click OK try some of the other settings and see their effect in the preview window.

Figure 6.11 Fade dialog box.

While the dialog box is on screen you can use the Papers palette to change the texture and see the updated result immediately. Figure 6.12 shows the result at the 68% setting.

It is often difficult to assess the amount needed as the preview window is small, so it is usually better to make the amount fairly strong and then to go to Edit> Fade to reduce the strength. This option to fade an action is really useful to remember as it applies not only to this effect but also to many actions throughout Painter, including individual brush strokes. Figure 6.11 shows the Fade dialog box.

Another way of making textures crisper in a print is by applying sharpening to the picture. In Painter this can be done in the Effects menu. Effects> Focus> Sharpen.

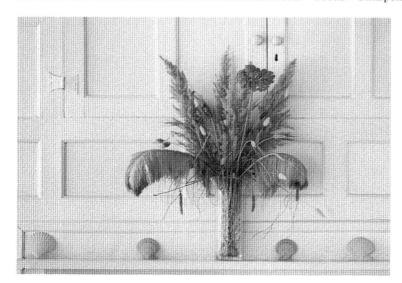

Figure 6.12 Vase with paper texture applied.

Using – Image Luminance

The Image Luminance option bases the texture on the luminance or brightness of the image itself. In effect, this means that you are putting an embossing effect directly upon the picture. The effect is used to add depth and texture to a picture.

Step 1 File> Open> DVD> Step-by-step files> '06 Rose'.
Step 2 File> Quick Clone.
Step 3 Select the Cloners> Soft Cloner, brush size 262.0 opacity 7% and make a soft clone as seen in Figure 6.14.
Step 4 Effects> Surface Control> Apply Surface Texture. Select Image Luminance from the Using drop down menu and move the Amount slider to 30%. Leave the other settings on default. The picture will now have an embossed texture on top as can be seen in Figure 6.15.

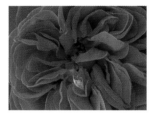

Figure 6.13 *Original photograph.*

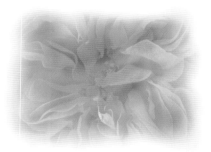

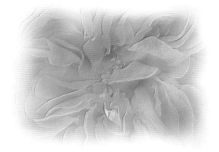

Figure 6.14 *Soft clone.*

Figure 6.15 *Soft clone with embossing effect.*

Figures 6.16 and 6.17 show another example of this setting, the texture in the old photograph album cover has been enhanced with the Image Luminance texture. This is quite difficult to appreciate printed at this size so the files are on the DVD.

Figure 6.16 *Original photograph.*

Figure 6.17 *With added texture.*

Using – Original Luminance

This option uses the original picture as the source of the texture and applies it to the clone copy. You must have the clone source active on the desktop and linked to the clone before the texture can be applied. The original and clone need not be the same picture as the texture can be taken from any open image by changing the clone source in the Edit menu.

Step 1 File> Open> DVD>Step-by-step files> '06 Edwardian Corner'.

Step 2 File> Quick Clone.

Step 3 Select Cloners> Soft Cloner. Brush size 308.0 opacity 7% and make a soft clone as seen in Figure 6.19. Leave the edges clear so that you can see the effect clearly.

Figure 6.18 Original photograph.

Step 4 Effects> Surface Control> Apply Surface Texture, select the Original Luminance option from the Using menu. Set the Amount at 20% and leave the other settings unchanged.

Figure 6.20 shows the result, look especially at the book and shelf support and you will see that an embossed texture has been created which is not present in the clone.

Figure 6.19 Soft clone.

Figure 6.20 Clone with original luminance applied.

Using – 3D Brush Strokes

This final option compares the original picture with the clone and puts the texture on the difference between the two. This is a little difficult to imagine but it does give a very three-dimensional effect to the brush strokes, particularly when a rough brush and textured paper have been used. The illustrations below show the differences between the various options and by looking closely at the textures you will be see how each one can be used in a picture.

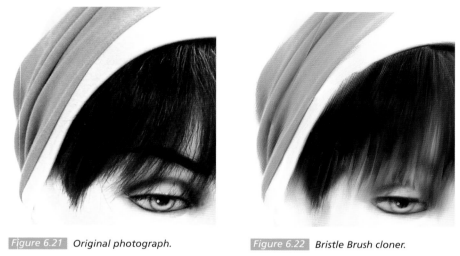

Figure 6.21 *Original photograph.* Figure 6.22 *Bristle Brush cloner.*

Figure 6.21 shows the original image before cloning. Figure 6.22 is the cloned image using the Bristle Brush Cloner.

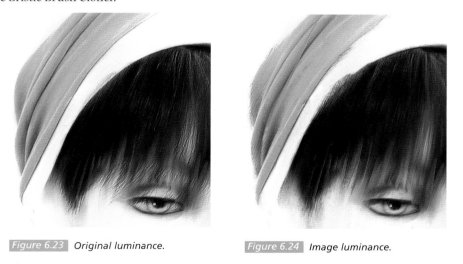

Figure 6.23 *Original luminance.* Figure 6.24 *Image luminance.*

Figure 6.23 has had the Original Luminance option applied, note how the harder lines of the original image have been superimposed over the softer clone. Compare this with Figure 6.24 which has used the Image Luminance option, the image is softer as the texture has reinforced the cloned detail.

Figure 6.25 uses the three-dimensional Brush Strokes option and the texture is somewhere between the Original and the Image Luminance examples above. Figure 6.26 uses the Paper option on the clone copy, the paper used is Artists Canvas.

At the printed size shown here it may be difficult to see the subtle differences between these pictures, I have therefore added the examples to the DVD so that you can open the images up in Painter to see the detail better. They are under the name '6 AST' in the Step-by-step files folder.

Figure 6.25 *Three-dimensional Brush Strokes.*

Figure 6.26 *Artists Canvas paper texture.*

Applying texture to a soft clone

When a paper texture is applied to a clone image that has white areas around the edge, the texture can be intrusive, as Figure 6.27 shows. To stop the texture showing in the white vignette areas take the following steps before applying the texture.

Step 1 File> Open> DVD>Step-by-step files> '06 Groynes Clone'.
Step 2 Use the Magic Wand and click in the outer white area to select the edges.
Step 3 Select> Feather 50 pixels then Select> Invert to select the inner area.

Step 4 Apply the surface texture, this will now only affect the area enclosed by the selection. You may need to vary the amount feathered to ensure the edges are not visible. Figure 6.28 shows the picture with these steps carried out.

 Figure 6.27 *Texture overall the image.* **Figure 6.28** *Texture only on the central area.*

Applying texture to a layer

This technique applies the textures created in Apply Surface Textures onto a separate layer rather than putting them directly on the image. The advantage in doing this is that the image remains unchanged and the texture is adjustable at any time as it is not part of the picture.

There are several ways of achieving this, a duplicate copy of the canvas can be made, and the texture applied to this. Reducing the layer opacity will lessen the effect. Any type of texture can be applied and adjusted in this way.

The next step-by-step process will involve making a new layer and applying the texture to it.

Step 1 File> Open> DVD>Step-by-step files> '06 Window Model'.

Step 2 File> Clone. Do not clear the image.

Step 3 Click the new layer icon to make a new layer.

Step 4 In the Colors palette select 50% gray (click into the inner color triangle and slide the cursor halfway down the left side until the readout reads S: 0%; V: 50%).

Step 5 Effects> Fill and choose Current Color.

Step 6 Change the layer composite method to Hard Light and the gray layer will disappear.

Step 7 Effects> Surface Control> Apply Surface Texture. Select three-dimensional Brush strokes in the Using menu and make the Amount 100%. Click OK.

Figure 6.29 *Layer composite method.*

Now that the texture is on a separate layer it can be adjusted. Reduce the layer opacity to lessen the effect. Change the layer composite method to Overlay and Soft Light and see how the texture looks different each time, for more extreme changes try Multiply and Screen. Figure 6.30 shows the original and Figure 6.31 the applied texture in Hard Light composite method. Figure 6.29 shows the layers palette with the gray layer in Hard Light Composite Method at 67% opacity.

This technique can use the Paper, Original Luminance and three-dimensional Brush Strokes textures but cannot use Image Luminance as it is being applied to a layer empty of imagery.

Figure 6.30 *Normal layer composite method.*

Figure 6.31 *Hard Light layer composite method.*

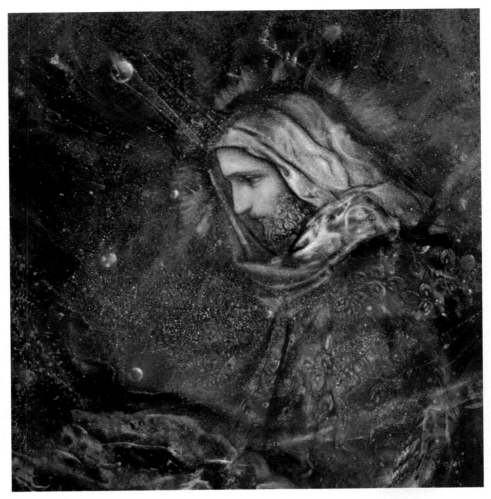

Figure 7.1 *Holy man.*
Montage created in Painter X from three different images.

7

Layers and Montage

147

L ayers are an important part of Painter and they give considerable additional flexibility both in cloning and in bringing together elements from different photographs. If you are already familiar with using layers in Photoshop you will find that the Painter layers palette looks very similar, however there are some differences, which you will need to be aware of.

This chapter is in four distinct sections.

Section 1 takes the form of a reference section that introduces all the main functions which will enable you to follow and understand the step-by-step examples in the later sections.

Section 2 explains how to use Layers as part of the cloning process. This will enable you to make several different versions and merge them together to make the final picture.

Section 3 is a step-by-step example of a montage consisting of several different images.

Section 4 covers the subject of making montages using cloning techniques from several different original photographs.

The portraits shown in Figures 7.1 and 7.2 were created with several layers of imagery and combined in the layers palette using various Layer Composite Methods, these are described later in this chapter.

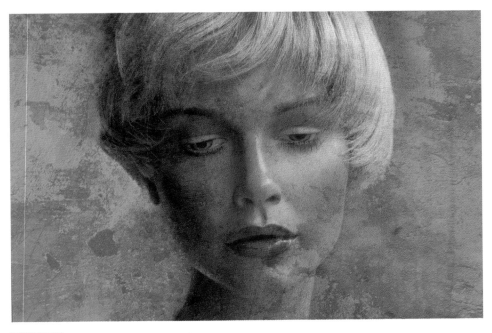

Figure 7.2 *Dreamer.*

The Layers palette

The Layers palette will be in use throughout this chapter so if the palette is not already visible on screen, go to Window> Show Layers.

Open the file that is on the DVD called '07 Multi-layered file' which is shown in Figure 7.3. This file has several layers already present which you can use to follow the examples.

Layers can be thought of as clear sheets of acetate placed on top of the Canvas. The layer stack is being viewed from the top so that when the top layer is full of imagery none of the layers beneath are visible.

Figure 7.3 *Layers palette.*

Active layer

Click on any layer and it becomes the active layer, which means that it can be edited, moved or painted on. Normally only one layer can be active at any one time and the active layer is colored dark blue.

Layer visibility

Click the eye icon to the left of the top layer, this will turn the visibility of the layer off and reveal the layer below. Continue to turn off the eye icon of each of the layers until you reach the canvas layer at the bottom of the stack. When a layer has its visibility turned off it does not contribute to the picture and if the picture is printed the layer would be ignored.

Canvas

The Canvas is always at the bottom of the stack and is similar, though not identical, to the background in other graphics programs. This layer cannot be moved or have layer masks applied and is restricted in some other ways.

Making new layers

New layers can be made either by going to Layers> New Layer and selecting the type of layer required or by clicking one of the icons in the Layers palette as shown in Figure 7.4.

Figure 7.4 *Layers palette icons.*

There are several types of layers all of which have their own special characteristics. To make a new standard layer, click the third icon from the left. Standard Layers can be painted on with most types of brush and are the ones that are mainly used for cloning.

The second icon will make a Dynamic Plug-in layer, which is a special effects layer that will make adjustments to the layer beneath. They are a bit-like adjustment layers in Photoshop as the settings can be changed at a later date, this type of layer is described in Chapter 13.

The fourth icon from the left, which has the blue droplet design, makes a new Watercolor layer, these are described in Chapter 8 and can only be used with Watercolor brushes.

The fifth icon from the left makes a new Liquid Ink layer, which may only be used for Liquid Ink brushes. A step-by-step example of Liquid Ink brushes is in Chapter 9.

Deleting layers

Layers that are active can be deleted by clicking on the Trash can on the far right of the new layer icons. This will immediately delete the currently active layer, there is no warning given, so be careful!

Merging and flattening layers

Generally I recommend that you keep the layers intact rather than flattening the picture, however if you do need to, click the icon on the far left and select Drop. This will merge the active layer with the Canvas. If you need to flatten all the layers go to either the Palette menu and select Drop All or to Layers> Drop All. In Painter X you can now merge the visible layers, hold down the Shift key and click on the layers you want to merge, then in the Layers palette menu click on Collapse.

Grouping layers

It is sometimes convenient to store layers in groups, this is rather like keeping them in folders. Layers can be grouped and ungrouped by clicking the first icon at the bottom of the layers palette and selecting Group or Ungroup, these commands are also available from the Layers menu and the palette menu. To collect several layers into a new group select them before clicking on the group icon (hold down the Ctrl/Cmd key and click the layers needed to select them). The Collapse command will merge all the layers within a Group. In Figure 7.5 Group 1 contains four layers and they are offset in the layer stack to show that they are contained in a group. Group 2 is collapsed and hides the layers within it to save space.

Layer masks

Layer Masks work very much like their cousins in Photoshop. By painting into the mask with black the contents of the layer are hidden. If you have not used masks before you may want to try the short step-by-step example below:

Step 1 File> Open> DVD> Step-by-step files> '07 Multi-Layered File'.
Step 2 Click the top layer to make it the active layer.
Step 3 Make a layer mask by clicking on the layer mask icon highlighted in Figure 7.5.
Step 4 Click on the layer mask itself to make it active, the mask thumbnail will have a black line around it. You must do this or you will be painting on the image itself rather than the mask.

Figure 7.5 *Layer mask.*

Step 5 Select the Pencils> Grainy Cover Pencil 3 with a size of about 65.0 and Opacity 100%. In the Colors palette make the painting color Black.

Step 6 Paint with the brush in the picture area, you will see the face disappearing and the layer below being revealed. The painted layer mask can be seen in Figure 7.6 while the resulting picture is shown in Figure 7.7.

Step 7 Reduce the brush opacity to 25% and paint again. Note that these strokes have only partially hidden the top layer, black hides the picture but shades of gray only partially hide the layers below.

Step 8 Change the painting color to white and paint over the masked area, this will reveal the original picture again.

To delete a layer mask, click on the layer mask to activate it then click on the Trash can which will delete the mask and leave the original layer intact.

Figure 7.6 Layers palette showing layer mask.

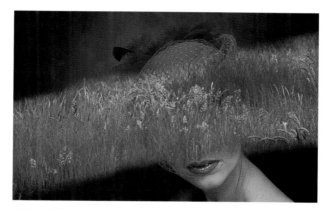

Figure 7.7 The effect of a layer mask on the top layer.

Locking a layer

To lock a layer, click on the layer then depress the padlock symbol just above the layer stack. Locking is useful to prevent accidental erasure or painting on the wrong layer. Click the padlock icon again to unlock.

Duplicating layers

To duplicate a layer go to Layers> Duplicate Layer or if you are using a computer which runs Windows you can right click the layer and select duplicate from the pop up menu.

The procedure to make a duplicate copy of the Canvas Layer is different and is shown below:

Step 1 Make the Canvas active.

Step 2 Select All (Ctrl + A).

Step 3 Make the Layer Adjuster tool active.

Step 4 Hold down the Alt/Opt key and click in the picture area.

This will make a copy of the Canvas on a new layer at the top of the layer stack leaving the Canvas layer intact. If you forget to hold down the Alt/Opt key the picture on the Canvas layer will be erased and moved to the top of the stack as a layer. (Use the Undo command to correct this if needed.)

Layer opacity

The slider near the top of the layers palette controls the layer opacity, move the slider to the left to gradually reveal the layer beneath. With multi-layer images it is very useful to be able to fine-tune the opacity of each layer with this slider.

Figure 7.8 shows the slider at 100% opacity.

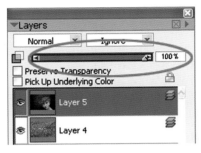

Figure 7.8 *Opacity slider.*

Layer Composite Depth

The box to the right of the layer blend mode is the Layer Composite Depth control. The default here is Ignore. This set of options is active when using brushes which have Impasto strokes which show depth and a three-dimensional appearance. To try the effect now, use the

Impasto> Thick Wet Round 20 brush with a brush size of about 40. Select a bright red color and paint into the picture, you will see how shadows have been added to the paint strokes which give them a three-dimensional appearance. The Layer Composite Depth option will have changed automatically to Add when you used this brush, change it to Ignore and see the brush strokes flatten. Figure 7.9 shows the impasto effect on the top brush stroke and the effect removed on the lower stroke.

Figure 7.9 *Impasto.*

Preserve transparency

This option is used to protect areas of a layer that has no imagery and is often used to paint over objects on that layer without affecting the surrounding empty space.

To see how this works, make a new empty layer (Layers> New Layer) and select the Pencils> Grainy Cover Pencil 3 with a size of about 35% and Opacity 100%. Paint into the picture with any color but leave plenty of blank areas. Tick the Preserve Transparency box and change the paint color. Paint all across the layer and you will see that the paint has only recorded in the areas that already have some imagery while the areas that were transparent have been preserved untouched, hence the name. Now turn off the Preserve Transparency option and paint again. This time the paint is laid down wherever the brush is used.

Renaming a layer

If you create several layers in a document it is often helpful to rename them to aid in identification.

To rename an existing layer, open the Palette menu and click on Layer Attributes and type the name there. You can also double click on the layer to bring up this dialog box.

Layer compatibility

When moving image files from Photoshop to Painter and vice versa, most of the elements stay intact including the layers, layer masks and selections. However, there are some special elements that do not work in the same way, so it is well to be aware of these differences. These are the differences particular to moving layers, for a fuller account of Painter/Photoshop compatibility refer to the description in Chapter 1.

Photoshop CS to Painter X
Adjustment layers are not translated, so you will need to merge them in Photoshop prior to moving the file to Painter, otherwise the adjustment will be discarded. Type layers will become normal bitmap layers and will not be able to be directly edited again.

Layer blend modes that have the same names in both programs will translate well, but newer ones such as Hard Mix, Linear Light, etc. will change to the Default mode and look quite different.

Painter X to Photoshop CS
The Canvas will translate as a background and Normal layers will stay the same. The specialist layers that include Water Color layers, Liquid Ink Layers, Dynamic Plug In Layers, Type Layers and Mosaics will change to Normal layers.

All these special layers will be rasterized during the process of saving to PSD format. Rasterized means that they become normal bitmap layers and the special effects cannot be directly edited again. If you wish to keep any of these special layers to be edited at a later date you must save in Painter's own file saving format that is called RIFF.

In Painter go to File> Save As and select RIFF and you will then be able to edit this layer in the future. If you are working in any of these special types of layers you may wish to save two versions, one in RIFF format in case you need to change something later and another in PSD format to transfer immediately into Photoshop.

Layer Composite Methods will translate pretty closely into Layer Blend Modes in Photoshop. The modes that are exclusive to Painter will go to Normal mode, which will usually look totally different. If the mode fails to translate correctly it may be necessary to flatten the picture within Painter before saving it.

Layer Composite Method

The layer composite method controls how a layer will interact with the layer beneath and offers a lot of creative opportunities when using multi-layer files. The layer composite method box is at the top of the

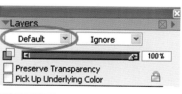

Figure 7.10 *Layer composite method.*

Layers palette and is highlighted in Figure 7.10 where it is shown in the default mode.

The first set of examples illustrates how the Layer Composite Methods will combine layers with different images on each layer. This is extremely useful when making montages as it allows you to mix image layers in ways that are not possible by any other method. Often this can spark off new directions in which to develop your image.

The following screenshots will provide a brief insight into how each composite method works. The effect of the composite method will differ considerably depending on the content of the two layers that are combined. The opacity setting will also change the appearance. Try this with the multi-layered file we used earlier in this chapter.

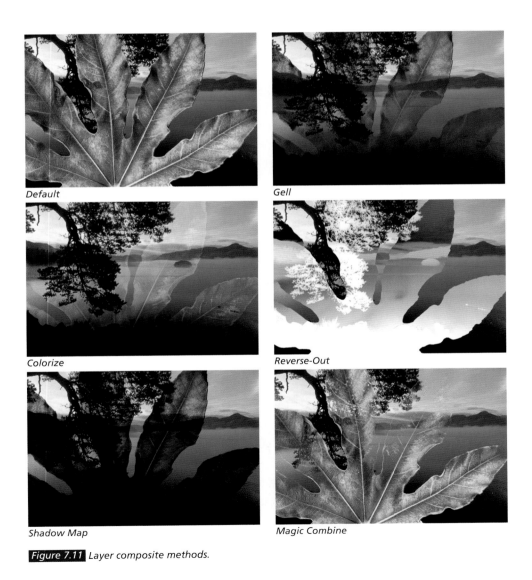

Default

Gell

Colorize

Reverse-Out

Shadow Map

Magic Combine

Figure 7.11 *Layer composite methods.*

Pseudocolor

Normal

Dissolve (60% opacity)

Multiply

Screen

Overlay

Soft Light

Hard Light

Figure 7.11 *(continued)*

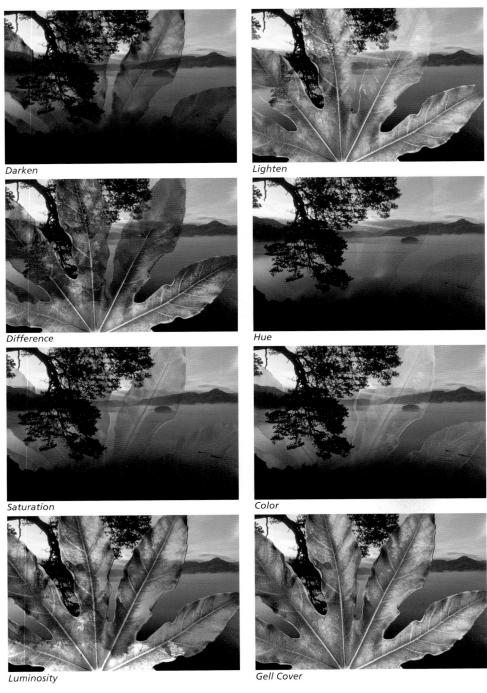

Darken

Lighten

Difference

Hue

Saturation

Color

Luminosity

Gell Cover

Figure 7.11 (continued)

Altering tone and color with layers

The second set of examples uses the Layer Composite Method in a different way. This method uses a duplicate copy of the same layer (or a copy of the Canvas) and the composite method to adjust the layer beneath. Depending on which composite method is used the picture can be made lighter or darker or the color changed. The following examples give some idea of possible uses. Remember that the opacity slider will reduce the effect and should be used to fine-tune the result. There is a step-by-step example on the following page.

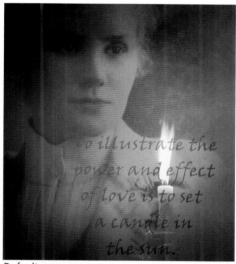

Default

Multiply

Overlay

Screen

Figure 7.12

Step 1 File> Open> DVD> Step-by-step files> '07 Candle in the Sun'.

Step 2 Select> All.

Step 3 Make the Layer Adjuster tool active.

Step 4 Hold down the Alt/Opt key and click in the picture area, this will make a duplicate copy of the Canvas.

Step 5 Change the Layer Composite Method to the one required.

Reverse-Out

Colorize at 66%

Hue at 73%

Screen at 73%

Figure 7.13

Using layers with cloning

Making a multi-layered clone

This step-by-step example will show you how to use the Layers palette while making clones. Several clone versions will be combined to make the final picture:

Figure 7.14 Layers palette.

Step 1 File> Open> DVD> Step-by-step files> '07 Donna'.

Step 2 File> Clone.

Step 3 Select> All but do not clear the image.

Step 4 Activate the Layer Adjuster tool (top right in the toolbox) and click in the main image with the cursor. This will lift the image off the canvas layer onto a new layer leaving the Canvas plain white. The Canvas will provide a white backdrop for the new layers about to be created.

Step 5 Layers> Layer Attributes and change the name to Donna Original.

Step 6 Click the eye icon for this layer in the layers palette to hide the picture. You should now have nothing showing in the picture area.

Step 7 Make a new empty layer by clicking on the new layer icon at the base of the layers palette (third from the left). Open the layers palette and click on Layer Attributes to rename this layer Round Soft Pastel 10.

Step 8 Click the top layer to activate, it is now ready to clone into. The layers palette should now look like Figure 7.15.

Remember to save copies of your work at regular intervals, this is always good practice.

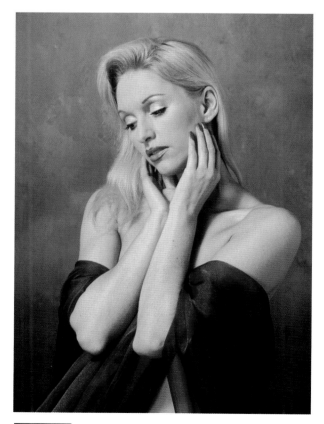

Figure 7.15 Original photograph.

The first clone

Step 9 Select Thick Handmade Paper from the Papers palette, this is a fairly strong texture which will work well with the pastel brush.

Step 10 From the Brush Selector choose Pastels> Round X-Soft Pastel 30, brush size 60.0. This pastel brush has a captured dab which means that it has been created from a shape or design.

Step 11 In the General palette make the following settings: Dab type Captured, Method Cloning, Subcategory Grainy Hard Cover Cloning, Opacity 60%, Grain 10%. If the General palette is not on screen go to Window> Brush Controls> Show General. The other palettes that open at the same time can be closed as they will not be used here. This palette is also contained in the Brush Creator if you are using some earlier versions of Painter.

Step 12 Click back in the document and make a light

Figure 7.16 *General palette.*

clone of the head and shoulders. Paint over the face again to make it a little more distinct. Your picture should look something like the one in Figure 7.17.

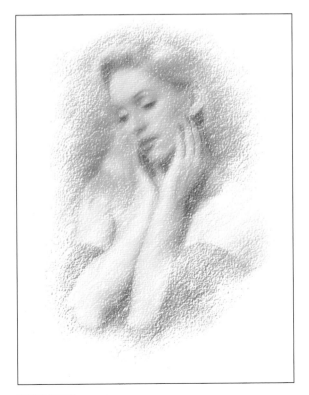

Figure 7.17 *First clone.*

The second clone

Step 13 Click the eye icon of the newly cloned layer to hide it, the screen will be blank again.

Step 14 Make a new layer above the cloned layer. Rename it Square Chalk 35 in the Layer Attributes box.

Step 15 In the Papers palette, select French Watercolor Paper.

Step 16 Choose Chalk> Square Chalk 35 brush size 45.0.

Step 17 Make the following settings in the General palette. Dab type Captured, Method Cloning, Subcategory Grainy Hard Cover Cloning, opacity 7%, grain 12%.

Step 18 Paint in the new layer and make a clone of just the head and shoulders as before, Figure 7.18 shows how this clone should look.

Save the picture at this point.

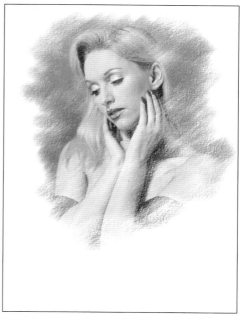

Figure 7.18 Second clone.

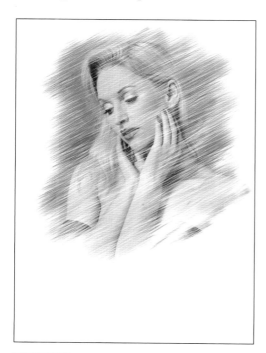

Figure 7.19 Third clone.

The third clone

The third clone uses a very different paper that you will have to load specially. If you have not already loaded a paper texture library, the full instructions are in Chapter 5.

Step 19 Click the eye icon of the newly cloned layer to hide it.

Step 20 Make a new empty layer on top of the cloned layer and name it Variable Width Chalk.

Step 21 Click the Papers palette menu arrow and select Open library from the drop down menu. When the Open box appears, go to where your paper libraries are kept and choose Wild.

Step 22 With the new library loaded, select the paper called Streaks.

Step 23 Select the Chalk> Variable Width Chalk. Dab type Circular, Method Cloning, Subcategory Grainy Hard Cover Cloning, opacity 24%, brush size 50.0. Make another clone as in Figure 7.19.

The fourth clone

For the final clone the brush changes to an airbrush that will give an even texture.

Step 24 Click the eye icon of the newly cloned layer to hide it.

Step 25 Make a new empty layer on top of the cloned layer and rename the layer Broad Wheel Airbrush 50. This airbrush does not use a special paper.

Step 26 Choose the Broad Wheel Airbrush 50 with the following settings. Dab type Airbrush, opacity 44%, brush size 150.0. Click the clone color button in the Colors palette to change this to a cloning brush.

Step 27 Spray the airbrush lightly all over the picture concentrating in the centre and allowing the spray to go each side. Figure 7.20 shows this version of the picture.

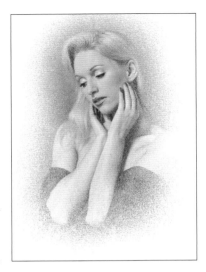

Figure 7.20 Fourth clone.

The final stage

The next stage is to look carefully at each clone layer and decide which of the layers are the most successful. Once you have done this you can adjust and combine them in several ways.

Move the layers up or down the layer stack.
Alter the opacity of the layers.
Change the layer composite method.
Use layer masks to hide parts.

This stage is very much about trying out the combinations that look the best, experiment and you will produce many different results. You may well decide that some layers are not required and delete them. If you are still not satisfied with the picture, then you could start another clone layer with a different brush or paper.

The layers palette arrangement for my final version is shown in Figure 7.21 with the finished picture overleaf in Figure 7.22.

Figure 7.21 Final layers palette.

The layer settings, from the top are:

1 Colorize composite method, 73% opacity.
2 Default composite method, 61% opacity.
3 Default composite method, 77% opacity.
4 Hard Light composite method, 66% opacity.

The final layer is the original copy of the photograph and in this case it has not been used. It is however very useful on occasions to move the layer to the top of the layer stack and use a layer mask to hide or reveal parts of the original.

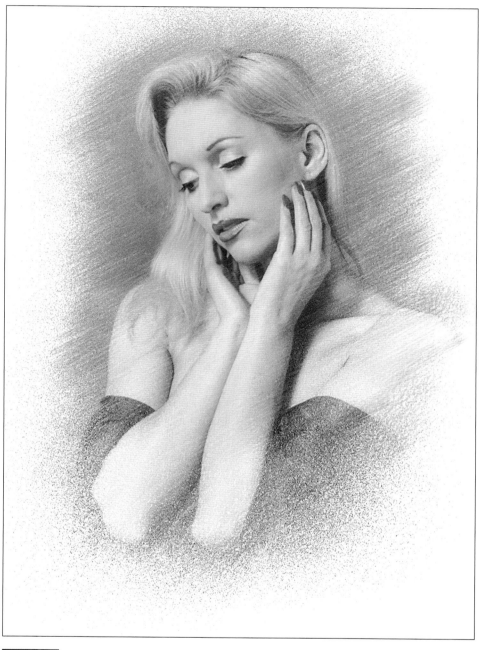

Figure 7.22 Donna.

Creating a montage

One of the most interesting and exciting uses of layers is to make a montage. Montage is when several different images are combined in a way that makes the final result more than the sum of its parts. Montages can be used to get across a message, or to make an image that is interesting and satisfying in its own right using layers of texture and imagery.

Certainly one of the most important things to do before starting work on a montage is to think really hard about the picture that you are intending to create. The more you can plan in advance the better, but that is not to say that you should not experiment as you go along, indeed one of the great joys in making montages is that they can go off in directions not originally envisaged. Obviously if you are working to a commercial brief you may not have this opportunity, but in personal work you are free to go where your imagination takes you.

Step-by-step montage

In the step-by-step montage you are about to embark on there is no specific end planned, rather a choice of some interesting textures and imagery that should work well together. As you work through the steps you will use many of the techniques that have been described earlier in the chapter plus some others. When you have completed the exercise you should have enough experience to make your own montage using photographs that will blend well together.

Remember to save your montage at regular intervals to avoid loss. I recommend that you use the Iterative Save from the file menu as this will save a new version each time and give them different reference numbers. When the picture is finished they provide a useful overview of how the montage has developed.

The first layer

Step 1 File> Open> DVD> Step-by-step files> '07 Montage 1'.

Step 2 File> Quick Clone.

Step 3 Select the Square Chalk 35 brush and in the General palette change the Method to Cloning and the Subcategory to Grainy Hard Cover Cloning. Use brush size 40.0, opacity 13% and grain 10%. Clone the picture following Figures 7.23 and 7.24.

Step 4 Select the paper, use French Watercolor paper from the Default set of paper textures.

Step 5 Paint the top half of the figure in fairly roughly then reduce the opacity to 9% and complete the lower half including the blue towel. Go over any areas that need more emphasis.

Figure 7.23 Early stages.

Adding the rock texture

Figure 7.25 is a photograph of a section of rock that has an unusual honeycomb texture and will make an interesting overlay for the figure.

Step 6 File> Open> DVD> Step-by-step files> '07 Honeycomb Rock'.

Step 7 Click back in the clone document, make a new layer and rename it Rock Texture. Always use a new layer for each element so that you can adjust it separately.

Step 8 Select the Broad Wheel Airbrush, brush size 76.8, opacity 44% spread 40, flow 672. In the Colors palette click the Clone Color icon.

Figure 7.24 Filling out the detail.

Step 9 File> Clone Source> '07 Honeycomb Rock'.

Step 10 Spray over the picture with the airbrush, paint from top to bottom and follow the flow of the rock pattern. You need not worry if it looks too strong, as the next step will enable you to adjust it.

Figure 7.25 Honeycomb rock.

Using a layer mask to reduce the effect

Step 11 Click the layer mask icon in the layers palette to add a layer mask to this layer then click the mask thumbnail to activate it. Don't forget to click the mask otherwise you will be painting onto the picture rather than the mask, this is an easy mistake to make!

Step 12 Using the same brush and settings paint into the mask and hide parts of the rock overlay. Because you are using the same brush you retain the texture of your original brush strokes or in this case airbrush texture. If you paint out too much,

Figure 7.26 Airbrushing in the rock texture.

paint into the mask with white. When you have finished this step your picture should look something like Figure 7.26. It will not look identical, as each version is always different and this is just to give you guidelines.

If you find that the texture that remains over the figure looks unattractive, change to the Medium Felt Tip Pens with black as the painting color and paint in the mask to remove some of the sootiness.

Changing the layer composite method

Now that you have completed this separate layer it is worth experimenting with changing the composite method to see the difference it can make. Check through the information and examples earlier in this chapter if you haven't used the composite methods before.

It is always very difficult to predict how each composite mode will affect the balance of a picture, experience helps and the names give some guidance, but until you try it you can never be sure.

Step 13 Take a good look at the picture, click the composite method box and try all of the options and decide which one looks best. Some will have very little effect while others are totally unsuitable. Try the following two in particular which should work well with this picture.

Figure 7.27 Changing the layer composite method.

Hard Light will give the picture a brighter appearance as it increases the contrast and removes some of the gray.

Luminosity retains the contrast level and enhances the color slightly.

It is your choice, whichever looks best on your version. Remember that this is not final as it can be changed at any time. Before going any further you can close down all the other images as they are finished with for the present. If you do need them again later, they can be re-opened and the clone source re-established by going to File> Clone Source.

Changing the color

The next step is to alter the color tone, there are several ways of doing this, but one of the easiest and most effective is to create a colored layer.

Step 14 Make a new layer on the top of the layer stack.

Step 15 Effects> Fill. With the Fill palette open go to the Colors palette and choose a light orange color, the color will change in the Fill palette as you click the colors. You can choose your own color, but if you prefer to use the one in the example go to the Colors palette and to the right of the color wheel is a small readout which shows either RGB or

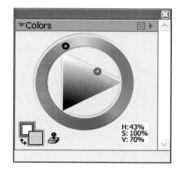

Figure 7.28 The color values shown in the Colors palette.

HSV values. This display changes when it is clicked so make it so that it shows HSV, which stands for Hue, Saturation and Value. Move the cursor in the outer color ring until the Hue reads 43%. Put the Saturation at 100% by keeping it on the top or bottom edge of the inner triangle. The value, or brightness, increases as the slider is raised so take this to 70%. Figure 7.28 shows the color values in the Colors palette. Click OK in the Fill palette when you have chosen the color.

Step 16 The new color layer will block out everything else so the layer composite method must be changed to Colorize which will allow just the color values to change the layers below. The color will be too strong so reduce the layer opacity to about 34%, which will allow some of the existing color to come through. A lighter depth of color could have been chosen in the Colors palette, but it is usually better to make it stronger and then reduce it via the layer opacity. Figure 7.29 shows the picture at this point.

Figure 7.29 Overlaying the color fill.

Overlaying a texture from another picture

The next step is to take a handwriting sample and overlay it on the montage. This involves using the Apply Surface Textures command, which is explained in more detail in Chapter 6.

Step 17 Make a new layer at the top of the layer stack. Effects> Fill, and choose 50% gray in the Colors palette. You can select 50% gray by placing the cursor on the left edge of the inner triangle and moving it until the Value shows 50%. This will hide all the other layers with a gray color.

Step 18 File> Open> DVD> S tep-by-step files> '07 Elizabethan Handwriting' (Figure 7.30).

Step 19 Click back onto the montage document and go to File> Clone Source> '07 Elizabethan Handwriting'.

Step 20 Effects>Surface Control>Apply Surface Texture. In the dialog box that appears change the Using box to Original Luminance and leave the other sliders on the default setting. Figure 7.31 shows the dialog box. Click OK and the handwriting will appear as embossed on the gray layer. Change the layer composite method to Overlay and the gray will disappear and the embossed letters will be superimposed on top of the montage. There are two other composite methods that work with a gray layer, Soft Light gives a softer effect and Hard Light emphasizes the texture. Figure 7.32 shows the layer before the layer composite method is changed.

Figure 7.30 Elizabethan handwriting.

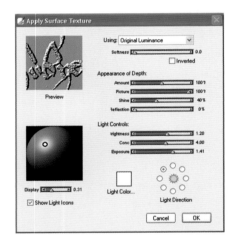

Figure 7.31 Apply Surface Texture dialog box.

Step 21 Add a layer mask to this layer and using the Medium Felt Tip pen again paint into the mask with a size 84.0 brush and 85% opacity. Make sure the painting color is black and that you are painting on the mask and not the gray layer. Remove the embossed letters from most of the figure leaving it over the towel and background. If you remove too much, change the painting color to white and paint over again. Figure 7.33 shows the picture at this stage.

Figure 7.32 Handwriting as a texture overlay.

Figure 7.33 Adding the embossed letters.

Adding extra imagery

Having reviewed the picture at this stage, the bottom of the picture is not as strong as the top and will require some additional material.

Step 22 File> Open> DVD> Step-by-step files> '07 Hosta Leaves' (Figure 7.34).

Step 23 Select> All, then Edit> Copy and returning to the montage document paste it into the picture via Edit> Paste. This is the standard way of moving one photograph into another. Move this to above Layer 1 and change the layer composite method to Lighten. The incoming picture will have been placed in the centre of the screen so use the Layer Adjuster tool to move the picture down to the bottom.

Figure 7.34 *Hosta leaves.*

Step 24 Make a layer mask and paint into the mask with the same Felt Tip brush as in the previous step. Use 100% opacity to paint out the leaves in the top left corner and to hide the hard edge, then reduce the opacity to 60% and paint to partially hide the other leaves. Check Figure 7.35 for the picture at this stage, you will see that the leaves are only just visible but help support the lower areas.

Figure 7.35 *After adding the Hosta leaves.*

Finishing off the picture

This is the stage to step back and assess the picture and decide what needs doing before it is declared finished. Check if the colors are correct. Is the picture too light or too dark?

Step 25 You may well need to lighten some areas and darken others, an easy way to do this is to make another one of those very useful gray layers.
Make a new layer, fill with 50% gray as before and change the layer composite method to Overlay. Use the Felt Tip brush, opacity around 65% to start with. The way this works is that in overlay method the gray disappears but if you paint with a lighter gray it will lighten the picture and the opposite will happen with dark gray or black. Do that now to balance any areas that are too light or dark, adjust the layer opacity to adjust the effect.

Adjusting the saturation and contrast

Step 26 To reduce the color saturation make a new layer at the top of the layer stack and fill it with black. Change the layer composite method to Colorize, this will turn the picture to monochrome. Reduce the layer opacity to partially allow the color back. Use a layer mask if you want to restrict this muted color to certain areas of the picture.

Step 27 To increase the color and contrast, make a new layer at the top of the layer stack and fill it with black. Change the layer composite method to Overlay and adjust the layer opacity as required. The layers palette at the end looked like Figure 7.36.

Creative cropping

When the picture is complete it is time to consider whether your picture needs cropping. It is very easy when working on a picture to accept the format and shape in which it was originally conceived. However a picture can look good in several different ways of presentation so it is worth spending a few minutes in trying out several different crops. Try out some radical ones too, they can often be very interesting.

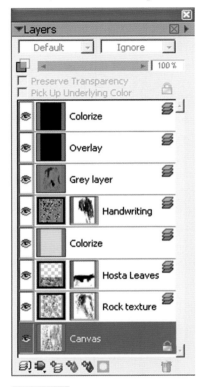

Figure 7.36 *Final layers palette.*

Some of the crops that I tried with this picture are shown in Figures 7.38–7.40 together with some from earlier stages of the montage (Figures 7.41 and 7.42).

This has been a long and complex set of instructions to follow, but I hope that is has given an insight into how a montage might be created. I have introduced several ways to blend images, through cloning, merging layers and the use of layer blending modes. The whole process is very much one of developing ideas as you go along and not being afraid to experiment. Not everything will work but invariably something worthwhile will come out of the creative process.

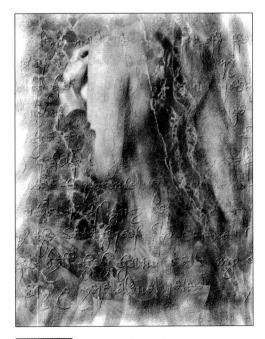

Figure 7.37 *The completed picture.*

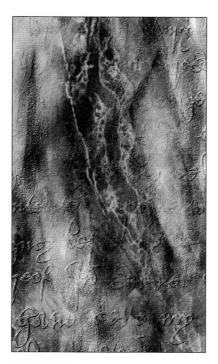

Figure 7.38 Alternative crop 1.

Figure 7.39 Alternative crop 2.

Figure 7.40 Alternative crop 3.

Figure 7.41 Alternative crop 4.

Figure 7.42 Alternative crop 5.

Montage using cloning

Using multiple originals from which to clone, means that textures and imagery can be drawn from two or more photographs and parts of each photograph cloned into the final picture.

It is easy to jump from one original picture to another, which means that the image can be modified as the picture is created which allows a lot of flexibility. Despite this flexibility it is still very important to plan ahead both from the technical requirements of image size and resolution and from the creative aspect. You can clone from different sized originals however the tracing paper facility will not work in this case.

Figure 7.43 *Feathers.*

Step 1 File> Open> DVD> Step-by-step files> 07 Statue 3.

The original picture of the statue was scanned from a 35 mm slide and was in 24 × 36 mm format. The picture that it is going to be combined with is nearer 46 × 36 mm, so if you cloned form the original scan the statue would appear in the top left corner when it is needed to be in the centre. In order to clone it into a roughly square background the canvas size had to be enlarged and the result can be seen in Figure 7.44, which is the image on the DVD. The background has been filled with black to show the shape but as you are not going to clone from that area the color is immaterial.

Step 2 File> Open> DVD> Step-by-step files> 07 Feathers.

The picture that will be combined the statue had already received some creative work in Photoshop. The original was a slide of cockerel feathers that had been copied and flipped to form an abstract design. The colorful feathers inspired the idea of flames from which the figure could emerge.

Step 3 Make the statue the active document by clicking in the image.

Step 4 File> Clone, which will make an identical copy of the original statue image, do not clear the clone copy.

Step 5 File> Clone Source> Feathers.

This last step changes the source of the clone, so

Figure 7.44 *Statue.*

the clone information will be taken from the feather image and painted into the portrait. There is no limit to the number of pictures from which you can clone and the clone source command allows you to toggle between them. Other pictures can be brought in at a later stage.

Figure 7.45 *Step 9.*

Step 6 Select Acrylic> Opaque Acrylic 30 from the Brush Selector.

Step 7 In the General palette, change the dab type to Static Bristle, Method to Cloning and Subcategory to Soft Cover Cloning. Make the opacity 5% and the brush size 127.0.

Step 8 Click the tracing paper icon, this will overlay the feather picture.

Step 9 Paint lightly over the feathers, just enough to give some idea of where they are, then you can turn off the tracing paper to get a clearer view. This stage is shown in Figure 7.45.

Step 10 Gradually build up the density of the feathers and allow the 'flames' to reach up to and around the face. Don't worry if you overdo this as it can be adjusted in the next step.

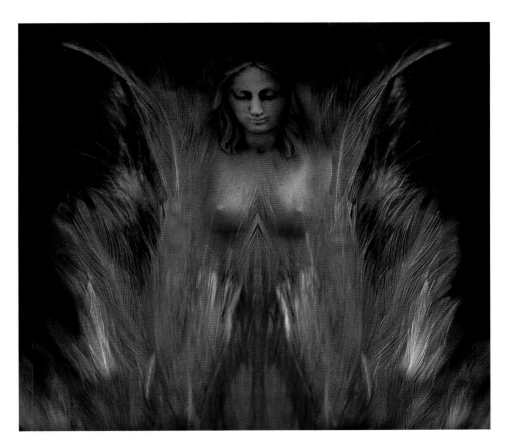

Figure 7.46 *Phoenix.*

The edges of the smaller picture are visible and these need to be hidden so increase the brush opacity to 15% and paint over these in the direction the feathers run. Paint over the hands at the top of the picture as these are not needed.

Step 11 Decrease the brush size to 14.4 and increase the opacity to 62%. Use this brush to flick out brighter marks that will increase the contrast and texture.

Step 12 Change the clone source back to the statue (File>Clone Source>07 Statue 3) and paint any areas of the statue that have been covered unintentionally. Go back and forth between the two sources until the effect looks good.

In the final picture shown in Figure 7.46 some additional surface texture was added this procedure was covered in Chapter 6.

Cloning from three images

Try to visualize what you want to achieve before you start making a clone montage. These three elements were carefully selected to work together, the common element were trees of course, but using three very different scales will add a sense of mystery to the final picture.

The holes in the old leaf are particularly interesting and the way this hole punches through the more realistic landscapes will also emphasize the sense of unreality.

Step 1 File> Open> DVD> Step-by-step files '07 Leaf'.
Step 2 File> Open> DVD> Step-by-step files '07 Tree'.
Step 3 File> Open> DVD> Step-by-step files '07 Sky'.
Step 4 File> Clone with the Leaf as the active document. This will make a clone

Figure 7.47 Leaf.

Figure 7.48 Tree.

copy of the Leaf picture without clearing the picture.

Step 5 Change the clone source to the tree picture (File> Clone Source> '07 Tree').

Step 6 Choose the Graffiti brush from the Airbrush brush category. In the Colors palette click the Clone icon and make the brush size 190.0 and the opacity 61%.

Step 7 Paint over the Leaf picture, the graffiti brush will spray dots that will give the picture an attractive texture. Emphasize the lines of the tree trunk and branches as seen in Figure 7.50.

Step 8 Change the clone source to the sky picture (File> Clone Source> '07 Sky').

Step 9 Change the brush to Airbrush> Fine Tip Soft Air 50, brush size 150.0 and opacity 4%. In the General palette change the Method to Cloning and the

Figure 7.49 Sky.

Figure 7.50 Using the Graffiti brush in step 7.

Sub Category to Grainy Soft Cloning. Paint in the sky and tree giving it a dreamlike quality by cloning in some areas but not in others.

Step 10 In the previous step it is difficult to get exactly the right amount of blue, it can also result in the texture being too smooth. If this is the case, change back to the Leaf as your clone source and return to the Graffiti brush used earlier. Brush over with this to get the right balance between the three images.

Continue to swap between the three original pictures by using the clone source option until the picture is to your satisfaction.

Step 11 Finally you will need to crop the picture as the originals are not exactly the same size, you can see this by the line down the right side of the picture.

Select the Crop tool in the Toolbox, click in the top left corner and dragging down to the bottom right, include all of the picture you want to keep. Adjust the edges by dragging them to the desired position and click in the picture to crop.

The picture in Figure 7.51 has been cropped at the top and right quite substantially which has strengthened balance of the picture.

In this example we used three separate images from which to clone, it is also possible to clone from a multi-layered image so these three pictures could have been in a single document.

The way to change the clone source is to make the original picture the active document and to turn the layers on and off. Whatever is visible on the screen is what you will be cloning. This also works when a layer is only partially visible.

Figure 7.51 *Tree and leaf montage.*

Figure 8.1 *Lilies.*
These lilies were painted with a combination of the RealBristle, Real Blender Round and the Smart Stroke, Acrylics Captured Bristle.

8

Watercolor, oil and pastel

The step-by-step examples in this chapter will show you how to make clones using watercolor, oil and pastel brushes. These clones differ from those in earlier chapters in several ways, the method of building the image is to gradually bring in detail, and the result is a lot more like a traditional painting.

The chapter begins with an explanation of Watercolor painting in Painter and the many different controls which are available to customize these brushes. A step-by-step example of Digital Watercolor follows with a scene featuring an old English building.

Oil painting is very popular and another step-by-step example follows which shows in detail the method which can be used to gradually refine the painting from an impression to a detailed finished picture.

In the picture below the outer edges of the frame have been cloned with the Thick Wet Oils brush with the centre area being left clear. The painterly section around the edge contrasts with the clarity of the photograph.

Figure 8.2 *Mountain view.*

Watercolor or Digital Watercolor?

Painter has two categories of Watercolor brushes: one simply called Watercolor and the other Digital Watercolor, so what is the difference and which should you use?

The main difference is that Watercolor brushes have to be used on a separate layer and those layers can only be used for Watercolor brushes. The digital version can be used

on a standard layer and can be used like any normal brush. Digital Watercolor tends to be much quicker to use but the end result can look very similar depending on the choice of brush.

If you are painting from scratch, the Watercolor brushes have more controls to customize the brush and is probably the one to choose. If you are cloning from a photograph, Digital Watercolor is often more convenient. In earlier versions of Painter the two were very different, however in Painter X they are now operating in a similar way.

Watercolor explained

Before you start work on the next step-by-step clone it will be helpful to explore some of the very special features of the Watercolor brush category. This category has a lot of unique features and the following exercise will take you through some of the settings in the Water palette and explain how the brushes can be adjusted to suit the style of painting you need.

There are 52 brushes in the Watercolor category and each one has a particular arrangement of settings in the Water palette, with so many brushes available it is worth trying out several to find the one you need before you start to customize the brush.

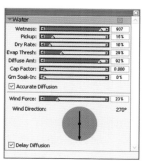

Figure 8.3 *Water palette.*

Step 1 Bring the Water palette on the screen, Window> Brush Controls> Show Water will bring all the brush control palettes to the screen. Drag the Water palette out of the stack and close down the remainder, it is useful to have this palette on screen when using the Watercolor brushes, it is also available in the Brush Creator.

Step 2 File> Open> DVD> Step-by-step files> '08 Old Building'.

Step 3 File> Quick Clone.

Step 4 Select the Smooth Runny Flat 30 brush from the Watercolor brush category. Figure 8.3 shows the default Water palette for this brush. If your palette has different settings then go to the Brush Selector palette menu and click on Restore Default Variant. You may find it useful to return to the default between each of the examples.

Step 5 Click the clone color option in the Colors palette, switch the tracing paper off and you are ready to try out the examples.

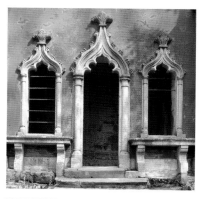

Figure 8.4 *Old building.*

Watercolor Layers

All the brushes in this category use a
dedicated layer on which to paint and this is
automatically created when you select and
use a Watercolor brush. These layers have
some special characteristics, e.g. because
watercolor will blend when wet, you can
return to these layers at a later date and
having wet the layer again, paint over the
image and paint 'wet on wet', a traditional
watercolor technique. This is only possible if
you save the picture in RIFF file format, if
you save it in any other format this option
is lost.

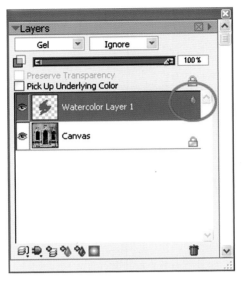

Figure 8.5 *Layers palette showing Painter is
calculating watercolor brush strokes.*

One other thing to be aware of is that the
diffusion process to get the watercolor effect
is very complex and brush strokes can take
longer than usual. Check the layers palette when you have used this brush for several
strokes and you will see a blue water-droplet symbol (highlighted in Figure 8.5), when this
is moving the brush effect is still being computed so you will need to wait until it has
finished.

Water – Wetness

Make some brush strokes on the default
wetness setting, which is 937 for this brush
and see how the paint runs down the page.
This blending of color washes is one of the
special characteristics of traditional
watercolor painting and is caused by the
liquid nature of watercolor paint. To get
this blending effect the paper is tilted
downwards and if you look at the bottom of
the Water palette you will see under Wind
Direction the arrow is pointing downwards,
this is telling you that the paint will run down
the page.

Figure 8.6 *Wetness slider.*

To understand how the Wetness slider affects the blending make two more groups of brush
strokes, one with the slider set at 500 and the other at 0. Figure 8.6 shows how the
blending becomes less as the amount of wetness is reduced.

Water – Dry Rate

The Dry Rate controls how quickly the paint dries and has a similar effect to the wetness slider at the extreme settings, but rather different at 50%. Make brush strokes at 8%, 50% and 100% to see the difference, Figure 8.7 shows these settings. Brush strokes at low settings will work more slowly.

The other difference that is not apparent in this example is that when the paint is applied on top of the previous brush stroke the colors will blend if the paint is still wet. This is more noticeable when painting rather than cloning.

Figure 8.7 *Dry Rate slider.*

Water – Diffuse Amt

The Diffuse Amt slider controls the amount of diffusion, the top section of Figure 8.8 shows the brush at the default setting of 92% which produces significant diffusion, while the others at 50% and 0% show very much less.

Figure 8.8 *Diffuse Amount slider.*

Figure 8.9 shows a detail where the brush strokes were applied at Diffuse Amount 92% and opacity 18%. More brush strokes were painted on top with the Diffuse Amount set to 33%.

See how this has brought in more detail in a rather gentle manner.

Figure 8.9 *Diffuse Amount settings.*

Water – Wind Force

This was mentioned earlier and is a fascinating feature that replicates the ability in traditional watercolor painting to angle the paper downwards so that a wet wash will run and mix with other washes. In Painter both the angle and direction of the movement can be altered.

Figure 8.10 shows three different examples of using this control, the top is with Wind Force at 0%

Figure 8.10 *Wind force at various settings.*

so the diffusion has not significantly moved. The centre shows the Wind Force at 50% so the diffusion has moved downwards. The final example is with Wind Force at 100% and the direction of the wind is now to the right, a real gale-force in fact! This is really useful as you can control the final result very effectively.

Water – Other Controls

There are several other sliders in the Water palette not all of which affect this particular brush but will affect others.

Delay Diffusion, which is turned on in the default setting, allows the brush stroke to finish before the diffusion process starts. Try the two options to see the difference.

Accurate Diffusion results in the clone copy having more clarity. Untick this option to get a rougher impression that can be very useful for backgrounds. Figure 8.11 shows the result of this option, the first and third bands from the top have Accurate ticked, while the second and fourth are not ticked.

Figure 8.11 *Accurate diffusion.*

Digital Watercolor

This first Watercolor clone step-by-step uses the Dry Brush technique which is one of the easier Watercolor brushes to use. The painting method is to start with a Watercolor wash and then to use the Dry brush to gradually bring in more detail.

Step 1 File> Open> DVD> Step-by-step files> '08 Lower Brockhampton Court'.

Step 2 File> Quick Clone.

Step 3 Select the Digital Watercolor brush category and the Coarse Water variant. Use brush size 85.0 and opacity 1%. Click the Clone Color option in the Colors palette.

Step 4 Paint a light wash over all of the picture area as shown in Figure 8.13, keep the appearance very light.

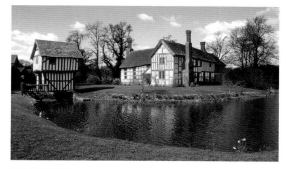

Figure 8.12 *Original photograph.*

Step 5 Change the brush to Digital Watercolor> Dry Brush. Size 30.0, opacity 2% and grain 5%. Click the Clone Color option in the Colors palette. Select the French Watercolor paper. Turn the tracing paper on and paint over all the main shapes. When you turn the tracing paper off you will see that the shapes are very rough, go over them to make them more defined. Figure 8.14 shows the picture at this early stage.

Figure 8.13 *Painting a very light wash.*

Figure 8.14 *Starting with the Digital Watercolor brush.*

Step 6 Make the brush size 10.0, opacity 5% and go over the buildings again, keep switching the tracing paper on and off to check the detail. Figure 8.15 shows the house starting to show more detail.

Figure 8.15 *Bringing in more detail.*

Step 7 Using the same brush, change the size to 23.0 and the opacity to 1% and paint over the remaining areas again to bring the picture together. Paint over the edges of the darker brush strokes you did earlier to integrate them with the lighter areas. Figure 8.16 shows the picture at this stage. You will need to vary the brush size and opacity to make the various parts of the picture blend well.

Figure 8.16 *Step 7.*

Step 8 Reduce the brush size to 4.3 and increase the opacity to 55%. This will put a lot more detail in the buildings, follow the lines of the building to emphasize the dark wooden beams and the white areas between (magnify the picture to see more clearly). If this looks too harsh, go over it afterwards with a larger brush and lower opacity. Paint over the sky and foreground with brush size 23.3 and opacity 9%.

Step 9 Paint over the trees with brush size 8.2 and opacity 55% to emphasize the trunks and branches. Use brush size 12.0 and opacity 4% to paint over areas where different textures join and look wrong.

Figure 8.17 *A smaller brush and larger opacity shows more detail.*

Step 10 In the General palette change the Method to Eraser and the Sub Category to Soft Paint Remover, brush size 32.0 and opacity 10% and go around the edges to remove any dirty marks or brush strokes you would prefer were not there.

Increase the opacity between 60% and 100% and use this brush to add some sparkle to your picture especially in the white areas of the buildings and in their reflection in the water.

Figure 8.18 *Lower Brockhampton Court.*

Soft Runny Watercolor

Step 1 File> Open> DVD> Step-by-step files> '08 Slater's Bridge'.

Step 2 File> Quick Clone. Turn off the tracing paper as it is difficult to see the detail in this very light clone.

Step 3 Select the Watercolor> Soft Runny Wash brush, size 100.0, opacity 2%. Click the clone color option in the Colors palette.

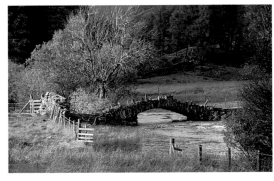

Step 4 Starting from the bottom, gently paint into the picture allowing the picture to slowly reveal itself. This brush uses a lot of diffusion and is therefore very slow to use. Keep an eye on the watercolor symbol in the layers palette and wait for it to stop moving before continuing to paint.

Figure 8.19 *Original photograph.*

Step 5 Decrease the brush size to 50.0 and increase the opacity to 3% and paint over the key parts, which are the bridge, the foreground posts, the water and the trees. This will give the picture more shape while still maintaining the delicate overall appearance.

Step 6 If the picture looks too dark when finished, lower the opacity of the watercolor layer. Figure 8.20 shows the final version. The end result is very soft and delicate and could be used as a base for a more detailed picture.

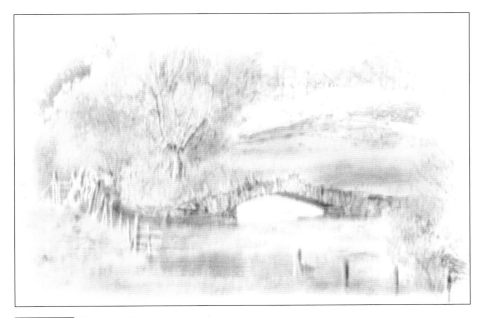

Figure 8.20 *Slater's bridge.*

Dry Bristle Watercolor

Step 1 File> Open> DVD> Step-by-step files> '08 Slater's Bridge'.

Step 2 File> Quick Clone.

Step 3 Select the Watercolor> Dry Bristle brush, size 30.0, opacity 2%. Click the clone color option in the Colors palette.

Step 4 Brush over the main elements of the picture with the tracing paper on, then turn the tracing paper off and continue to paint in the picture. You will find this brush much quicker to use than the Soft Runny brush as the paint does not diffuse as much.

Step 5 Increase the opacity gradually, paint with 3%, then 4% which should be sufficient to give you good density, Figure 8.21 shows the final picture.

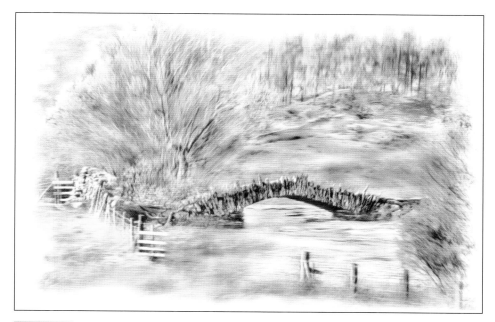

Figure 8.21 Slater's bridge.

Figure 8.22 is an enlargement of the finished clone where you will see the brush strokes in more detail.

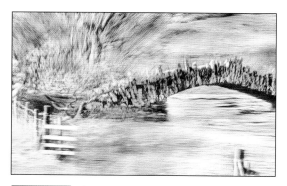

Figure 8.22 Slater's bridge – detail of brush strokes.

Oils

Many of the brushes in the Oils category have textured brush strokes and in this next step-by-step you will see how this can transform a photograph into an image which appears to have depth. The impression of depth is called Impasto, which is described in more detail in Chapter 4.

Step 1 File> Open> DVD> Step-by-step files> '08 Autumn Color'.
Step 2 File> Quick Clone.
Step 3 Select the Thick Wet Oils 30 brush, size 35.0, opacity 100%. Click the clone color option in the Colors palette. On the Properties bar change the Resat box to read 100%, this change means that the brush will keep on painting with the full amount of paint rather than running out.

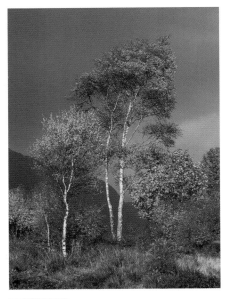

Figure 8.23 Original photograph.

Step 4 Paint the entire picture with a layer of paint, this stage is shown in Figure 8.24. Paint the sky first, which will darken it considerably, then paint the rest of the picture using short brush strokes to give a textured effect. More detail can be seen in the enlargement as shown in Figure 8.25.

Figure 8.24 Thick Wet Oils brush.

Figure 8.25 Detail of brush strokes.

Figure 8.26

Figure 8.27 *Detail of brush strokes.*

Step 5 Reduce the brush size to 15.0 and using very short brush strokes paint over the autumn leaves, pushing the brush strokes outwards from the centre of the foliage. Enlarge the picture on the screen to work in greater detail and check the detail shown in Figures 8.26 and 8.27.

Step 6 Reduce the brush more to between 8.0 and 10.0 and run the brush down the tree trunks to bring them out clearly. Paint the side of each tree trunk to emphasize the light and dark areas. Continue to paint over the leaves at varying brush sizes to give an interesting texture as in Figures 8.28 and 8.29.

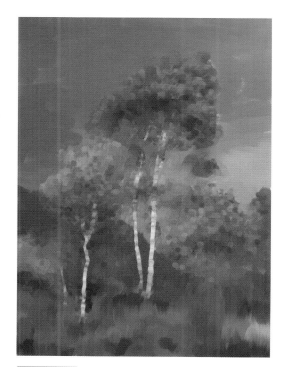

Figure 8.28

Figure 8.29 *Detail of brush strokes.*

Step 7 Press Ctrl/Cmd + B or go to Window> Show Brush Creator and click on the Spacing tab. Change the Spacing slider from the default 8% to read 63%. This will space out the brush dabs and reduce the smoothness of the brush, which is useful to create a more individual texture on the leaves. Paint over the edges of the trees and look for groups of leaves to highlight. This brush will break up the edge and give more highlights, Figures 8.30 and 8.31 shows this stage completed.

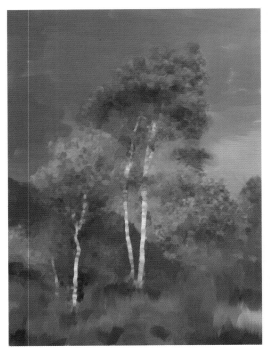

Figure 8.30

Figure 8.31

The picture needs more contrast to make it spring off the page but we cannot clone from the original photograph until it has been brightened, so the next stage is to alter the contrast of the original by making two extra layers.

Step 8 If the layers palette is not on screen bring it up via Layers> Show Layers. Activate the original image by clicking in the picture and then select the Layer Adjuster tool from the Toolbox. Select> All then holding down the Alt/Opt key, click in the picture to make a copy of the Canvas, this will automatically be placed on a new layer. Repeat this step to make a second copy of the Canvas.

Step 9 Click on the top Layer and rename it Lighten (via the Layers palette menu).

Go to Effects> Tonal Control> Brightness and Contrast and move the sliders to the approximate positions shown in Figure 8.32.

Figure 8.32 *Adjusting Brightness and Contrast.*

Step 10 Click the eye icon on the top layer to hide it, then click on the middle layer and rename it Darken.
Go to Effects> Tonal Control> Brightness and Contrast and move the sliders to the positions shown in Figure 8.33.

Figure 8.33 *Adjusting Brightness and Contrast.*

This has given us two extra versions of the original picture from which to clone. The two extra layers are shown in Figures 8.34 and 8.35 and the Layers palette in Figure 8.36.

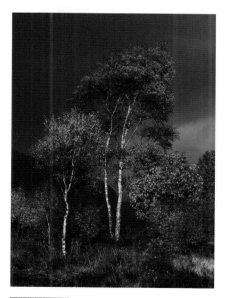

Figure 8.35 *Dark layer.*

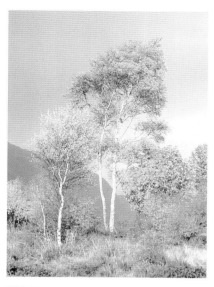

Figure 8.34 *Light layer.*

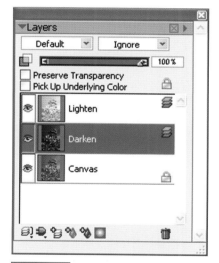

Figure 8.36 *Layers palette showing the three layers to clone from.*

Step 11 Click on the Darken layer in the original image to make it active and turn off the visibility of the Lighten layer. Return to the clone copy and using brush size 12.0 and 33% opacity, brush some darker areas into the picture where you would expect to see shadows.

Step 12 Click on the Lighten layer in the original image to make it active and turn off the visibility of the Darken layer. Return to the clone copy and using brush size 14.0 and 33% opacity brush highlights into the top of the trees and in the groups of leaves. Increase the opacity to 65% and dab in more highlights. Increase the opacity to 100% and add just a few more highlights very carefully, don't overdo it!

The final cloned image after a small crop is shown in Figure 8.37. Some extra texture was added to complete the picture and the procedure for this is covered in Chapter 6.

In the same way these extra layers were created to increase contrast, the original image can be altered at any time, for instance, to clone out something distracting, to blur the picture or to change the color before continuing to clone.

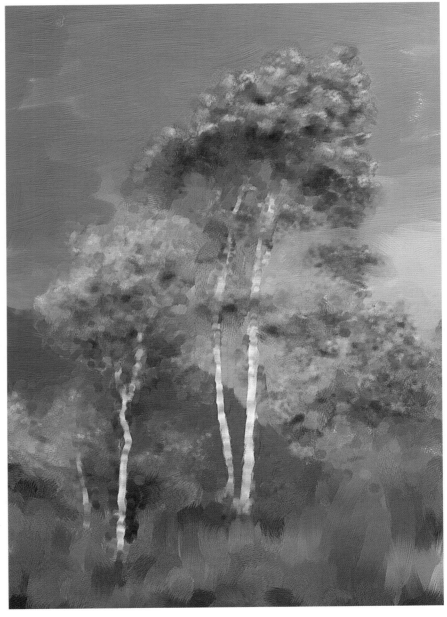

Figure 8.37 *Autumn Colors.*

Pastel

Pastel pictures have a very distinctive texture as the pastel interacts strongly with a textured paper. The choice of pastel brush is critical as they vary considerably, hard pastels emphasize the paper texture while the soft ones blend into the paper but still have the texture present, particularly on the edges of the brush strokes. One of my favorite pastel brushes is the Artists Pastel Chalk which you will be using in this example.

Figure 8.38 Original photograph.

Step 1 File> Open> DVD> Step-by-step files> '08 Peony'.
Step 2 File> Quick Clone.
Step 3 In the Papers palette select Sandy Pastel Paper.
Step 4 Select the Artists Pastel Chalk Brush size 161.0, opacity 12% and grain 23%. Click the Clone color option in the Colors palette.
Step 5 The first stage is to paint over all the picture with the brush to get a base color on which to add detail. Figure 8.39 shows this stage completed.
Step 6 Change the brush size to 37.8 and opacity 32% and start to put more detail in the petals. At this size the brush becomes much smoother and much of the texture is blended out.

Figure 8.39 Laying down the base color.

Step 7 Go over the petals again with brush size 99.6 and opacity 32%, this will help to smooth the differences between the detailed and less detailed areas.
Step 8 Reduce the brush size to 15.0, increase the opacity to 65% and then to 100% and add more definite detail into the petals and centre. Keep flipping the Tracing Paper on and off to see what your painting looks like.

Figure 8.40 Putting detail into the petals.

Step 9 Reduce the brush further to 6.4 and go over the individual stamens and some of the lines in the petals. The stamens should come out very clearly and make a strong focal point for the picture.

Step 10 We are about to change the brush and from now on will interchange regularly between the two so it is useful to make a custom palette to make it quicker to change brushes.

Click on the brush variant in the Brush Selector menu and drag it out into the screen area. This will automatically make a custom palette. Now change the brush to the Blenders> Soft Blender Stump. Brush size 52, opacity 33%. Drag the brush icon into the custom palette you have just made and the result should look like the palette in Figure 8.41. When you need to change brushes you can now simply click on the one you need. If you need to delete the palette later this can be done in the Window> Custom palette menu.

Figure 8.41 *Custom palette.*

Step 11 Using the Blender brush paint out the background until it is smooth, you may need to increase the brush size to get it very smooth.

Step 12 Change back to the Artist Pastel brush size 6.4, opacity 100%, go around the flower and carefully bring out the edges without straying into the background.

Step 13 Still using this brush bring out more detail in the petals, especially the veins and folds.

Figure 8.42 *Blending out the background.*

Step 14 Where the texture becomes too hard, change back the blender brush and lightly run over the detail to slightly soften the picture.

Step 15 When you are happy with the picture apply a low level of Apply Surface Texture (Chapter 5) to emphasize the brush strokes.

Figure 8.43 *Paeony.*

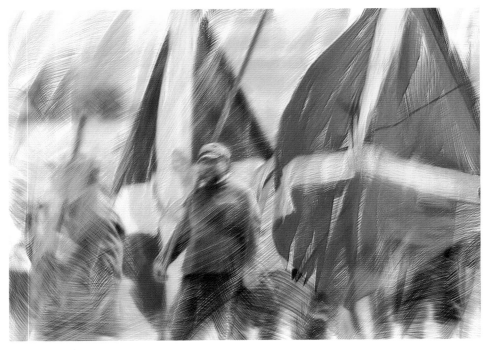

Figure 9.1 *Battle flag.*
One of the new RealBristle brushes was used to paint this picture from an English Civil War re-enactment. The variant was the Real Fan Soft which has a very distinctive bristle texture.

9

Mosaics and other clones

The step-by-step guide to making a mosaic clone will enable you to experiment with this unique picture making method. This is not the uniform pattern imposed by mosaic filters in other programs, each tile is individually laid and adjustable and this results in a fascinating and satisfying image based on your own photograph.

Monochrome images are perennially popular and some ways of approaching these are explained in more detail, including using a Liquid Ink brush.

In the early stages of making a clone picture it is often helpful to paint all over the picture quite roughly in order to break up the photographic texture of the original image and then to clone more detail into critical areas. Painter X now has an Auto-Painting palette which can help and speed up the process of this initial underpainting. There is also a new brush category called Smart Stroke Brushes which was created to use with this feature and the variants include a selection of differing types of natural media brushes ready set up for cloning.

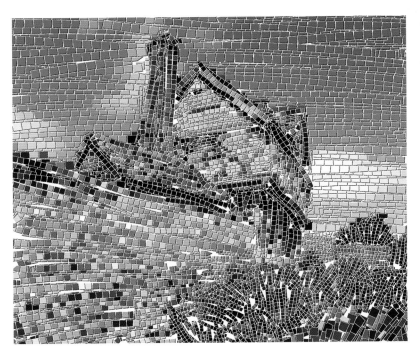

Figure 9.2 *Manor house mosaic.*

Making Mosaics

Mosaic Clones work in a completely different way compared to all other clones. Most of the toolbox and palettes are not available when using Mosaics, so all the controls you need are available from within the Mosaics dialog box. Choosing the right picture to make into a mosaic is important as not all photographs are suitable, pictures with good strong shapes and lines usually work best.

Step 1 File> Open> DVD> Step-by-step files> '09 Quarry Truck'.
Step 2 File> Quick Clone.
Step 3 The brush chosen is unimportant but you must click the clone color option in the Colors palette for the colors to be taken from the original image.
Step 4 Canvas> Make Mosaic will bring up the Mosaic dialog box. Click the icon on the left to start laying the tiles.

Figure 9.3 Original photograph.

Figure 9.4 shows the Mosaics dialog box as it first opens. The left hand icon (which is highlighted) in the dialog box is the one for applying mosaic tiles. The other icons are for removing, changing and selecting tiles after they have been laid.

The Width and Length sliders change the size and shape of the tiles.

The Pressure slider determines the variation of the tile size when using a pressure sensitive stylus. A zero setting means the tiles vary from small to large, there is no variation at the maximum setting.

The Grout slider alters the space between each tile as it is laid.

Figure 9.4 The Mosaic dialog box.

Clicking in the white box will change the color of the grout and effectively changes the background color. Figures 9.5 and 9.6 show the difference between white and black grout.

Before starting to make this picture it is worth trying out some brush strokes to see how the tiles are laid on the picture. You will quickly notice that it is impossible to lay one on top of another, just as in a real mosaic.

The tracing paper is turned on and off by ticking the option in the dialog box.

Tiles that you have already laid can be removed, click the second icon and brush over the tiles, they can then be laid again.

201

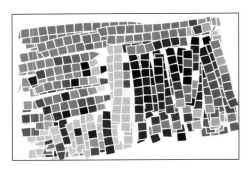

Figure 9.5 White grout.

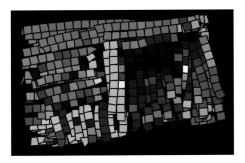

Figure 9.6 Black grout.

To change the color of the tiles after they have been laid untick the clone option in the Colors palette and select a color. Click the third icon (highlighted in Figure 9.7) and paint over the tiles, they will change to the color selected in the colors palette. Remember to tick the clone option again before you start to lay more tiles.

Click in the box below the icons where it says Color and select one of the other options and the tiles will be darkened, lightened or tinted as you paint over them.

Figure 9.7 Selecting, removing and changing color.

When you have tried out the options and are ready to start cloning the picture, close down the clone copy unsaved and make another Quick Clone. Usually you can clear a cloned image by Select> All and Edit> Cut, but in the case of mosaics this does not work. The image will be cleared but the memory of where tiles were laid is retained and makes it impossible to lay tiles in the same place.

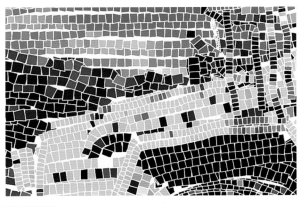

Figure 9.8 Laying tiles following the lines in the picture.

Step 5 Using the new clone copy and with the tracing paper turned on, paint over the picture using a tile size of about 25.0. How you lay the tiles depends on the picture but generally it is better to follow the main lines of the picture and then to fill in the other areas afterwards.

Figure 9.8 shows how the tiles can be laid in this way.

Step 6 As with all pictures you will want to save your work as you go along and when using mosaics this must be done using Painter's RIFF format. In any other file type you will lose the ability to alter it later.

File> Save As and select RIFF as the file type. When saved in RIFF format the file can be opened again at any time and tiles added or altered but make sure that you also re-open the original picture and set the clone source correctly. With the cloned picture open go to Canvas> Make Mosaic and continue cloning.

Figure 9.9 Save all mosaics as RIFF files to retain flexibility.

Step 7 When you have finished making the mosaic picture there is one final operation, which is to add a texture to the mosaic, which will give it greater depth.

Figure 9.10 Without mosaic mask.

Select Render Tiles into Mask from the Options drop down menu at the top of the dialog box and click on Done. This will not appear to have any effect, but it has made a mask that will be used in the next step.

Figures 9.10 and 9.11 show the difference this mask makes.

Figure 9.11 With mosaic mask applied.

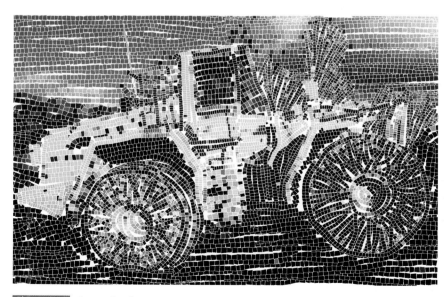

Figure 9.12 Quarry truck.

Step 8 Go to Effects> Surface Control> Apply Surface Texture and in the Using menu select Mosaic Mask. This will add a three-dimensional impression to the tiles. Save the picture again as a RIFF if you want to adjust it later or as any other type of file when it will become a normal bitmap file type that can be opened in other imaging programs.

As a matter of interest, in the mosaics dialog box Painter tells us how many tiles have been used in the picture and in the Quarry Truck example I have used 10,530.

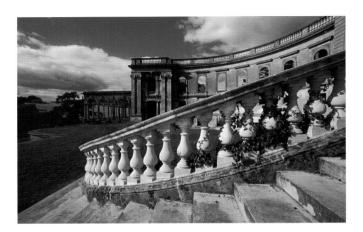

Figure 9.13 *Original photograph.*

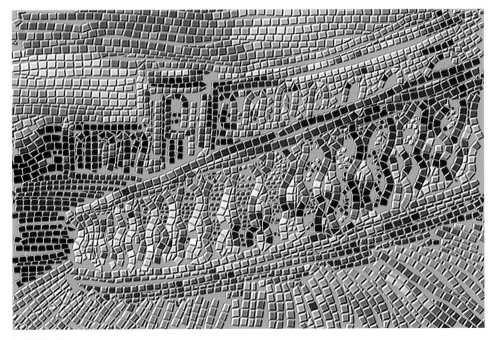

Figure 9.14 *Witley Court.*

204

Monochrome clone

Clones using monochrome photographs can work very well. They need no special techniques apart from removing the color if your original picture is in color. This picture was originally photographed on Kodak Infra-Red film and that has given it a very grainy and contrasty appearance.

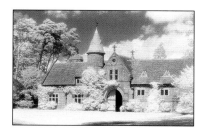

Step 1 File> Open> DVD> Step-by-step files> '09 Old Coach House'.

If your own picture needs to be changed to monochrome, make a new empty layer above the canvas and fill it with black. Change the layer composite method to Colorize and click on Drop All in the palette menu.

Figure 9.15 **Original photograph.**

Step 2 File> Quick Clone.

Step 3 Select the Sketching Pencil 5 from the Pencils category, brush size 175.0 with opacity at 4%. In the General palette change the Method to Cloning and Subcategory to Grainy Hard Cover Cloning.

Step 4 Select the Italian Watercolor paper.

Step 5 Sketch lightly over the picture leaving the edges white as in Figure 9.16.

Step 6 Reduce the brush size to around 66.6, increase the opacity to 10% and paint over the picture bringing out more detail were necessary.

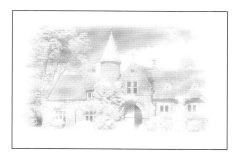

Figure 9.16 **First sketch.**

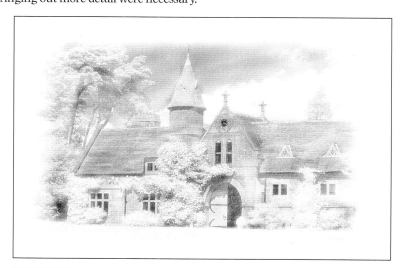

Figure 9.17 **Old coach house.**

Liquid Ink

This next example uses a monochrome original and the unusual properties of a Liquid Ink brush to create a very hard rough finish. Like Watercolor clones, Liquid Ink uses a special layer which can be adjusted at any time. Because of this you will need to save the file in RIFF format until the picture is completed.

Step 1 File> Open> DVD> Step-by-step files> '09 Knight Statue'.

Step 2 File> Quick Clone.

Step 3 Select the Coarse Bristle Resist brush from the Liquid Ink brush category. Make the brush size 99.6, the opacity 12% and the Smoothness 10%. This resist brush will put unseen marks on the layer that will stop ink from taking on the paper. This is like putting wax on a piece of paper then painting over with water-based paint, the wax will stop the paint from being absorbed.

Step 4 Make four brush strokes down the centre of the picture with the resist brush. You will not see anything but the effect will become apparent in the next step.

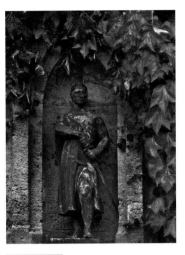

Figure 9.18 *Original photograph.*

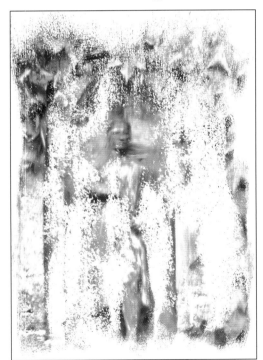

Figure 9.19 *Painting over the resist brush strokes gives this broken effect.*

Step 5 Select the Coarse Bristle brush from the Liquid Ink category. On the Properties bar make the brush size 44.4, opacity 30% and Smoothness 22%.

The change to the Smoothness slider will make this brush very rough. Click the clone color option in the Colors palette.

Step 6 Paint in short strokes from the top of the picture, give the brush time to finish each stroke as this is a very complicated brush and works slowly. Don't allow the brush to linger in one place as the density will be too strong. As you can see in Figure 9.19 the picture is very broken up, partly due to the resist paint applied earlier. Change the Layer Composite Method to Hard Light, which will increase the hardness of the texture.

Step 7 Make a new Liquid Ink layer by clicking on the new Liquid ink icon in the Layers palette, the icon is the fifth from the left. Change this layer to Hard Light composite mode as previously.

Step 8 Use the same brush and paint again to show more of the picture. Figure 9.20 shows this layer seen with Layer 2 and the white Canvas (Layer 1 is turned off in order to show the layer separately).

Step 9 Make another Liquid Ink layer in Hard Light composite mode and paint more texture, fill in areas that are blank. Figure 9.21 shows this layer with just the white Canvas below, you will be working with all the layers visible and will therefore see the whole picture as it develops rather than one layer at a time as illustrated here.

Figure 9.20 *Adding more detail with additional layers.*

The reason for making separate layers is that it allows more flexibility when the picture is being finished. The opacity and composite method of each layer may be changed.

The Layers palette is shown in Figure 9.22 and the final picture in Figure 9.23.

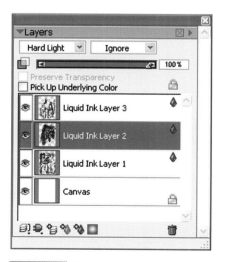

Figure 9.21 *Filling in areas not previously painted.*

Figure 9.22 *Final layers palette.*

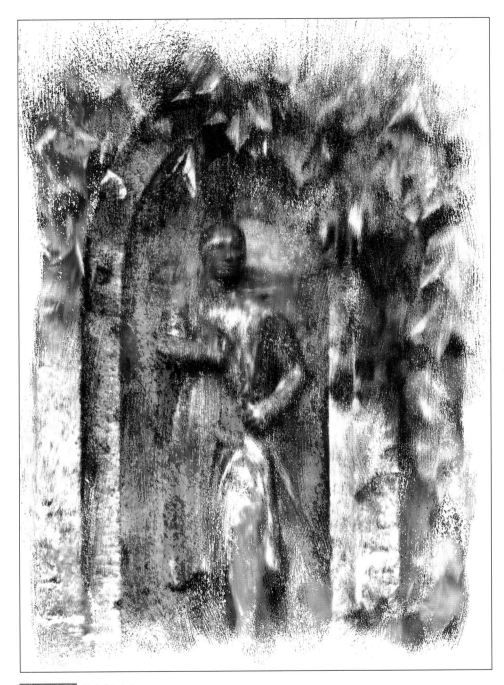

Figure 9.23 Knight statue.

Auto-Painting palette

The Auto-Painting feature was introduced in Painter IX.5 and further improved in Painter X. It will allow you to make fast painterly clones using a vast number of brush variants. The new Smart Stroke brush category has been specially developed to work with the Auto-Painting palette.

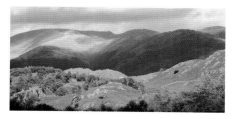

Figure 9.24 *Original photograph.*

One of the uses of this palette is to provide an underpainting prior to bringing more detail back with a regular clone brush or by using the Restoration palette which was introduced at the same time.

Step 1 File> Open> DVD Step-by-step files> '09 Mountain view'.
Step 2 File> Clone.
Step 3 Select the Smart Stroke> Acrylics Captured Bristle brush, size 20, opacity 100%.
Step 4 Window> Show Auto-Painting.
Step 5 In the Auto-Painting palette tick the Smart Stroke Painting but leave the Smart Settings unticked. Click the play button bottom right.
Step 6 Allow the process to paint the picture, you can stop it any time by clicking in the picture. Press the play button to continue.

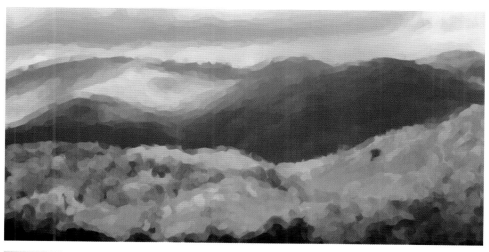

Figure 9.25 *Auto-Painting with the Smart Stroke AcrylicsCaptured Bristle variant.*

Figure 9.26 *The Auto-Painting palette.*

Figure 9.27 *Auto-Painting with the Artists>Impressionist variant.*

When the Smart Stroke Painting option is not selected other options in the palette become operable. The Stroke box reveals a large choice of brush strokes which will modify the choice of brush previously selected in the Brush Selector. There is also the chance to customize the brush further by altering the five sliders in the palette.

Figure 9.28 shows the Impressionist brush with the Smart Stroke Painting option selected, notice how the brush strokes follow the lines of the original photograph. In Figure 9.29 this is not used and the Zig Zag stroke was chosen instead, see how the brush strokes are random and do not follow the lines of the photograph.

Figure 9.28 *Impressionist brush with Smart Stroke Painting option selected.*

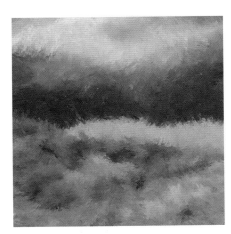

Figure 9.29 *Impressionist brush with the Zig Zag stroke used.*

Two further examples now, Figure 9.30 shows the Impressionist brush again but this time with the Splat stroke used. Figure 9.31 uses the Smart Stroke Painting with the Square Chalk 35 brush.

Figure 9.30 *Impressionist brush with Splat stroke.*

Figure 9.31 *Sharp Chalk 35 brush with the Smart Stroke Painting option chosen.*

Also introduced at the same time as the Auto-Painting palette is the Restoration palette and this allows easy access to the Soft Clone in order to restore parts of your original source photograph.

Figure 10.1 The old fence.
This old fence was photographed in Infra-red using a digital camera and then hand colored in Painter X following the same procedure as the step-by-step example in this chapter.

10

Hand coloring and toning

This chapter starts with a reference section on choosing colors using the various palettes and commands. Also included is a description of the Mixer palette which will be used in the hand coloring step-by-step examples.

Hand colored pictures have a charm which is quite unique and in this chapter you will discover the best way to use this fascinating technique.

Allied to hand coloring is the ability to remove the color and tone photographs, this technique takes a picture a step away from reality which often makes that bit more special.

The scene below has been hand colored using the techniques explained in this chapter.

The picture seen in Figure 10.1 has been photographed in a digital camera using an almost opaque filter to allow only infrared light to enter the camera. This has created the very light delicate tones which are ideal for hand coloring.

Figure 10.2 *The lost garden.*

Choosing colors

Painter X has a variety of ways to select and use colors whether for toning, painting or coloring and is the ideal program in which to paint or hand tint photographs. Apart from the vast range of brushes, the ability to keep the palettes live on screen while working is something that many other programs including Photoshop cannot do.

There are three principal palettes to use, Colors, which have been used many times before in this book, Color Sets and the excellent Mixer palette.

Colors Palette

The Colors palette is shown in Figure 10.3, if this palette is not visible on the screen go to Window > Color Palettes > Show Colors.

This is the chief color picker for general use in Painter. Colors are chosen by first selecting the Hue and then the value and saturation. In case you are not familiar with the terminology I will briefly explain what these terms mean.

Hue is the principal color and is chosen by clicking in the circular color ring.

Figure 10.3 The Colors palette.

Saturation is the purity of the color. It is at its most intense on the far right of the inner triangle and as the cursor is moved to the left the color is diluted by being mixed with black or white.

Value is the brightness of the color and is selected by moving the cursor up or down in the inner color triangle. Maximum value is white and minimum black.

The two squares bottom left show the Main and Additional colors. The Main color is the one that is used for painting and is the one in front. The square behind is the Additional color and is used for some special brushes that use two colors. It is not the same as the background color in some other graphics programs.

The small white readout in the bottom right corner shows the numerical values of the Hue, Saturation and Value of the color chosen. Click in this readout to change it from HSV to RGB. These readouts are useful if you need to know exactly how to replicate the color at a later date.

The rubber stamp icon is, of course, the Clone Color option, which we have used many times throughout this book, and makes the brush pick the color from the clone source instead of the Colors palette. When the Clone Color is selected the colors in the palette are muted.

Small Color palette

There is a smaller version of the Colors palette available, click in the palette menu and select Small

Figure 10.4 The small color palette.

Colors and the palette will change to that shown in Figure 10.4. It works in the same way as the standard Colors palette.

Color info

The color info palette, which is shown in Figures 10.5 and 10.6, is very useful for making colors when you have the specific color values. Move the sliders or type directly in the boxes the color values you need. Click the palette menu to change the display between HSV and RGB. This palette will also list the values of any color when you click the eyedropper in a picture. This palette is available from Window > Color Palettes > Show info.

Figure 10.5 *Hue, saturation and value.*

Figure 10.6 *Red, green and blue.*

Color Sets

Color sets are another way of picking colors and like the other palettes is displayed via Window > Color Palettes > Show Color Sets. Figure 10.7 shows the Color Sets palette with the palette menu extended.

It can be an advantage to choose a color from the Color Sets palette as specific color shades may be more readily identifiable from the individual squares rather than from a continuous color range. To select a color, click on the square and the brush will paint with that color.

Figure 10.7 *The Color sets palette with extended menu.*

The palette menu shown in Figure 10.7 contains options for customizing the display. The first block of options is for creating new color sets from a variety of sources.

New Empty Color Set is for when you want to individually pick a range of colors and store them for future use. This could be useful if you are designing a layout or color scheme and want to keep all the colors used together. Click the New Empty Color option in the menu to make an empty set. Use the eyedropper to add colors, click on a color in the active image and then click the color set icon with the + symbol. Click the color set icon with the − symbol to remove a color.

New Color Set from Image creates a Color Set from the image currently active on the desktop. You could use this to restrict the number of colors in a new image to those of an existing one. The new color sets from Layers or Selections work in the same way but take the colors from the active layer or the active selection.

New Color Set from Mixer Pad takes the colors from the Mixer, which will be covered later in this chapter.

The default color set is only one of many sets available and Open Color Set will replace the current set with a different one. The extra color sets are loaded with the Painter program and when the open box appears it will normally take you straight to the relevant folder from where you can choose the new color set. If this does not happen you will need to navigate to where the Corel Painter program files are and go to the Color Sets folder.

There is large selection to choose from, about 50 in all, and Figure 10.8 shows a few. From the top they are Black Walnut Ink, Vivid Spring, Gray Range, Flesh Tones and Rich Oils.

Append Color Set will add the new color set and not delete the existing one.

Save Color Set will save sets that you have created.

The other options are all self-explanatory, I will just mention the Swatch Size option, this will show the swatches at various sizes, I find it very useful to enlarge them as the colors can be seen more easily.

Figure 10.8 *Some additional Color sets.*

Mixer

When the Mixer was first introduced in Painter it was a huge advance in recreating traditional techniques, it works like an artist's palette where paints can be mixed together to blend colors. Figure 10.9 shows the current Painter X Mixer palette with the flyout palette menu.

Click on the second brush icon and select a color from the selection at the top of the palette or use the Eyedropper and click in the current open picture. Paint some brush strokes into the palette then select another color and paint some

Figure 10.9 *The Mixer palette with extended menu.*

more, the slider will change the size of the brush that adds the color. The paint will mix together as it is layered on top of the previous brush strokes. When you have added several colors click the palette knife icon and mix the colors together.

When you are ready to paint, first click the eyedropper icon then click in the mixer to select the color you need and paint into your picture. The Eyedropper icon in a circle is used for brushes like Artists Oils which can pick up more than one color at a time.

When using bristle brushes click on the two brush icons and after adding paint to the palette you can paint immediately in the picture without going to the eyedropper icon. The brush updates automatically as you mix.

The magnifying glass icon will enlarge the mixer display to make blended colors more easily visible, double click the icon to return to full view.

The Hand icon will move the display when the mixer display is magnified.

The palette menu has controls to save and import mixer palettes and also the option to create a color set from the mixer palette.

Click on the Trash can to clear and reset the palette.

Toning techniques

There are several ways to tone photographs in Painter and in this section you can try out some of these starting from a color original.

Figure 10.10 *Original photograph.*

Adjust Colors

The very blue early morning atmosphere of this picture will look more interesting as a toned picture and here is a very simple way of changing the tones.

Step 1 File> Open> DVD> Step-by-step files> '10 Lakeside view'.
Step 2 Effects> Tonal Control> Adjust Colors. Make the settings Hue −50%, Saturation −59%, Value 53% and leave the Using box on Uniform Color.
Figure 10.11 shows the final image, the strong blue has been transformed into a much more delicate picture.

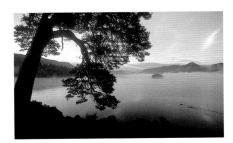

Figure 10.11 *Lakeside view.*

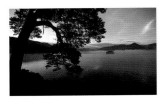

Figure 10.12 *Adjust Colors dialog box.*

218

Posterize using color set

This command will posterize your picture and base the posterization on the Color Set currently in use. The levels of posterization is dependent on the number of colors in the selected Color Set.

Step 1 File> Open> DVD> Step-by-step files> '10 'Pot'.

Step 2 Load the '72 Pencils' Color Set (see previous page for how to load Color Sets).
Step 3 Effects> Tonal Control> Posterize using Color Set.

This is a one step option with no controls to alter.
Try loading different Color Sets and run the command again, you will notice that the sets with more colors will have a more subtle effect.

Figure 10.13 Pot.

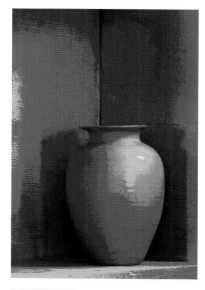

Figure 10.14 Posterized pot.

Color Overlay

Step 1 File> Open> DVD> Step-by-step files> '10 The robe'.
Step 2 To remove the color from a photograph go to Effects> Tonal Control> Adjust Color and move the Saturation slider fully to the left (−139).
Step 3 Add a paper texture to the picture, Effects> Surface Control> Apply Surface Textures, select Paper in the Using box and 50% as the Amount. In the Papers palette choose French Watercolor Paper. Figure 10.16 shows this stage.
Step 4 Choose a color in the Color palette, a light orange or similar. Go to Effects> Surface Control> Color Overlay. Select Paper in the Using box, 100% opacity and Dye Concentration.
Step 5 The picture looks rather dull as you can see in Figure 10.17, so the next step is to brighten it and it is best to do this on a duplicate layer. Make the Layer Adjuster tool active, Select> All then holding down the

Figure 10.15 Original photograph.

Figure 10.16 With paper texture applied.

Alt/Opt key, click in the picture area. This will make a copy of the canvas.

Step 6 With the duplicate layer active go to Effects> Tonal Control> Brightness and Contrast and move both sliders to the right.

Step 7 Certain parts of the picture, the arm in particular, will be over bright, so click on the mask icon to make a layer mask. Click in the mask to activate it then using the Digital Airbrush size 242.2, opacity 2% paint over the brightest areas with black, the mask will then reveal the original, darker layer beneath.

Figure 10.17 **Dye Concentration.**

Figure 10.18 **The robe.**

Hand tinting

Hand tinting photographs is as old as photography itself and in recent years has experienced a revival as artists and photographers seek to make pictures that have that very special magic that hand tinting can give. This step-by-step example will explain the techniques needed to get the right degree of color in the final picture.

The starting point is the picture of Hodge Tarn as seen in Figure 10.19. The original color slide has been desaturated and lightly toned in

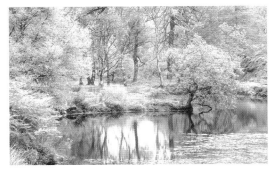

Figure 10.19 **Original photograph after desaturation.**

preparation for the hand coloring. It often helps to add a tone prior to hand tinting so that areas left unpainted will have a residue of color.

Step 1 File> Open> DVD> Step-by-step files> '10 Hodge Tarn'.

Step 2 Open the Mixer palette, which is ideal for hand tinting. If it is not on screen go to Window> Color palettes> Show Mixer. You will also need the Colors and the Layers palettes open on screen.

Step 3 Click the brush tool icon at the bottom of the Mixer palette and add a selection of colors to the mixing pad from the color swatches at the top of the palette. Figure 10.20 will give you a guide as to the range of colors needed. As you can see the colors are mainly reds, greens and yellows for the trees and some blue for the sky.

Step 4 Click the palette knife tool and mix the colors together as in Figure 10.21. More colors can be added later on if you need to.

Figure 10.20 Loading the mixer with colors.

Figure 10.21 Mixing the palette colors.

Step 5 Make a new empty layer by clicking the new layer icon. The color for each main element will be painted on a different layer, this retains maximum flexibility in the finishing stages as the layer opacities can be adjusted as necessary.

Step 6 Change the layer composite method to Color, this is an important step to take for all the layers as it makes the paint translucent so that it does not cover up the picture beneath. Rename the new layer 'Grasses' via the Layer> Layer Attributes dialog box or by double clicking the layer.

Step 7 Select the Tinting> Bristle Brush 10, brush size 4.6 and opacity 20%.

Step 8 Click on the eyedropper icon in the mixer palette and then with the Tinting brush active, click into the mixer color to select the painting color. Paint into the grasses using short dabs rather than large brush strokes and change the color continually to get a wide variety of hues. Figure 10.22 shows how this should look.

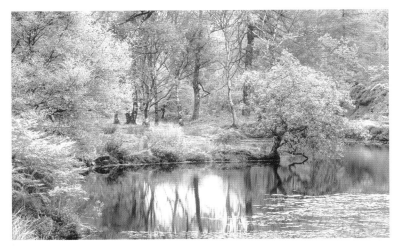

Figure 10.22 *Painting the grasses.*

Step 9 When you have completed the grasses, make another new layer and name it 'tree on left'. Remember to change the layer composite method to Color.

Step 10 Change the brush to Sponge> Sponge, size 56, opacity 33%. This brush gives an attractive dappled texture that is ideal for trees and foliage. Dab the brush over the tree starting with bright yellow then gradually changing to brown and red. If the colors in the mixer are not sufficient you can change the tones by moving the cursor in the inner triangle of the colors palette either to the black corner to darken, or towards white to lighten. Figure 10.23 shows the tree after tinting.

Step 11 Make another new layer in Color composite method and title it 'ferns'. Paint them

Figure 10.23 *Painting the tree and ferns.*

using brown and bronze tones. Each of the main elements needs to have a slightly different color range in order for them to stand out from the other trees and bushes.

Step 12 Make another new layer in Color composite method and title it 'tree on right'. Use the sponge brush again starting with yellow then moving into the green tones. Remember that trees are normally lighter at the top and darker underneath and that the leaves on some branches will not have changed color as much as others. Figure 10.24 shows the picture so far.

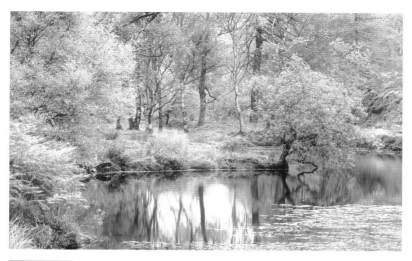

Figure 10.24 *Painting the green tree.*

I have emphasized how important it is to change the layer composite method to Color while making a hand tinted picture, so to illustrate the difference between the normal and color methods, Figures 10.25 and 10.26 show both types. In the picture on the left the mode is Default while on the right it has been changed to Color. At first sight the tree foliage may look pretty good in the Default mode but when you look closer a lot of the branches have been obscured.

Figure 10.25 *Default layer composite method.*

Figure 10.26 *Color layer composite method.*

Step 13 Make another new layer in Color composite method and title it 'sky and reflection'. Use the Tinting brush again and lightly paint in bits of sky between the trees in the centre, then using a deeper blue color, brush in the reflections in the water using downwards brush strokes.

Step 14 Make another new layer for the background trees and paint them with the Sponge brush. Use a larger brush here size 175 and opacity 5% to cover the whole area lightly. Keep changing the colors, the brush size and opacity to get more variation.

Step 15 Make another layer for the reflections and the colors in the water and change the brush to Airbrush> Soft Airbrush size 30, opacity 2%. This will give smooth gentle reflections. Repeat the colors that are in the bank and trees.

Figure 10.27 shows the Layers palette with separate layers for each element, the final picture is below.

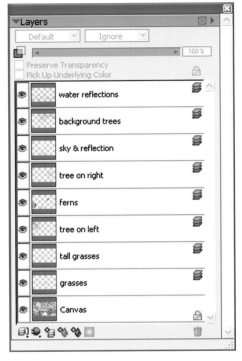

Figure 10.27 *Final Layers palette.*

This completes the first part of the hand tinting exercise and as you will have seen the result is really very attractive. I have always found it very enjoyable to make these pictures and hope you do also.

Figure 10.28 *Hodge Tarn in Autumn.*

Hand tinting – Changing season

The next stage follows on from the previous exercise and illustrates how with hand tinting you can change the season at will. The first snowfall has arrived at our autumn scene and the brown and gold tones will soon be covered with a layer of snow. Many of the autumn leaves are still on the trees, so you can use your final version to build on or use the new starting version provided on the DVD.

Figure 10.29 *New starting photograph.*

Step 1 File> Open> DVD> Step-by-step files> '10 First snow at Hodge tarn'.
When you compare this starting version with the previously completed picture in Figure 10.28 you will see some differences and if you are using your own version you will need to take the following steps.

Reduce the opacities of all the layers in your picture, the opacities will change to between 26% and 64% and the intention is to lower the strength of color prior to adding the snow. The layer with the tree on the right that was still green in color will look completely wrong so delete this layer. Make a new layer in its place and with the Sponge brush, paint over a light covering of autumn colors to blend with the rest of the picture. This should now look like the starting picture in Figure 10.29.

Step 2 Open the Mixer palette and click the waste bin to remove any existing colors. Add blue and white into the Mixer in various shades and mix them together.
Figure 10.30 shows the Mixer palette.

Step 3 Rather than using the Mixer palette again from which to paint I would like you to make a new Color Set. If the palette is not on screen, show it from Window> Color Palettes> Show Color Sets.
Click the Mixer palette menu and select New Color Set from Mixer Pad. This will make a color set which should

Figure 10.30 *The Mixer palette.*

225

resemble that in Figure 10.31 and can be used to select colors to paint the rest of the picture.

The blue shades will be needed to introduce cooler areas into the picture where the light is being reflected from the blue sky. As the brush will be used at a low opacity the colors will also be much weaker than they appear in the Color Set.

Step 4 Make a new layer on top of the layer stack, if you are using your own multi-layered file it is advisable to make a duplicate document and drop all the layers to keep the file size down. This time the layers will be in the Default layer composite method rather than using Color as the snow should look as though it is lying on top of the trees and grasses.

Figure 10.31 *The Color set created from the Mixer palette in Figure 10.28.*

Figure 10.32 *Tree on the left.*

Step 5 Select the Sponge> Glazing Sponge 60, brush size 60.0 and opacity 20%. Dab lightly over the picture with some blue shades to generally cool the atmosphere down. Change the color regularly by clicking in the Color Set palette.

Step 6 Make another new layer and work on the tree on the left, use brush size 161.0 and opacity 44%. This brush will give a very textured finish, so keep making multiple brush dabs over the tree until the foliage texture looks good. Figure 10.32 shows the tree. At all stages vary both the colors and the size and opacity of the brush to give more variety to the texture.

Step 7 Make a new layer again for the ferns and using the same Sponge brush, dab these with a light blue color. Change the brush to Opaque Acrylic 10 size 5.4, opacity 65%. Use this small brush to make brush dabs with white following the lines of the ferns, we are effectively painting snow on the top of the fronds. Push the opacity up

Figure 10.33 *Ferns.*

towards 100% on some of the most prominent fronds.

Step 8 Make a new layer and paint the tree on the right with the Glazing Sponge size 7.5, opacity 85%. Additional texture can be added with the Opaque Acrylic brush. Figure 10.34 shows the effect.

Step 9 Paint the background trees with the large Sponge brush, size 161.0, opacity 44%, lightly covering the area with white. Finish off the rest of the picture using the same brushes and finally use the separate layer opacities to balance the picture if required.

Figure 10.35 shows the final scene on a winter day.

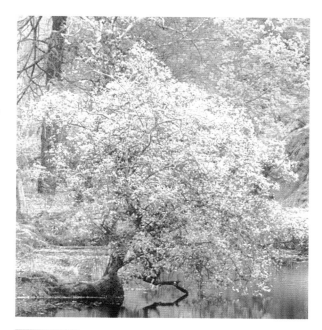

Figure 10.34 *Detail of the snow covered tree.*

Figure 10.35 *First snow at Hodge tarn.*

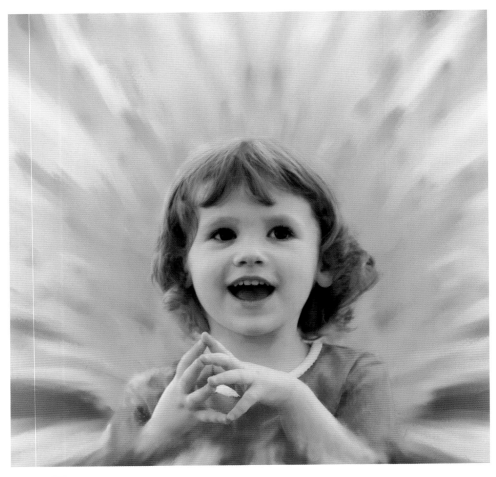

Figure 11.1 *Flower girl.*
Chapter 7 shows how to merge photographs by cloning from two pictures and this is how this picture was made. The bottom layer was painted over with Chalk and Pastel brushes and on a new layer on top the girl was cloned in with Soft Cloner and then reworked with Pastel and RealBristle brushes.

11

Children and young people

I n this chapter a variety of brushes are used to create painterly pictures of children and young people. This chapter starts with an explanation of some of the brushes in the Blenders category as these are particularly useful when making portraits and also for finishing off pictures of all types.

Brush categories which I find particularly valuable for portraits are the Pastel and Chalk ones and there is a step-by-step example using the Pastel brushes which are great for making light delicate portraits.

Another traditional style of painting is with Oils where the rich textures give a much more substantial finish with some lovely brush textures. The example of Griff shows how to use some of the Oil brushes.

Also included in this section is a step-by-step illustration of how to use inset mounts to make a picture more special. In the first edition of this book I included two pictures using this technique, but no step-by-step example and I had several enquiries as to how to make one in Painter. Hopefully this will provide the answer for anyone who wishes to create this effect.

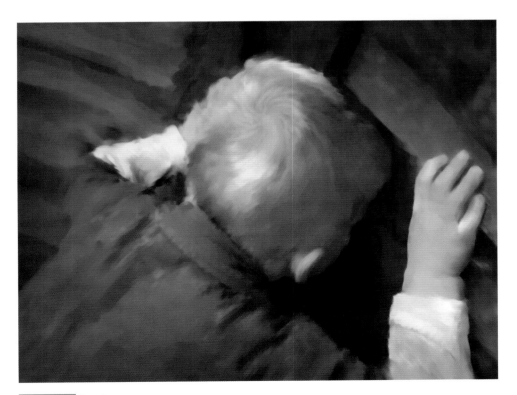

Figure 11.2 *Peeping.*

Using Blender brushes

Some of the most valuable tools for creating cloned pictures of people are the Blender brushes, these reside in several different brush categories including Blenders, Tinting and Distortion and can also be created from many other brushes by altering the settings.

Before we start making the first step-by-step tutorial it will be useful to check out the brush examples below as they highlight some of the most useful blending brushes.

The principal characteristic of a blending brush is that it smears or distorts the existing image and in doing so creates soft, rough or textured versions of the original picture. The brushes work directly on the image and although in all cases we will use a clone copy to work on, the brushes do not depend purely on taking information from the original.

At the size shown here it may not be possible to see the different textures very clearly so the original files have been included on the accompanying DVD.

Figure 11.3 *Grainy Blender, Coarse Smear, Just Add Water.*

Figure 11.4 *Coarse Oily and Soft Blender Stump.*

Three blenders were used for this example:

Blenders> Grainy Blender was used for the edges and the background, this is a rough blender which is affected by the paper chosen.

Blenders> Coarse Smear was used for the hair, this is similar to the previous brush but is not affected by the choice of paper. Both the above blenders are useful for hair.

Blenders> Just Add Water was used on the face, this is a very soft smooth blender which is a useful brush for removing blemishes on skin. Use it at a low opacity for the best results.

Blenders> Coarse Oily Blender was used for the background and gives a very chunky, rough appearance and smears the images around significantly.

Blenders> Oily Blender was used for the hair, this is smoother than the grainy blenders used in the picture above.

Blenders> Soft Blender Stump is a good brush for the face, used at a low opacity it polishes the skin beautifully. I used it here at between 5% and 10% opacity.

Figure 11.5 Tinting Diffuser, Grainy Mover and Grainy Water.

Figure 11.6 Marbling Rake and Diffuser.

Figure 11.7 Acrylic Captured Bristle.

Tinting> Diffuser 2 was painted all over this picture at 49% opacity and brush size 30. This gives a very attractive watercolor effect to the edges. Blend the edges outwards first then run the brush around the edges several times and the edge will spread very effectively. The central area was then restored with Soft Cloner.

Distortion> Grainy Mover was used for the hair and dress.

Diffuser>Grainy Water was used on the face, this leaves a little more texture than in the earlier examples.

Distortion> Marbling Rake, size , strength 100% was painted all over this picture. This is a rather drastic result but it achieved the intention which was to thoroughly break up the image. The central areas were then restored with Soft Cloner.

Distortion> Diffuser was blended over the central areas at various sizes and opacities, leaving the edges roughed up. The face was blended at 25% opacity.

One of the new brushes in Painter X was used for the whole of this picture. This is the Acrylic Captured Bristle from the Smart Stroke Brushes category.

The background and edges were painted using a size 26 brush with 41% opacity.

The face was blended with brush size 11 and opacity 51, then again with size 56 and opacity 5%.

This is a very bristly brush and gives the edges an attractive finish.

Portrait using Blenders

In this first example you will use some of the blenders described in the previous pages. The general process with portraits is to start with the rougher brushes and to gradually bring back more detail where required. In all cases it is advisable to work on a clone copy so that you always have the option of using the Soft Cloner to return parts to the original source state.

Step 1 File> Open> DVD> Step-by-step files> '11 Annabel 1'.

Step 2 Canvas> Canvas Size and add 150 pixels to each side and 200 pixels to the top and bottom. This will add a white border into which the edges can be blended.

Step 3 File> Clone.

Step 4 Select the Blenders> Grainy Blender 30, brush size 136, opacity 100%.

Step 5 Change the paper to Sandy Pastel Paper and paint over all the edges leaving the head and body clear. The intention is to remove all traces of the original picture edge, but not to extend right to the edge of the canvas. If you paint over part of the figure by mistake it can be restored with the Soft Cloner. Figure 11.9 shows the picture at this point.

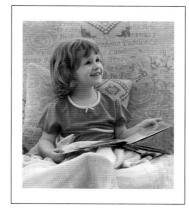

Figure 11.8 Original photograph.

Step 6 Select a new brush from the Blenders brush category Just Add Water, size 160, opacity 20%. Paint over all the background with this large brush until all the area is completely smooth. You will need to reduce the brush size down gradually to do the areas around the head and body. Figure 11.10 shows the result.

Figure 11.9 Using Grainy Blender to break up the background.

Figure 11.10 Just Add Water.

Step 7 If you have encroached on the face and clothes this is the time to restore it to the original. Select the Cloners> Soft Clone brush and brush over the areas which need replacing. There is no need to be totally accurate with this step as the edges will be softened in the next step, the face is the most important.

Step 8 Change to the Distortion> Grainy Mover 20, brush size 20, strength 25, paint over the hair making sure that you follow the direction that the hair flows. Cover all the hair with brush strokes. Reduce the brush size to 10 and smooth out all the texture, the hair should look soft and silky when you have finished.

Figure 11.11 Blending the hair.

Step 9 Select the Blenders> Grainy Blender 10 size 10, opacity 38% and paint over the pink top following the lines and shadows of the material. Leave the white lace until you have finished the pink, then use the same brush and paint over the lace with small circular motions, this will remove the photographic appearance but it will remain distinct from the pink.

Step 10 Use the Blenders> Soft Blender Stump 10, size 10, opacity 20% to smooth out any rough areas, these are usually near the darker sections, Figure 11.12 shows a detail of the dress.

Step 11 Return to the Grainy Blender 10 and blend the book and the remaining non-blended areas with the exception of the face and arms. Soften the rougher sections with the Soft Blender Stump as before.

Step 12 To paint the face and arms select the Soft Blender Stump 10, size 4.9, opacity 25%, grain 23% and bleed 56%. Enlarge the picture on the screen and carefully blend all over the face, remember that the blenders will drag one color into the next so do not drag darker tones such as eye shadow into light areas. For larger areas of skin use a larger brush, up to size 25, this will give a smoother overall blend.

When you blend the hair shadow on the left side of her face, move the brush in the direction of the hair which will lighten the area slightly.

Figure 11.12 Blending the dress.

Step 13 Continue with the same brush and blend the arms and hands.

Step 14 Look at the picture to see if it needs any further work, in the one I have made the white blanket under the book looks rather dark, so select the Airbrush> Soft Airbrush 50, size 206, opacity 2%. Hold down the Alt/Opt key and click on a light gray area of the blanket, this will activate the eyedropper tool and select the color with which to paint. Lightly paint over the darker gray areas. If necessary select lighter tones and paint until it looks bright but not overbright.

Step 15 Finally, check over the picture and blend any areas that still look photographic or are rather rough. The final version is shown in Figure 11.13.

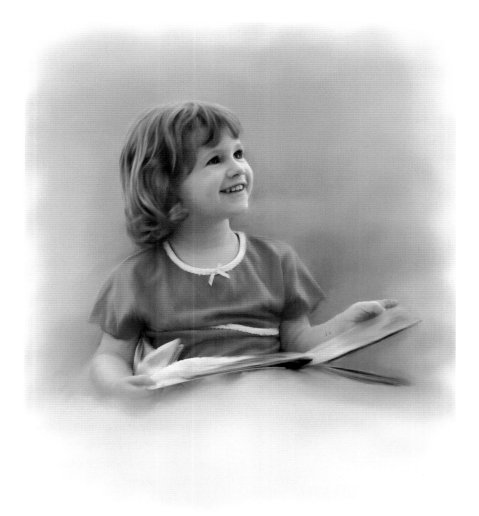

Figure 11.13 *Annabel with book.*

Portrait in Pastel

For this next picture we will use brushes from the Pastels section, this particular brush is a favorite of mine as it has such a lovely finish to the brush strokes.

Step 1 File> Open> DVD> Step-by-step files> '11 Annabel 2'.

Step 2 Canvas> Canvas Size and add 150 pixels to each side. This will add a white border into which the edges can be blended.

Step 3 File> Clone.

Step 4 File> Select the Pastels> Artist Pastel Chalk, size 127, opacity 65%.

Step 5 Click the Clone Color option in the Colors palette.

Step 6 Change the paper texture to Sandy Pastel Paper.

Step 7 Paint around the edge, pushing the color to the outside, then run the brush around the very outside to restore the white border. Paint out all the background. Unlike the previous example, this brush is cloning from the source picture and not just blending the picture, Figure 11.15 shows this completed.

Figure 11.14 Original photograph.

Figure 11.15 Edges complete.

Step 8 Reduce the brush size to 12.2 and make the opacity 100%. Paint over the hair following the flow of the hair, this will give it quite a chunky appearance.

Step 9 In order to restore some delicacy to the hair select the Cloners> Smeary Camel Cloner brush. Make the brush size 23, opacity 50% and move the Feature slider to 4.9. The Feature slider affects how the individual hairs in the brush work and by increasing this to 4.9 the individual brush hairs are emphasized; you should experiment with this slider to understand how the control works. Figures 11.16 and 11.17 show the difference in the hair.

Step 10 Return to the Artists Pastel Chalk and with brush size 22 and opacity 100% paint over the pink dress.

Figure 11.16 Hair detail Step 8.

Figure 11.17 Hair detail Step 9.

Step 11 The face can be painted with the same brush, reduce the opacity to 21% and make the size about 40. At this opacity the brush will smooth out any blemishes but still leave a delicate texture on the skin.

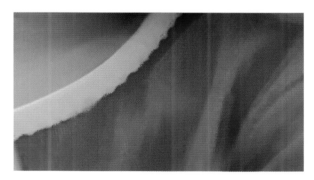

Figure 11.18 Dress detail.

Step 12 Paint over the lips and eyes with care, use a small brush and vary the size and opacity until they look right. Eyes are particularly difficult to handle as too much overpainting will look wrong, while not enough will look too photographic.

Step 13 Check over the picture now for final corrections, tidy the edge if necessary and adjust saturation and contrast prior to printing. Compare this picture to the previous step-by-step tutorial, the choice of a chalk brush has given it a more obvious pastel finish while the first example in this chapter has a watercolor look.

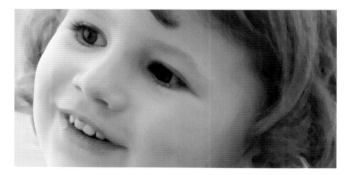

Figure 11.19 Painting the face with the Chalk brush.

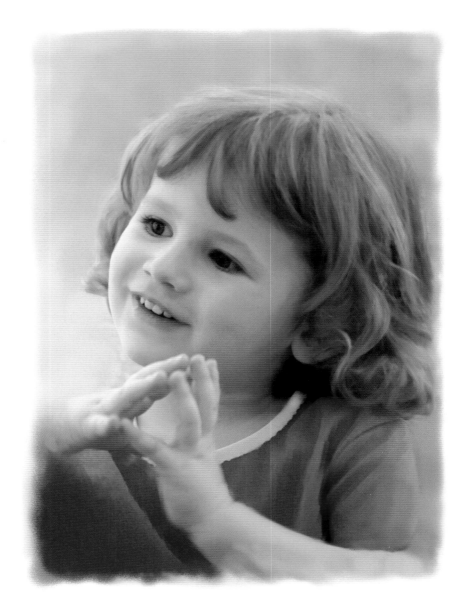

Figure 11.20 *Annabel.*

Making an inset mount

This rather charming picture was taken at a wedding, I loved the expressions on the faces of the girls but the background was rather distracting and needed to be simplified. This tutorial explains how to change the tones to a very pastel finish and make the inset mount.

Step 1 File> Open> DVD> Step-by-step files> '11 Wedding Children'.
Step 2 The first step is to remove all the distracting background, but before we do that the picture can be cropped to reduce the amount of work. Crop the left to the edge of the girls sleeve and the right side to where her arm goes up to the hand.
Step 3 Use the Rubber stamp tool (new in Painter X) hold down the Alt/Opt key and

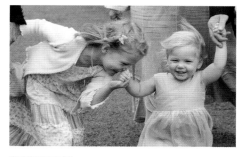
Figure 11.21 *Original photograph.*

click in the picture where the imagery is to be taken from, then paint. Use 100% for most of the background and reduce it to around 20% around the hair. It is not necessary to get it perfect as some imperfections will be hidden by later steps.
Step 4 File> Clone.
Step 5 In the Layers palette make a new empty layer.
Step 6 Effects> Fill with Clone Source.
Step 7 Effects> Tonal Control> Adjust Colors and reduce the Saturation to zero, this will turn the layer into monochrome. Figure 11.22 shows this stage completed.

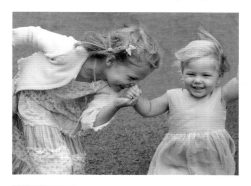
Figure 11.22 *Monochrome layer cloned.*

Step 8 Make a new empty layer and once again Fill with Clone Source.
Step 9 In the Layers palette change the layer composite method to Screen and reduce the opacity to 75%. This will gently overlay the original color.
Step 10 Effects> Focus> Super Soften and set 13.0 in the number box. This will add a very attractive gentle glow to the picture. This is a very useful technique for adding a softening layer to many pictures.

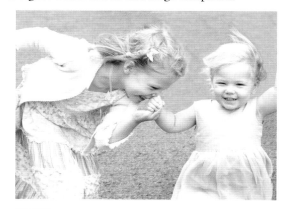
Figure 11.23 *Reduced color.*

Figure 11.24 *Super soften.*

Step 11 Make another new layer, choose white in the color picker and Effects> Fill> Current Color. Change the layer composite method to Soft Light, this will gently lighten the whole picture.

Step 12 Make another new layer and fill again with White. Leave the layer composite method on normal, this will hide all the picture.

Step 13 Create a layer mask (click the mask icon in the Layers palette).

Step 14 From the Brush Selector choose the Airbrush> Fine Tip Soft Airbrush Size 108, opacity 10%. Click on the mask to activate it and change the painting color to Black. Activate the Tracing paper briefly to see where you are painting then brush over the faces and clothing and gently remove the white from these areas. Reduce the layer opacity to around 50%. Figure 11.25 shows the picture at this point. As always with a layer mask if you want to reverse the effect simply choose White in the Color palette and paint in the mask again.

Step 15 Add another new layer and with the same Airbrush as before, size 160, opacity 10% and slowly paint with White around the edges creating a vignette. It is a good idea to paint outside of the picture and allow the brush strokes to gradually encroach into the image. If you don't already have your picture full screen, press Ctrl/Cmd + M to allow you to paint in this way. This creates the soft edges seen in Figure 11.26. You could use an oval selection to make the vignette but I prefer the flexibility available with this method. The layer opacity can be adjusted if necessary. This completes the first stage of the picture.

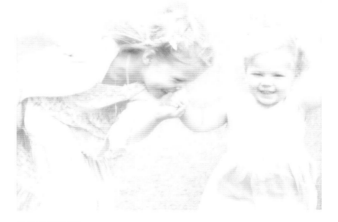

Figure 11.25 *Step 14 with white layers.*

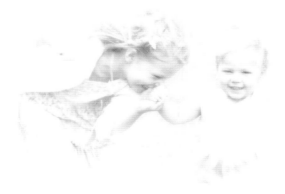

Figure 11.26 *White edges.*

The next step is to create the inset mount. You should have been saving the file at regular intervals and you need to save another copy at this point in its layered version. Then save it again using Save As and give it a new name so that you do not inadvertently overwrite it.

Step 16 Click on the Canvas layer then Select> Select All

Step 17 Edit> Copy.

Step 18 Edit> Paste in Place. This will paste a copy of the canvas at the top of the layer stack. Click on the copied layer and drag it down until it is under the other layers and on top of the original canvas.

Step 19 Highlight all the layers except the Canvas by holding down the Shift/Opt key and clicking on them in turn. All the layers except the canvas should have turned blue.

Step 20 Click on the layers palette menu and select Collapse. This will merge all the highlighted layers leaving the Canvas intact. Rename this layer 'Composite'.

Step 21 Select the Rectangular Selection tool from the Toolbox and make a selection which encloses the two children. This can be any size, you can see what I have chosen in the final version. This technique also works with circular or freehand selections.

Step 22 Select> Save selection and give it a name, this step is useful in case you lose the

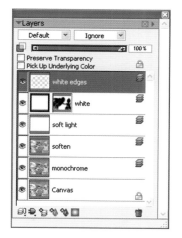

Figure 11.27 Layers palette at Step 15.

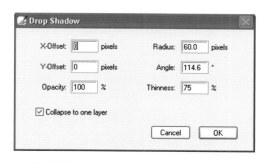

Figure 11.28 The drop shadow dialog box.

selection at any point. Make sure the single layer is highlighted before the next step.

Step 23 Edit > Copy then Edit> Paste in Place. This will copy the selection and put in onto a new layer.

Step 24 With the newly created layer active go to Effects> Objects> Create Drop Shadow. Use the settings in Figure 11.28 or experiment with your own. Tick the Collapse to one layer box. This layer can have the opacity reduced if the effect is too strong, I have reduced it to 68%.

Figure 11.29 Detail of background blending.

Step 25 Click on the layer above the Canvas and select the Blenders> Grainy Blender 30 change the size to 41, opacity 38%. Paint over all the background that is visible, this will add an attractive texture to the picture.

Step 26 Now to add back some of the original color to the central panel, go to Select> Load Selection and choose the previously saved selection.

Step 27 Click on the Canvas layer and Edit> Copy and Edit> Paste in Place to create a copy of the layer at the top of the stack. Reduce the layer opacity to about 30%.

Figure 11.30 Final layers.

Step 28 Return to the Canvas layer, reload the selection and copy and paste the image again to make another layer on top.

Step 29 Change the layer composite method to Screen and reduce the opacity to 20%.

Step 30 To give this a final blur, go to Effects> Focus> Soften and select Gaussian and level 40.00.

Step 31 The final layer stack is shown in Figure 11.30, turn the layers on and off to see what each one does, changing the opacity of any layer will alter the final appearance. I have made a final crop to tighten up the composition.

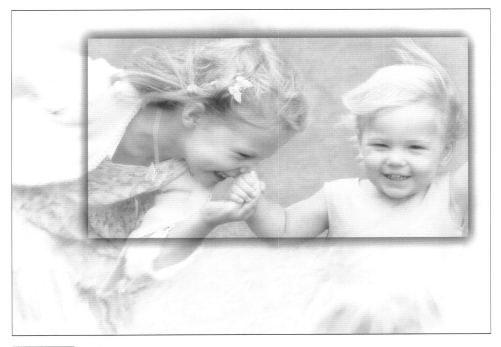

Figure 11.31 Final picture.

Portrait in Oils

The sun shining through the open door highlights this teenager filling in a waiting moment by playing with his electronic game. The warm tones will work well in Painter but there are background distractions, in this step by step you will see how easy it is to remove undesirable elements by simply painting over them.

Step 1 File> Open> DVD> Step-by-step files> '11 Griff'.

Step 2 File> Clone.

Step 3 Select the Oils> Round Camelhair brush, size 41, opacity 100%, Resat 17, Blend 100 and Feature 7.8. The Feature slide has been increased from the default and will result in a more textured finish.

Step 4 Click the Clone color option in the Colors palette.

Step 5 Start by painting the curtains, brush down the folds until the pattern has disappeared and the colors have blended well. The glass doors can be brushed straight down and the horizontal bars reintroduced by running a slightly smaller brush along them.

Figure 11.32 Original photograph.

Step 6 Continue to brush out all the background and the chair, follow the shape of the chair covers. This is a fairly large brush and you may well paint over the boys face or shirt, this can be corrected quite easily later.

Figure 11.33 Painting the background.

Step 7 Having completed the background and chair it is time to remove the distractions from the background. In order to really simplify the picture we will remove the two pictures, the stone fireplace on the left and also the black objects behind his left shoulder. I also feel that the patterned wallpaper will be better painted out.

Step 8 In the Colors palette untick the Clone color option so that the brush will paint color rather than clone. Holding the Alt/Opt key click on an area underneath the picture on the wall, wherever you click the brush will use that color to paint with.

Figure 11.34 *Overpainting the background.*

Step 9 Paint over the picture until it cannot be seen, then continue down the wall, hiding the texture of the wallpaper. Change the color frequently so that the wall has some small variations of color. Watch out for the shadow in the corner where the two back walls meet, this

should be retained to keep the perspective.

Step 10 Paint out the other wall, picture and stone chimney and the black area by his left shoulder.

Step 11 Change to the Soft Cloner brush and clean up the edges of the boy where previous brush strokes have spread too far.

Step 12 For his shirt use the Camelhair brush again making sure you are back in Clone color mode. We will use a smaller brush with less bristles. Size 16.9, opacity 60%, Feature 6.3. Follow the folds of the clothing but also paint the opposite way, this will give a subtle crosshatching effect. The lower opacity with overpainting several times will allow a more subtle finish to build up.

Step 13 When you get to the design and writing on the shirt go out of cloning and paint over the area, remember to sample the color many times and to keep the overall shape of the cloth. Logos and writing on clothes are difficult to handle, if you clone it very accurately it often looks false and if it is smeared then it can look dirty. In this case we will paint out all of the writing then bring back some parts (Figure 11.35).

Step 14 Turn on the Tracing paper and reduce the brush size to 2.9, enlarge the view on the screen and clone the bird design and the posts onto the shirt.

Figure 11.35 *Shirt detail.*

Step 15 We now come to the face and here we have another problem because Griff has freckles. We cannot paint every freckle but if we smooth out all the freckles then it will not reflect Griff as he appears. The solution in this case is to clone over the face using a medium opacity and a light touch on the pressure sensitive pen so that the sense of the freckles will still be there but in a diffused form. If you are using a mouse for this then reduce the opacity to around 30%.

Figure 11.36 Face detail.

Step 16 Reduce the brush size to 4.6, opacity 60% and the feature to 2.9. We could use a blender brush here but by altering some aspects of the brush but retaining the general characteristics the brush marks stay consistent with the rest of the picture. Paint over the face carefully, don't rush this stage as the face is the most important part of the picture. Under the chin and for some areas of the face a larger brush can be used, this will give a slightly more textural finish.

Step 17 Paint the arm and hands in the same way but use a larger brush, around 6.9 and use crosshatching again, pulling the light areas of the arms into the dark. Figure 11.37 shows this stage.

Figure 11.37 Arm detail.

Step 18 Paint the legs now, use a larger brush 15.6 and a lower opacity 28% and concentrate on where the light and dark areas come together. The reason for the light strokes pulling into the dark and vice versa are the Resat and Bleed settings. Try changing these and see how the brush characteristic changes.

Step 19 Paint his trousers with the same brush, remember that we do not need clean edges in this area, slightly smudge the edges to reduce their importance.

Step 20 If you have painted over any part of the Electronic game you can restore the clarity with the Soft Cloner, then use the Camelhair brush, size 5.4, opacity 65% and feature 2.0 to give back some texture.

Step 21 The hair can be done now, change to the Medium Bristle Oils brush, size 9.6, opacity 28% and click the clone color option in the Colors palette. The default bristles are too thick for this picture so go to the Window menu on the top bar, click on Brush Controls and then on Show Bristle. This will bring all the brush control palettes on screen and in the Bristle palette change the thickness to 29%.

Brush over the hair following the flow of the hair and allow the brush to streak out a little around the edge of the head so that the transition between the head and background looks good.

Step 22 The back of the head is very black so untick the clone color option and reduce the brush opacity to about 15%. Alt/Opt click a lighter part of the hair to select a suitable color and then lightly brush in some detail into the very dark areas. Don't fill all the dark areas in, just enough to provide some detail and texture. Figures 11.38 and 11.39 show details of the work on the hair.

Figure 11.38 Hair detail of original picture.

Figure 11.39 Hair detail of final picture.

Step 23 As always this is the time for a final check around the picture and finish any areas which are not satisfactory. Crop if necessary.

Step 24 To finish the picture it is often useful to add a texture overlay in order to emphasize the brush strokes. It is more flexible to apply this on a separate layer so that it can be reduced later if it proves to be too intrusive.

Step 25 Select> All, Edit> copy, then Edit> Paste in place will make a new layer with a copy of the Canvas.

Step 26 Effects> Surface Control> Apply Surface Texture. Select Image Luminance in the Using box, set the amount at around 30% and click OK.

Step 27 Check the result at 100% size on the screen. I reduced the overall layer opacity to 41% and still felt that the brush strokes on the face were too intrusive, so I made a layer mask and painted with gray in the mask which reduced the effect on the face but left the remainder intact.

Figure 11.40 Griff.

Figure 12.1 Dorette.
This portrait was painted primarily with the RealBristle Real Fan Soft brush with some additional blending and cloning with the Real Blender Round.

12

Portraits

n this chapter we look at various ways to make portraits of adults using a range of different brushes and techniques. As always when making portraits in Painter it is for you to decide just how painterly they should appear. The step-by-step examples included here are all fairly close to the original photographs, however, this is just a matter of choice and you can decide whether to make any one more impressionistic by increasing the amount the picture is painted over.

These techniques are intended to give you the basics and can be taken further depending on the result you think appropriate.

Towards the end of this chapter are included several ideas for handling pictures of weddings and how to take standard photographs and turn them into something that bit special for the bride and groom.

Figure 12.2 *The Showman.*

Portrait using Artists Oils

The brushes in the Artist Oils category have many interesting features that closely replicate the performance of a real brush. Two of the special features are that when sampling colors from an original to a clone copy the brushes will pick up multiple colors. Another speciality is that the brushes run out of paint fairly quickly as a real brush does. This portrait step by step takes advantage of both these features and in addition uses the Auto-Painting feature introduced in Painter X to start off the painting.

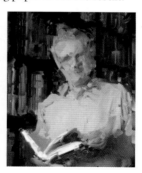

Figure 12.3 *Original photograph.*

Step 1 File> Open> DVD> Step-by-step files> '12 Bob'.
Step 2 File> Quick Clone to clear the clone copy.
Step 3 Select the Blender Bristle brush from the Artists Oils brush category. Brush size 60.0, opacity 100%. Click clone color in the Colors palette.

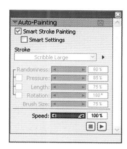

Figure 12.4 *Auto-Painting.*

Step 4 Window> Show Auto-Painting. Tick Smart Stroke Painting and leave Smart Settings unticked as in Figure 12.4.
Step 5 Click the arrow in the Auto-Painting palette to start the auto-clone. This will continue to paint until you either depress the stop button or click inside the picture. This will provide a roughly painted base for the picture. Let the program run until nearly all the picture has been painted, then stop the Auto-Painting and with the same brush paint out all the white areas that have been missed. Figure 12.5 shows the process, turn off the tracing paper to see the result.

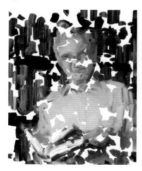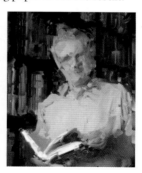

Figure 12.5 *The Auto-Painting process.*

Step 6 Reduce the brush size to 35 and untick the clone color option so that the brush is painting rather than cloning. Hold down the Alt/Opt key and click into the picture to sample a color to paint with. Start with a darkish brown color. The way that this brush works is that it will start painting with the selected color, run out of paint fairly quickly and then turn into a blender. We can use this feature by introducing a color onto the canvas and then continue

to paint with the brush and blend this new color gently into the existing colors. The intention in using this on the background is to darken it right down but still to retain traces of the original colors to add interest and subtlety. Change the sampled color regularly, making the bright areas darker and introducing touches of color into the black areas. Use the tracing paper to check where the figure is and paint over the edges to keep the background consistent. The figure will be cloned in again in a later step. Figure 12.6 shows the picture at this point.

Step 7 Reduce the brush size to 21 and the opacity to 40% and start work on the shirt. Keep the brush strokes short to retain a chunky feel to the painting use longer light strokes to smooth down the larger areas.

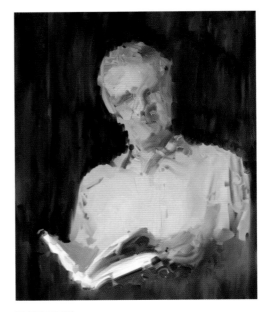

Figure 12.6 Step 6.

Step 8 We now turn to the face and have a change of brush. Art Pen Brushes> Soft Flat Oils will be much softer and allow more detail to return to the face. Use Clone Color and set the brush size to 40 and the opacity at 100%. Turn the tracing paper on and start painting the face. The speed with which you use this brush is critical, too fast and the face will be completely blurred, too slow and the detail will be too clear. Brush slowly, just enough to see some detail and make short brush strokes. Paint over all the face and hair.

Step 9 If you have made the face too clear, reduce the opacity to 30% and make short fast brush strokes over the area, this will diffuse the area. Try making rapid dabs with the brush, this adds a texture which can be softened again by using the same brush.

Step 10 Reduce the brush size to 10 and 24% opacity and work over any rough areas that need smoothing out.

Step 11 Paint over the hair with the same brush, take it out of cloning mode and paint

directly with color to improve texture, Alt/Opt Click in the picture to sample colors. Darker parts of the hair will benefit from this application of lighter color and texture.

Step 12 Check over the picture and make any final adjustments.

Figure 12.7 Shirt detail.

Step 13 Make a new layer and Select> All, Edit> Copy, Edit> Paste in Place to make a copy of the Canvas.

Step 14 Effects> Tonal Controls> Apply Surface Texture. Select Image in the Using box and 25% as the Amount.

Step 15 Adjust the layer opacity to suit the picture, I suggest around 35% to add a light texture to the brush strokes but not to be intrusive. I have cropped the picture slightly to tighten up the composition and also to remove some of the hand under the book which did not look very satisfactory. This completes the portrait of Bob.

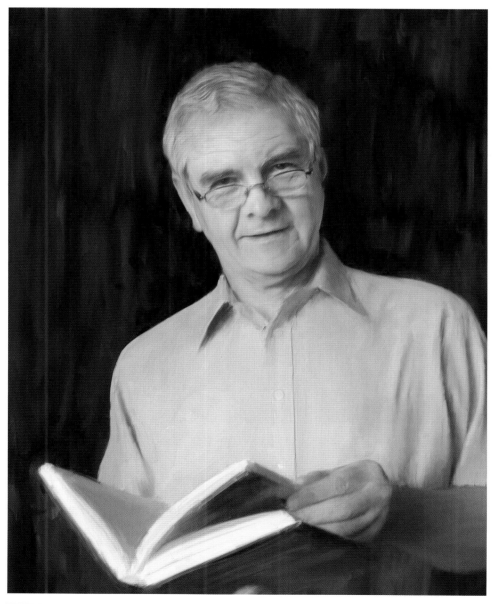

Figure 12.8 Bob.

Portrait using Pastels

Pastel brushes are excellent for making a picture from this colorful and joyous photograph. These two delightful ladies were enjoying a visit to a jazz music festival, a lifelong love and I captured them in all their colorful clothing and beneath a traditional jazz umbrella. In the painterly version we will retain the strong colors and vivacity of the scene.

Step 1 File> Open> DVD> Step-by-step files> '12 Jazz Ladies'.
Step 2 File> Clone.
Step 3 Select the Pastels> Round Soft Pastel 40, brush size 40, opacity 100%.
Step 4 Click the clone color option in the Colors palette.
Step 5 Select the Sandy Pastel paper in the Papers palette.
Step 6 Paint over the picture ensuring that

Figure 12.9 Original photograph.

all the photograph is covered. Follow the general direction of the colors so that the picture still retains the overall shapes. The aim is to produce an underpainting upon which more detail

Figure 12.10 Step 6 Under-painting.

can be cloned in with a smaller brush. Paint over the faces as well.
Step 7 Before we start adding detail it is good to deal with any problem areas such as the dark corner bottom right. Take the brush out of cloning mode by un-ticking the Clone color option. Sample the painting color by holding the Alt/Opt key and clicking in the picture, in this case one of the gray colors next to the very dark corner. Paint over the dark corner, changing the color at regular intervals so that the result is a blend of colors that matches the color and texture of the rest of the picture. Figure 12.10 shows the picture at this stage.
Step 8 Reduce the brush size to 20 and the opacity to around 50% and paint over any other areas that look too dark.
Step 9 Click the Clone color option again, reduce the brush size to 7.5, opacity 100% and paint down the umbrella handle. Go over this again with brush size 20 to blend it better with the background.

Step 10 Reduce the brush size to 13.0 and paint more detail into the hat and the hair of both ladies, this size brush will give a softer finish.

Step 11 Using brush size 10 with 100% opacity paint over the colorful red and purple feathers bring out more detail and highlights. Use the Tracing paper to check where the areas of contrast are greatest and paint over these.

Figure 12.11 Hair at Step 10.

Step 12 Change the brush size to 10 to paint the faces and gently emphasize the detail. Repeated strokes in one direction will smooth out the textures.

Step 13 Reduce the brush size to about 3.4 to paint the eyes and using the Tracing Paper carefully paint following the light and dark areas. This size brush may leave too clear a mark so you can paint over the same areas using brush size 8.9 which will soften the appearance.

Step 14 To bring back more clarity in the eyes switch to the soft cloner brush and restore detail from the original then lightly brush over with the pastel brush to blend with the rest of the picture. Do the same with the teeth. Figure 12.12 shows the faces at this stage.

Step 15 Having completed most of the picture it is time to add the important finishing touches to improve the detail and textures of the picture. The hair needs better definition so change to the Square X-Soft Pastel 30, size 3.4, opacity 27% and clone in the hair to add more texture.

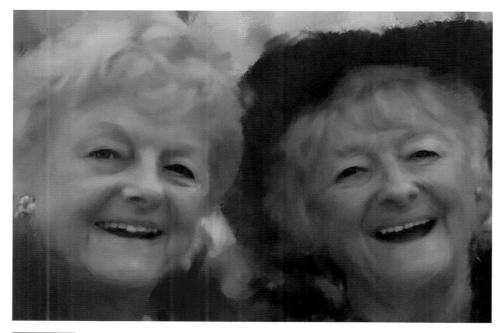

Figure 12.12 Faces at Step 14.

Step 16 If the result is too harsh, change the Resat to 0 and the Bleed to 100%, this changes the brush to a blender which will soften the brush strokes where necessary.

Step 17 Change to the Artist Pastel Chalk and polish any rough areas off the face. This also works well as a blender and is excellent on skin. Use a size 10 brush with 11% opacity.

Figure 12.13 Hair detail added using Square X-Soft.

Step 18 Paint out the top left corner with suitable colors to avoid a change of color there.

Step 19 Add a surface texture if required as in the previous example and make any final tonal adjustments.

This completes this step-by-step example, as you will have seen the Pastel brushes are very versatile and particularly effective with pictures of people.

Figure 12.14 Jazz Ladies.

Smart Stroke Brushes

Smart Stroke Brushes are a new category of brushes introduced in Painter X, they are designed for use in cloning pictures and give a really beautiful texture. In this step-by-step example several brushes are used to complete the picture.

Step 1 File> Open> DVD> Step-by-step files> '12 Dorette'.

Step 2 File> Clone.

Step 3 From the Smart Stroke Brushes category select the Acrylics Captured Bristle, size 20, opacity 35%, resat 60% and bleed 38%.

Step 4 Carefully paint over the face and remove all photographic detail. If you are using a mouse then you will need to reduce the opacity to about 10–15%.

Step 5 Reduce the brush size to paint around the eyes and when the face is finished, reduce the opacity to 15% and smooth any areas which are too rough. Don't take all the texture out however and make it too smooth.

Figure 12.15 Original photograph.

Step 6 The next step is to paint the hair and in order to get more texture in this brush we will make some adjustments to the brush settings. Go to Window> Brush Controls> Show Bristle and change both the Clumpiness and Hair Scale sliders to 100%, this will make the brush show the bristles more clearly.

Step 7 Paint the hair following the flow of the curls.

Step 8 Your hair texture may still be a little too smooth, if so use the Blenders> Water Rake brush size 4.6, opacity 7% and lightly brush over some of the hair to give more feeling of brush strokes.

Step 9 The hair has lost many of the original highlights in this process so we need to add more. Change the brush to Sharp Chalk size 5.1, opacity 80% and after choosing an almost white color in the Colors palette, brush on highlights as in Figure 12.16. This will look strange until they are blended in the next step.

Figure 12.16 Adding highlights to the hair.

Figure 12.17 *Hair highlights blended.*

Step 10 Using the Blenders> Grainy Blender 30, size 25.3, opacity 38%, blend all the added white marks until the individual strokes are invisible and they appear as a general brightening of the hair. Figure 12.17 shows this in more detail.

Step 11 Return to the original Smart Stroke brush and paint the neck and where the blouse is open. Dorette is wearing a necklace and it is preferable to paint and blend it out. Use the Smart Stroke brush first, then untick the clone color option and use it to paint out the shadows. Check the original picture to see where the shadows lie.

It is often necessary to check the original for details and a quick way of doing this is to use the keyboard shortcut of Ctrl/Cmd and Tab to switch between the two active documents. If you have the clone document magnified on screen enlarge the original to the same magnification to make comparisons easier.

Step 11 Next step is to paint her blouse and for this we can use another new brush from Painter X. Go to the RealBristle brush category and choose Real Oils Soft Wet, size 32, opacity 100%. Figures 12.18 and 12.19 show before and after painting with this brush, see how it has added a beautiful brush texture to the cloth.

The finished picture is shown in Figure 12.20, this is after some tonal adjustments and sharpening.

Figure 12.18 *Before adding texture.*

Figure 12.19 *Texture on blouse.*

Figure 12.20 *Final picture.*

Figure 12.21 shows the picture after some radical alterations. A tight crop improved the composition and a new background was added and some darkening of the corners. The background was painted using the colors of the final picture which was blurred then inserted using layer masks.

Figure 12.21 Final picture after cropping and new background added.

Design ideas for portraits

Painter can be valuable in creating design concepts as well as making cloned pictures. In this example the original photograph will be overlaid against a painted backdrop.

Step 1 File> Open> DVD> Step-by-step files> '12 Donna'.
Step 2 Open the Layers palette and make a copy of the canvas layer, Select> All, Edit> Copy, Edit> Paste in Place.
Step 3 Activate the rectangular selection tool in the toolbox and draw a selection to include the head of the model.
Step 4 With the new layer active make a copy (Edit> Copy, Edit> Paste in Place) this will place a copy of the selected area on a new layer above.

Figure 12.22 **Original photograph.**

Step 5 Hide the top layer by clicking the eye icon and activate the layer below.
Step 6 We need to lighten and desaturate this layer, go to Effects> Tonal Controls> Adjust Colors and adjust the sliders to Saturation −55 and Value +40.
Step 7 Blenders> Grainy Blender 30 make the size 85 and opacity 100%.
Step 8 Change the paper to Sandy Pastel paper.
Step 9 Blend the whole layer so that the picture is very well diffused. Turn the top layer on to see the effect and to make further blending

Figure 12.23 **Selection.**

adjustments. Figure 12.24 shows this stage.
Step 10 Select the overlaid picture again, use the layer adjuster tool to adjust the selection if necessary.
Step 11 Select> Modify> Border and enter four pixels as the size. Make the painting color white and then Effects> Fill with the current color.
Step 12 To make a drop shadow go to Effects> Objects> Drop Shadow. Change the opacity to 80% and the Radius to 30 pixels, leave the offsets at 10, angle at 114.6 and thinness at 45%. Tick the Collapse to one layer option.
Step 13 Activate the middle layer again and use Adjust Colors again to lighten and desaturate some more. I used −24 Saturation and +46 Value
Step 14 Finally crop the picture. The final image is shown in Figure 12.25.

Figure 12.24 **Step 9.**

Figure 12.25 *Final picture.*

Moody portrait

This example starts with a studio portrait and transforms it to a dark and moody low light picture. The process is simple and easy to follow:

Step 1 File> Open> DVD> Step-by-step files> '12 Studio portrait'.

Step 2 File> Clone. Do not clear the picture.

Step 3 Using the Eyedropper, click on a point behind her head to sample the color which is a dark red. Effects> Fill with the current color.

Step 4 Select Cloners> Soft Cloner brush, size 72.1, and opacity 2%. Lightly brush in the face, with this opacity the face will just be visible.

Step 5 Reduce the opacity to 1% and brush in the rest of the body.

Step 6 Increase the opacity to around 5% and go over the face again to make this brighter, Figure 12.27 shows the picture at this stage.

To finish off the picture I added a surface texture called Artists Canvas, this process is covered in detail in Chapter 6, Applying surface textures.

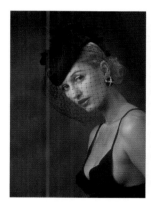

Figure 12.26 Original photograph.

Figure 12.27 Cloned copy.

Figure 12.28 Low light portrait.

Weddings

Weddings are a staple for many professional photographers and one way in which to sell a premium product is to offer a painted version of selected wedding portraits. In this chapter are some techniques which can achieve this using Painter. In all cases the emphasis is on being able to achieve the result as quickly as possible and without any knowledge of painting traditional painting techniques.

This first example takes a head and shoulders color portrait and turns it into a hand colored delicate image. The techniques are all done using Painter but some of the steps could be achieved in Photoshop if you are more conversant with that program and the painterly steps completed in Painter.

Figure 12.29 Original photograph.

Step 1 File> Open> DVD> Step-by-step files> '12 The Kiss'.
Step 2 Make a copy of the Canvas. Select> All, Edit> Copy, Edit> Paste in Place.
Step 3 Effects> Tonal Controls> Adjust Colors and move the Saturation slider to the far left, this will change the layer to monochrome.
Step 4 File> Clone, this will make a clone of the mono layer only.
Step 5 The background is messy so we need to even it out and before blending you should add some paint dabs. Select the Chalk> Variable Width Chalk brush at the default settings. Paint light onto dark areas and light onto dark. Figure 12.30 shows the mess at this stage!

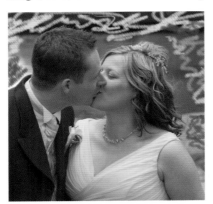

Figure 12.30 Painting in Step 4.

Step 6 Select the Blenders> Grainy Blender 30 size 84, opacity 100% and completely blend out the background. The dabs of paint you added in the last step have evened out the tones but left some variation in the background.
Step 7 Reduce the brush opacity to 10% and brush lightly over the figures following the general direction of the clothes. This will remove the last of the photographic finish. Figure 12.31 shows this stage.

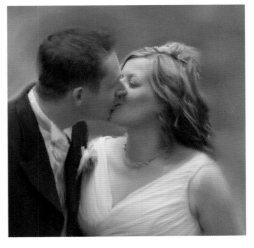

Figure 12.31 Background blended.

Step 8 Change the brush to Smart Stroke Brushes> Captured Bristle size 11, opacity 15%, resat 0 and bleed 38%. Blend the figures now, concentrate on the edges where the finish is rough, the roughness helps this blender to work better. Remember that as with all blenders the brush will drag one color into another so avoid dragging black areas into white as they will look dirty. Use this same brush at a larger size to clean up any rough areas in the background or to soften areas.

Step 9 Make a new empty layer and Fill> Clone Source, this will put the original color picture on top of the layer stack.

Figure 12.32 Blending detail with the Smart Stroke brush.

Step 10 Change the Layer composite method to Color.

Step 11 Add a layer mask to this layer and click on it to make sure it is active. Use the Tinting> Basic Round size 20, opacity 13% with black paint and paint out all the background leaving the figures in color. Use a smaller brush to clean up edges around the figures. Figure 12.33 shows this stage.

Step 12 Reduce the layer opacity to zero then gradually bring it up until the color is visible but subtle, I made the opacity 35%.

Step 13 Finally make any last minute adjustments and if required crop the picture as in Figure 12.34.

As with many tasks the first time that you carry out a painting like this it will take some time but will become much quicker with familiarity of the techniques.

Figure 12.33 Adding back in the original color.

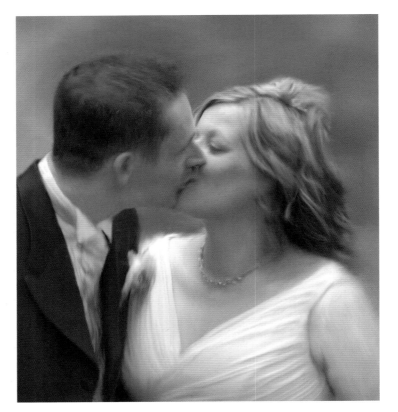

Figure 12.34 *Wedding couple.*

Bride in white

The intention with this example is to show how a simple picture of a bride can be represented in several ways to create pictures which are romantic yet that bit different.

Prior to starting this step-by-step example I have painted out the background as it was not very suitable. This can be done easily by using a brush with white paint on a separate layer on top of the canvas.

Step 1 File> Open> DVD> Step-by-step files> '12 Rebecca'.
Step 2 File> Clone.
Step 3 Select the Blenders> Grainy Blender 30, size 30, opacity 38%. This is used as a blender not as a cloner.
Step 4 In the Papers palette change the paper to Sandy Pastel paper.

Figure 12.35 *Original photograph.*

Step 5 I will mention here once again the convenience of using custom palettes for the brushes you are going to use. This is very useful if you intend to use the same process again on another picture. There is more information on making and saving palettes in Chapter 1. For now, click on the brush variant icon on the brush selector bar and drag it out onto the desktop, this will instantly make a custom palette. As you use the different brushes in this step by step, you can add them to this palette by dragging the brush icons to your new custom palette.

Step 6 Enlarge the picture on screen to 100% and start painting the dress. Paint the top first and paint down the dress, this will smooth out the creases and remove the detail. Figures 12.36 and 12.37 show the difference.

Figure 12.36 Original. *Figure 12.37* After blending.

Step 7 Continue down the dress painting downwards but if you need to remove more detail paint across the line and then blend down again, this breaks up the picture texture. Do this on the outside edges of the dress so that it appears to blend into the background.

Step 8 At the bottom of the dress the blender will drag out the edges beautifully, but do it gently so that the brush strokes show a delicate texture rather than a rough edge. See Figures 12.38 and 12.39 to see the details. Paint over the floor at the same time, blending out all the detail.

Step 9 Change the brush now to the Blenders> Soft Blender Stump 10, size 13, opacity 30%. Drag this brush to your Custom palette and position the icon to the right of the existing one, the icon is the same as the first.

Step 10 Very gently run over the edges of the bottom of the dress, this will just soften the edges a little.

Figure 12.38 Original.

Figure 12.39 After blending.

Step 11 Turning now to the face, use the Soft Blender Stump, size 8, opacity 25% and blend the face. As always take care not to drag darker colors into light areas, blend out the detail leaving a soft looking skin. Continue down the neck and arms using a larger brush, size 15.0 and 50% opacity.

Step 12 Blend the hand including the ring but then change to the Soft Cloner and bring the ring back so that is clear. Drag the Soft Cloner to your custom palette as you will need to use it later on.

Step 13 To paint the flowers change to the Pastels> Artist Pastel Chalk, size 5, opacity 100% and make small circular painting strokes to create an attractive texture to the petals and leaves. Add this brush to your Custom palette.

Step 14 We now need to add the finishing details, use the Soft Cloner, size 2, opacity 24% to add the suggestion of her necklace. Turn on the tracing paper to help identify where the chain lies. If it is too clear you can diffuse it with the Soft Blender Stump at a low opacity. Do the same process for the earrings and a few of the crystals at the top of the dress.

This completes the picture which is shown in Figure 12.40.

Figure 12.40 Rebecca.

Figure 12.41 This version has been cropped, a white layer placed on top of the canvas in Color Layer Composite Method.

Figure 12.42 Dress detail 1.
Another simple picture created from the back of the dress. This was blended using the Soft Blender Stump then lightened by added layers filled with white and in Soft Light composite method.

Figure 12.43 *Dress detail 2.*
This version has been softened with the Soft Blender Stump and then cropped to isolate the single shoe peeping form the beautiful dress.

Figure 13.1 Mountain impressions
The original picture was created with the new Auto-Painting palette which is described in Chapter 9, the design technique is very similar to that shown in Chapter 11 for the picture of two young children.

13

Special effects

T he heart of Painter is in the vast range of brushes and art materials, which have been explored in earlier chapters, but the program also has a range of special effects and this chapter explores a selection of them.

Special effects in Painter come in many forms, some are in the Surface Control menu while others come from the wonderfully named Esoterica section. Yet more are available from the Layers palette in the form of Dynamic Plug-in layers.

One of the most fascinating effects in this section is Kaleidoscope, this creates wonderful patterns as the viewer is moved over the picture, so easy to make and enjoy.

What is common to them all is the ability to make photographs look very different indeed.

Figure 13.2 Cable.

Glass Distortion

Glass Distortion will create distortions of the original photograph based on a huge variety of sources. The effect can be applied directly to a photograph, however it is better to use a clone copy as it gives you the option of bringing back imagery from the original and blending with the distorted image.

Step 1 File> Open> DVD> Step-by-step files> '13 Autumn Leaves'.

Step 2 File> Clone.

Step 3 Effects> Focus> Glass Distortion.

In the Glass Distortion dialog box shown in Figure 13.3, the first option box is Using and the choice of where the

Figure 13.3 Glass Distortion dialog box.

texture comes from is identical to the Apply Surface Textures dialog box covered in Chapter 6. The choices are Paper, three-dimensional Brush Strokes, Image Luminance and Original Luminance. As the Paper option is based on the huge range of papers supplied with Painter the choice is very wide indeed.

Map options are Refraction, Vector and Angle Displacement. The last two work in conjunction with Image Luminance in the Using box, which will result in powerful distortions of the image, you may have to increase the Amount to see the difference. Softness smooths the distortions.

Amount increases the overall effect.

Variation distorts the pattern into less recognizable patterns.

Direction works in conjunction with the Angle and Vector Displacement options.

Figure 13.4 Using: Paper – Wavey Threads.

Step 4 Select a paper of your choice, the one used here is Wavey Threads from the Textile Textures paper library. If you have forgotten how to load extra paper libraries check back in Chapter 5. Return to the Glass Distortion box and set the Using box as Paper, Softness 3.5, Map Refraction, Amount −0.54, Variation 3.0. The quality box stays on Good in all the examples and the Direction 266. Figure 13.4 shows the result of these settings.

Two other variations are shown in Figures 13.5 and 13.6.

Figure 13.5 Using: Paper – Angle Weave.

Figure 13.6 Using: Image Luminance.

Sketch

The Sketch effect reduces a color photograph to a line drawing. It can be used on its own or in many cases the effect can be mixed back into the original photograph to give a delicate colored effect.

Step 1 File> Open> DVD> Step-by-step files> '13 Steam Engine'.
Step 2 File> Clone.
Step 3 Make a copy of the Canvas on which to apply the Sketch effect. (Select All then hold down the Alt/Opt key and click in the image with the layer adjuster tool).
Step 4 Effects> Surface Control> Sketch. Enter the following settings, Sensitivity 3.56, Smoothing 1.63, Grain 0.00, Threshold High 60%, Threshold Low 100%.

Figure 13.7 Original photograph.

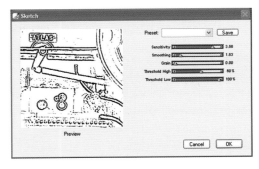

Figure 13.8 The Sketch dialog box.

Figure 13.19 shows the Sketch effect applied on the Steam Engine layer. The amount of noise in the background depends largely on the Threshold sliders, how you balance those two and the Smoothness slider will define the amount of detail in the sketch.

The Sketch effect as applied on this picture does not amount to much but it provides a starting point to make a more satisfying picture.

Step 5 Change the Layer Composite Method of the Sketch layer to Overlay, this will change the picture considerably, lightening and putting edge lines over the original.

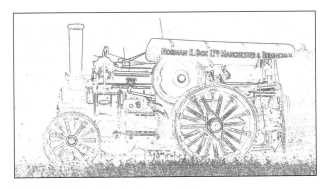

Figure 13.9 The Sketch effect applied.

Step 6 Make a duplicate layer via the Layers palette menu. Figure 13.10 shows how this extra layer, which is also in Overlay method, strengthens the effect. Reduce the layer to about 85% to bring back a little more color.

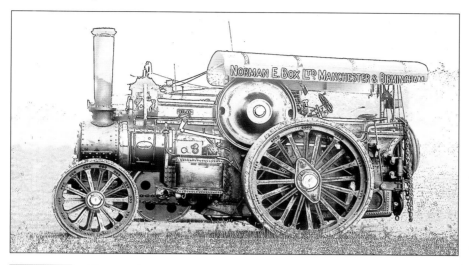

Figure 13.10 *Adding an additional layer in Overlay composite method.*

Step 7 Another change in the layers palette will create an alternative version. Duplicate the Sketch layer again, move it to the top of the layer stack and change the layer composite method to Pseudocolor. Adjust the layer opacity to around 75% to reduce the intensity of the blue. Figure 13.11 shows this version.

One point to note regarding the last step, if you are saving the picture in Photoshop file format, the Pseudocolor layer composite method will not be recognized and the picture will completely change color. The way around this is to drop the layers prior to saving in PSD format.

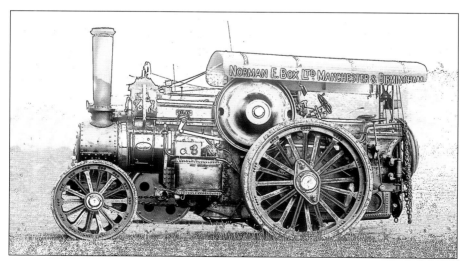

Figure 13.11 *Adding another layer using Pseudocolor as the composite method.*

Woodcut

Woodcut, as its name suggests, creates a very excellent woodcut effect from an original photograph. It initially creates a black and white result but can be colored quite easily. The steam traction engine picture used for the Sketch effect is also the starting point for this exercise.

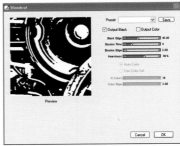

Step 1 File> Open> DVD> Step-by-step files> '13 Steam Engine'.

Step 2 File> Clone.

Step 3 Effects> Surface Control> Woodcut.
The settings for this are as shown in Figure 13.15.
Black Edge 40.00, Erosion Time 4, Erosion Edge 2.00, Heaviness 60%.
Output Black should be ticked but not the Output Color. This will produce the black and white picture as shown in Figure 13.13.

Figure 13.12 The Woodcut dialog box.

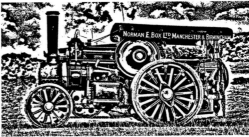

Step 4 The woodcut effect will now be combined with the original picture to create a colored version in the same way as we did with the Sketch effect. Change the layer composite method of the Woodcut layer to Overlay. Figure 13.14 is the result.

Figure 13.13 Using the Output Black option.

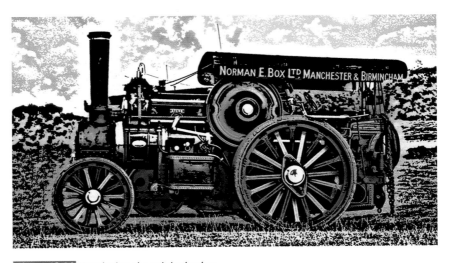

Figure 13.14 Overlaying the original colors.

Step 5 Colored versions are also available from within the Woodcut dialog box. Make a new clone copy to start afresh.

Step 6 Effects> Surface Control> Woodcut. The settings for this are the same as last time, Black Edge 40.00, Erosion Time 4, Erosion Edge 2.00, Heaviness 60%, but tick Output Color as well as Output Black. Ticking this option reveals a further block of controls in the palette.

With Auto Color ticked the woodcut will be colored using the selection of colors shown under the preview window. The number of colors to be used can be altered by using the N Colors slider, usually it is more effective to use a limited range of colors, but try moving the slider to see the difference. Instead of using the default set of auto colors, you can also choose another color set to base the colors on. Tick the Use Color Set option, open the Color sets palette and load a color set.

The example shown in Figure 13.15 has used the grayscale color set on one layer, the Flesh Tones on the layer above and the layer composite method of the top layer changed to Luminosity. This has produced a monochrome version that is very different to the one shown in Figure 13.13.

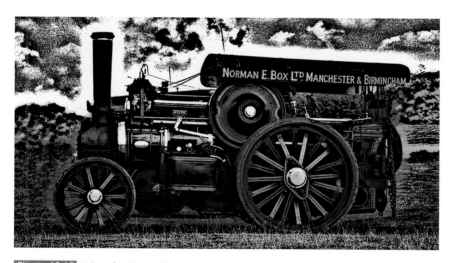

Figure 13.15 *Using the Grayscale and the Flesh Tones color set*

Liquid Lens

Liquid Lens is definitely one of the fun effects in Painter, it does what it says, it turns your precious photograph into liquid and then distorts the picture by using the various controls.

Open a picture and bring the Layers palette on screen. At the bottom of the palette click the second icon from the left which has the shape of a plug and in the drop down menu which appears select Liquid Lens.

The icons in the dialog box distort in particular ways when painted in the picture.

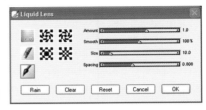

Figure 13.16 Liquid Lens dialog box.

The first icon top left simulates the effect of a droplet falling into water, select the icon then click and drag in the picture to increase the distortion.

The two icons top right twist the image to the right or left.

The two icons immediately below these will make the picture bulge or contract.

The eraser icon removes any distortion, returning the picture back to its original state.

The brush icon will distort as the brush is dragged over the picture, this is like the distortion brushes found in the brush selector.

The sliders modify the options and will alter the amount of the distortion, the smoothness, the brush size and how the dabs are spaced.

The four buttons along the bottom of the palette will clear the picture of distortion, reset the sliders to their default setting and OK accepts the effect. The less obvious button is called Rain, which deposits droplets of water on top of your picture, blurring it severely.

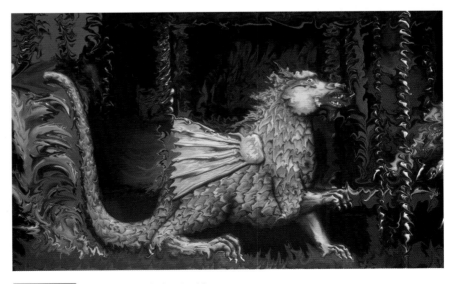

Figure 13.17 Having fun with the Liquid Lens.

Marbling

Marbling is a traditional technique which involves mixing colored dyes and using combs to pull through the dyes which creates the distinctive marbling pattern. Painter recreates this effect with the Apply Marbling command.

Step 1 File> Open> DVD> Step-by-step files> '13 Topsy'.
Step 2 Select> All, Edit> Copy. This is ready for the next step.
Step 3 Effects> Esoterica> Blobs. This step will add blobs to the picture which will aid the distribution of colors within the marbling pattern. Figure 13.19 shows the dialog box, alter the settings to: Number of blobs 60, Minimum size 50.0, Maximum size 100.0. Change the Fill Blobs With option to Paste Buffer, which will use the selection that was made in **Step 2**. Click OK and the poor cat will be covered with blobs as in Figure 13.18.
Step 4 Effects> Esoterica> Apply Marbling. Apply the following setting. (Figure 13.20) Spacing 0.17, Offset 0.00, Waviness 0.50, Wavelength 0.25, Phase 0.00, Pull 0.50, Quality 4.00.
Make the Direction Left to Right, click OK.
Step 5 Repeat the step with the same settings just changing the direction to Right to Left.
Figure 13.21 shows the marbling pattern after being cropped. As you can see the original picture has completely disappeared and replaced by a marbled design.

Figure 13.18 Blobs applied to the picture.

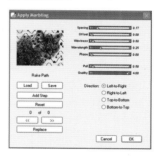
Figure 13.19 Creating Blobs.

Figure 13.20 Marbling dialog box.

In addition to making patterns by using the controls in the dialog box there are also some pre-set marbling patterns within the Painter program.

In the dialog box click on Load and choose from the menu that appears. Some of the pre-set marbling patterns are shown below.

Figure 13.21 Marbling pattern from the picture above.

Figure 13.22 Blue Pattern pre-set.

Figure 13.23 Gladioli pre-set.

Distress

Distress is in the Effects> Surface Control menu and can make powerful graphic statements from your photographs. Most of the detail will be etched away and replaced with heavy grain. A clear strong picture is needed to get the best out of this effect.

Step 1 File> Open> DVD> Step-by-step files> '13 Distressed'.

Step 2 Effects> Surface Control> Distress, use the following settings: Edge Size 63.47, Edge Amount 57%, Smoothing 1.96, Variance 128%, Threshold 50%.

Step 3 Select Grain in the Using drop down menu and Basic paper as the paper texture.

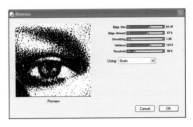

Figure 13.24 *Distress dialog box.*

Step 4 Click OK, then go to Edit> Fade and move the slider to 50%, this will fade the effect and allow some of the original color to show through.

The sliders interact with each other to get a balance of detail and overall exposure. Some of the sliders require very small movements to make a dramatic difference.

As in many other effects dialog boxes Distress can be based on either the current paper texture or the Luminance of the picture.

The sliders interact with each other and control the size and amount of the edges, the smoothness of the image and the amount of grain added.

Threshold alters the amount of black and has a very powerful effect on the result. Remember that for fine adjustments of all sliders, click the small arrows at each end. The settings above will give the result seen in Figure 13.25.

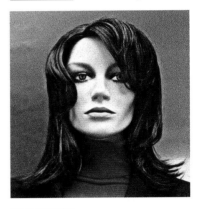

Figure 13.25 *Distressed.*

Using a different source image the result can be quite different as seen in Figures 13.26 and 13.27.

Figure 13.26 used the Image Luminance source while Figure 13.27 used the Paper source. After Distress had been applied, the picture had the effect reduced by 50% in the Edit> Fade command. This both reduces the Distress effect and brought back some of the original detail and color.

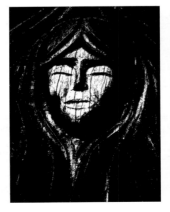

Figure 13.26 *Image Luminance.*

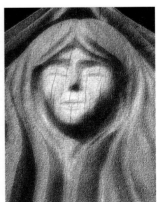

Figure 13.27 *Paper source.*

Apply Screen

Apply Screen is another technique which creates a strong graphic appearance. The original luminance values are split into three tones which can be set in the dialog box and will add new colors to the picture.

Step 1 File> Open> DVD> Step-by-step files> '13 Sunset'.

Step 2 Effects> Surface Control> Apply Screen.

Step 3 Enter the following settings in the dialog box. Using: Image Luminance, Threshold 1: 92%, Threshold 2: 52%.

Click the left colored square and a color picker will appear, select the first color with which to tone the picture and repeat the process for the other two colors. If you want to use the same color but in different densities, choose a dark color for the first square then move the vertical slider on the right to select the next two colors.

The Threshold 2 slider controls how much of the first color will be shown in the image while the Threshold 1

Figure 13.28 *Original photograph.*

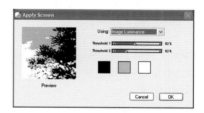

Figure 13.29 *The Apply Screen dialog box.*

slider controls the amount of the second and third colors.

Apply Screen can be applied in many different ways and will benefit from some experimentation to find the most useful settings for any particular picture. The examples on this page show other interpretations using this effect.

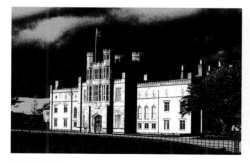

Figure 13.30 *The Apply Screen effect.*

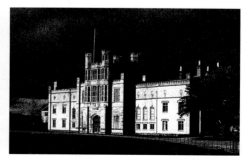

Figure 13.31 *Using: Image Luminance, Threshold 1: 133, Threshold 2: 67.*

Figure 13.32 *Using: Paper, Threshold 1: 116, Threshold 2: 94, Paper: Charcoal.*

Burn

Burn is a Dynamic Plug-in layer, which means that the layer can be re-activated at a later date and the settings changed.

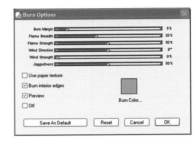

Step 1 File> Open> DVD> Step-by-step files> '13 Text montage'

Step 2 The burn effect will be based on a selection, so Select> All to burn the edges of the whole picture.

Step 3 Bring the Layers palette on screen and click the second icon from the left, with the shape of a plug. In the drop down menu select Burn.

Step 4 When the dialog box appears (it can take a while) leave the settings unchanged and click OK.

Step 5 A new dynamic plug-in layer will have been created, hide the Canvas layer to see the burnt

Figure 13.34 Burning the edges.

edges. The sliders can be changed to give differing colors and to alter the edge effect. Figures 13.34 and 13.35 show different settings on two photographs.

Figure 13.35 Using an irregular selection and stronger settings.

Bevel World

Bevel World is another Dynamic Plug-in and can be used to make bevels of all types, whether simply to add a border to a picture, or to make a creative montage.

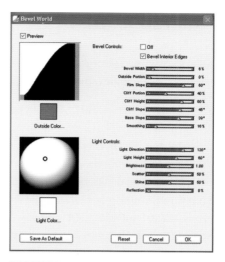

Step 1 File> Open> DVD> Step-by-step files> '13 Donna 4'.

Step 2 The bevel effect will be based on a selection, so Select> All to add a bevel to the whole picture.

Step 3 Bring the Layers palette on screen and click the second icon from the left, with the shape of a plug. In the drop down menu select Bevel World.

Figure 13.36 *Bevel World dialog box.*

Step 4 When the dialog box appears change the settings to see the hundreds of combinations available.

In Figure 13.37 the original has been brought back on top to enhance the contrast.

Figure 13.37 *A picture with a bevel applied.*

Kaleidoscope

Kaleidoscopic images are great fun and with Painter are incredibly easy to make. Try this out with the photograph on the DVD or try one of your own, the steps are below.

Step 1 File> Open> DVD> Step-by-step files> '13 Rusty metal'.

Step 2 Bring the Layers palette on screen and click the second icon from the left, with the shape of a plug. In the drop down menu select Kaleidoscope.

Step 3 In the dialog box change the size to 300 pixels, the default size is 100 which is too small for this picture.

Figure 13.38 Kaleidoscope dialog box.

Step 4 Click on the kaleidoscope and move it around the picture, the pattern changes constantly as it is moved.

The effect works best on photographs with strong colors and good contrast, although subtle patterns can also work very well.

Every time the kaleidoscope icon is clicked a new layer is made, this means that you can apply a kaleidoscope over top of another kaleidoscope thereby making even more complex designs. The patterns on these two pages have been created using photographs of rust, a building and a bark pattern.

Figure 13.39 Kaleidoscopic designs.

Figure 13.39 (Continued)

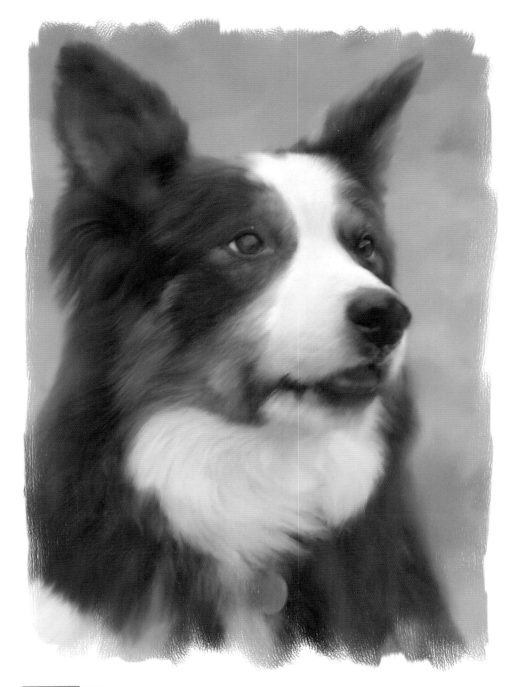

Figure 14.1 Collie.

14

Printing and presentation

The first part of this chapter looks at the technical aspects of printing, how to choose a suitable file size for the print you intend to make and what to do if you have to print it at a different size than originally intended. It includes a simple workflow from the camera to the final print setting and basic recommendations on what steps to take and in what order. This is aimed at the beginner using Painter and also covers sharpening and problems with printing textures.

You also need to carefully choose the paper to print on, a high-quality textured paper can make a huge difference to the final print. I use Permajet art papers in the UK which are excellent.

Understanding Color Management is vital to ensuring that the picture you see on screen will look the same when it is printed. This is a complex subject and I offer some basic suggestions on how to handle it when you use Painter.

Presentation is an important part of showing your work and in the second part of the chapter I show how to make simple vignettes and artistic edges to make the appropriate picture more attractive.

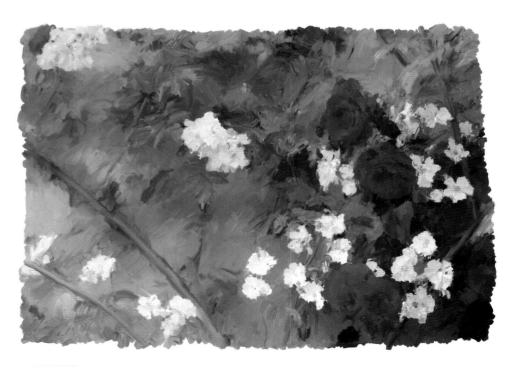

Figure 14.2 *Roses.*

A simple workflow

The workflow for Painter can be summarized in the following steps:

1 Photographic capture.
2 Importing into Painter.
3 Finishing the picture.
4 Preparing to print.

Photographic capture

Traditionally photographic capture has been on film and slides or negatives can be scanned using a slide or flatbed scanner and imported into Painter via Twain Acquire in the File menu.

Increasingly the capture is now made by digital methods and files can be imported using the Open command in the File menu provided they are in JPEG, TIFF or PSD format.

I will mention here the ability to photograph in RAW mode if your camera has this option. This is not the place to explain the many reasons why you should shoot in RAW mode, suffice it to say that in the majority of situations RAW mode will give you better quality and more flexibility over JPEG format.

You cannot however bring a RAW file directly into Painter so this must be done in another program. RAW files can be read in many programs, if you have Photoshop or Aperture or Lightroom these will work well, otherwise there are other RAW converters available including those from the main camera manufacturers Nikon and Canon.

It is better to turn off the sharpening in the camera and to do it prior to printing.

Figure 14.3 *The RAW converter in Adobe Bridge.*

File sizes

Early versions of Painter were notoriously slow in handling large files but Painter X has significantly improved in speed and this is no longer an issue with anything but very large files.

The question I am often asked is what file size is the best to use in Painter; there is no simple answer to this as it depends on many different things and in particular the original capture size and the final print size. Certainly I don't believe that you need huge file sizes and generally use between 10 and 20 Mb.

The best way to calculate the ideal file size is to decide upon the planned print size and work it back from there. So if the plan is to print on A4 (12 × 8 inches) paper and between 200 and 250 dpi then the ideal size would be between 11 and 17 Mb, however this is by no means essential and a 17 Mb file could easily be printed up to twice that size without significantly losing quality. As you will see later on we can increase the file size if necessary prior to printing.

For those new to digital capture it is worth mentioning that a photograph taken with camera that has a 6 Mb specification will open up as about 17 Mb in Painter, this is because the file is compressed in the camera.

Sharpening

Before printing it is usually necessary to sharpen the picture. This can be done in Painter by going to Effects> Focus> Sharpen. Select the Gaussian option as this generally gives the best result and adjust the sliders.

The amount controls the overall level of sharpening while the other two sliders restrict the sharpening to either the highlights or the shadows. The tick boxes will also restrict the effect to one of the three color channels.

The amount of sharpening required will vary from picture to picture and often is not required at all. I prefer to keep the

Figure 14.4 Sharpen dialog box.

sharpening to a minimum as over sharpening can easily ruin a fine picture.

The best way to apply sharpening is at the very end when the picture is finished, make a new copy of the file and give it a new name (add sharpened to the file name). Drop all of the layers if necessary and make a copy of the canvas (Select> All, Edit> Copy, Edit> Paste in Place) and sharpen that layer. Adjust the layer opacity to reduce the sharpening if required.

The amount of sharpening will also depend on the file size, the print size and the surface being printed on. The larger the file and print size the more sharpening will normally be required. If you are printing on a textured finish such as canvas the sharpening can be stronger than on a smooth paper. It is impossible to give specific amounts for these so experience and test prints are the way to learn how much sharpening needs to be applied.

Preparing to print

When you are ready to print you need to check the printing dpi and set the dimensions. Go to Canvas> Resize and the current sizes of the image are shown, as in Figure 14.5. In this example the picture will print at 8.33×8.33 inches at a resolution of 240 dots per inch (dpi).

To print this at a larger size without changing the file, tick the Constrain File Size box and change the dimensions to the size you want to print. Try changing to 12 inches and see that the resolution has dropped to 166.7 dpi which is still quite acceptable for most painterly pictures. To print go to File> Print and the printer dialog box will appear where you can set the paper size and printing options, this dialog box will vary depending on what printer you are using.

Figure 14.5 *Resize dialog box.*

Increasing the file size

If the resolution drops too low you may need to resize the file, in this case remove the tick from the Constrain File Size box and enter the new print size, you will see that the file size has risen to 32 Mb in Figure 14.6.

There are other ways in which to resize the picture, Photoshop has more sophisticated ways of doing this and there are many independent programs such as Size Fixer and Genuine Fractals which can be purchased and which give a much wider range of options.

Many photographers believe that rather than increasing the file size in one jump, a better result can be obtained by increasing the

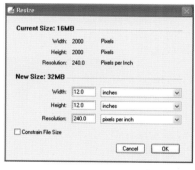

Figure 14.6 *Resizing the file size.*

file in small steps, that is by making a 10% increase and repeating the process until the required size is achieved. This can be made easier by creating a Script which can be run many times by pressing one button for each increase.

To make a script go to Window> Show Scripts. Make a new empty file and type in the picture space 10% to fill the file size, this will provide the icon in the palette (circled in Figure 14.7). Click the red button at the bottom of the palette to start recording and then go to Canvas> Resize and change the box to read percent and the dimensions to 110%, untick Constrain File Size and click OK. Press the Stop icon (bottom left in the Scripts palette) and this will bring up a dialog box in which you can name the script.

Figure 14.7 *Scripts palette.*

To run the script first select the script required by clicking on the blue arrow and choosing the one you named and simply press the Play button as many times as necessary until you get to the file size you require.

Color Management

Color management plays an important part in getting the printed image as close as possible to the image we see on the computer screen. The whole subject of color management is very complex and is the subject of several books so the following notes are a brief summary and include some practical tips on what settings to choose.

The Color Management controls are available from the Canvas menu and the dialog box is shown in Figure 14.8 with its default settings.

If you are using Painter X as a standalone program the following notes will help you with the settings required.

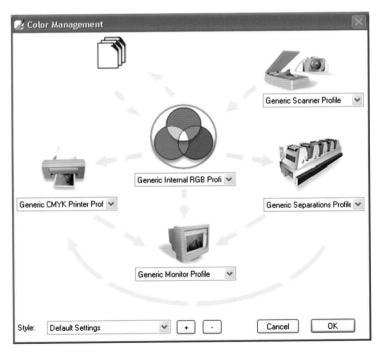

Figure 14.8 *The Color Management dialog box.*

Color profiles

Each device, whether it is a printer, monitor or scanner has a different way of using colors and to get them all working together means that they must communicate their own method to the other parts of the system. This is achieved by creating a color profile for each device which contains all the necessary information. The profiles are called ICC profiles and are controlled through the Kodak Color Management System.

Color profiles can be provided in various ways, the most accurate result will be by employing a specialist to calibrate your system. They will use expensive specialist equipment to analyze each device and will create a custom set of profiles for you to use.

The next best is to purchase calibration equipment yourself; there are several devices available at various price levels. These will be specific to your own devices and will therefore be reasonably accurate, depending on the system used.

The cheapest option is to use generic profiles provided by the equipment manufacturers, these are usually available from the supplier's websites at no cost. They will be based on the manufactured device, but not specific to your particular equipment. They may or may not be accurate, but are worth trying if you cannot get the profiles written any other way.

Using profiles in Painter X

Go to Canvas> Color Management and the dialog box will appear as seen in Figure 14.8 – you must have a document open in Painter to access this. There are a series of grayed out arrows going in various directions, click on any one and the arrow color will turn to orange which indicates that color management is now active for that particular link.

Selecting profiles

Click on the drop down menu below the computer monitor icon and a list of profiles will appear. If you have created a monitor profile, click on the name to select it. If you have a monitor profile and it does not appear in this list, click on 'get profile from disc' and navigate to where your profile has been saved.

Use the same process to allocate profiles for your printer and scanner. Bear in mind that you will need to change the printer profile when you print on a different paper.

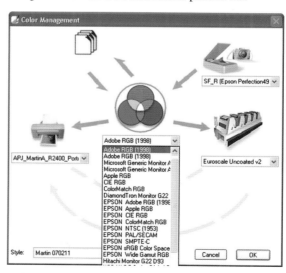

Figure 14.9 Selecting the profile.

Click the drop down menu below the RGB color icon in the centre, and select a color space from the list (Figure 14.9). If you are already using a color space for other programs select that one, otherwise use the Generic Internal RGB profile.

Click on the pages icon top left to reveal the Advanced Import/Export settings (Figure 14.10).

When using programs such as Photoshop and Painter color space profiles can be embedded as part of the image file and this dialog box determines how Painter will handle these profiles when importing or exporting.

At the top are buttons to choose CMYK or RGB and the series of options beneath will control whether profiles will be used.

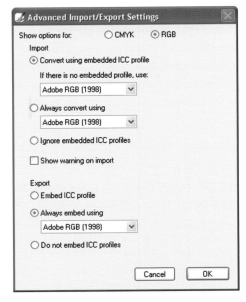

Figure 14.10 Advanced Import/Export.

In the Import section it is generally better to select the 'Convert to embedded ICC profile' option as this will keep whatever profile the image already contains. The other choices are to change the profile or to ignore the profile.

In the Export section the first option will export the picture with the color profile and this is the option most used. The other options will specify which profile is to be embedded and again, to ignore the ICC profile.

Click the grayed out arrows to activate the profiles you are using, this can be seen in Figure 14.11. When you have set all the various options and are happy that they are right for you, the settings can be saved. Click the + button at the bottom of the dialog box and enter a name in the Save box. In the Style box, click to reveal the drop down menu and select the name for the setting you have just saved, this will make them active.

Figure 14.11 Showing the color management arrows active.

This quick overview should help you set up the key options for color management, it is difficult to be more specific as the requirements are different due to the many ways in which Painter is used. For a more detailed description of color management issues go to Help> Welcome ... and click on the bottom tab of the new Welcome screen which opens when Painter is started.

Problems with printing textures

A well selected texture can considerably enhance the final appearance of a picture however it must be said that it can also ruin the picture if applied incorrectly. The main problem is trying to assess how the picture and texture will actually print, often the picture will look really good on screen, but when printed it will look quite different. There are a number of reasons for this and it is worth bearing the following issues in mind when deciding upon a paper texture.

Viewing on screen

One of the biggest barriers to deciding on a texture is the difficulty of assessing the result on the computer screen.

Take the following example shown in Figure 14.12. This file has had paper textures applied at four different strengths, however when viewed at 25% enlargement on screen the texture on the left has changed to a pattern and is unrecognizable. Enlarge

Figure 14.12 *Viewing textures on screen.*

the view on screen one step to 33% and that texture will look OK, but the second panel will have a pattern imposed over the picture.

The reason for this problem is that the computer screen is made up of a fixed number of pixels so when we try to show the whole picture on screen it can only show as many pixels as the screen resolution is set to. All the other pixels in your file will be hidden. This does not normally cause a problem, but when a regular pattern such as a paper texture is applied the screen pixels interact with the pixels in the picture and can create an interference pattern.

To avoid this problem completely you need to view the picture as Actual Pixels. This can be done in two ways, by activating the Hand in the Toolbox and clicking Actual Pixels on the Properties bar, or by using the keyboard shortcut Ctrl/Cmd + Alt/Opt + 0 (zero). This will show how the texture will look more accurately, the problem then is that we can see only a small part of the picture, particularly if you are using a large file.

Although it will not completely solve the problem, one way to avoid some of these problems is to stick to certain enlargement ratios, you will get less interference patterns when you use 75%, 50% and 25% views.

One final word on the subject of screen viewing, these interference patterns are only a screen-based artifact, they will not actually print, unless you can see them at Actual Pixels size in which case they may.

How file sizes affect paper textures

The actual size of the picture on which you apply the texture will, to a large degree determine the size of the paper texture which you choose in the Papers palette. In Figure 14.13 the Artists Canvas texture has been applied to a picture which is 23 Mb file. Figure 14.14 shows the same level of paper texture but applied to a file which is just 4 Mb. As you can see the texture is very overpowering on the 4 Mb picture but barely visible on the other. Another variation here is that the illustrations have been printed in this book at another resolution so the effect may not show correctly, but the difference should be apparent.

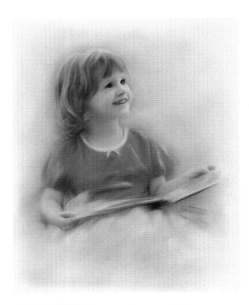

Figure 14.13 Canvas texture applied to a 23 Mb file.

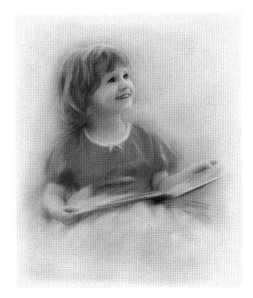

Figure 14.14 Canvas texture applied to a 4 Mb file.

How print sizes affect paper textures

The final variable to be taken into account is the size at which the final picture will be printed. If you are using a canvas texture then the texture should be somewhere close to the size of a real canvas texture. Looking at the two pictures above it should be obvious that to print the 4 Mb file up to an A3 (16 × 12 inches) size would result in the print having a texture which is far too large and distracting, quite apart from the issues of quality of a small file.

Resampling files with paper textures

When you have small file which you need to print larger than originally anticipated it is often useful to resample the file upwards to improve the print quality. However a word of warning, should you plan to do this with a picture that has a paper texture applied, don't! In nearly all cases it will result in unsightly lines in the print due to the pattern being repeated, rather like the screen examples shown in the previous page. If possible you should resample the file upwards and then apply the paper texture afterwords.

Edge effects

Edge effects are easy to make in Painter and can add a lot to the right picture. This step-by-step example uses two different brushes and two layers to make a flexible edge effect.

Step 1 File> Open> DVD Step-by-step files> '14 Collie'.
Step 2 Make a new layer.
Step 3 Effects> Fill with current color. Select White in the Color palette, this will block out the picture.
Step 4 Add a layer mask by clicking on the mask icon in the Layers palette.
Step 5 Click on the mask to make it the active layer.

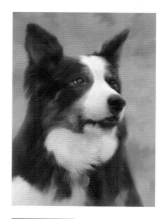

Figure 14.15 *Starting picture.*

Step 6 Select the Artists Oils> Bristle Brush, size 52, opacity 100%, tick the Dirty mode option on the Properties bar.
Step 7 Change the color to Black and paint into the picture mask and as you paint, the layer beneath will be revealed. Make single brush strokes from the top and ensure that the brush strokes have a good edge which show the bristles. Continue down the picture leaving white all around the edges and when you get to the bottom take care to get good shaped brush strokes as at the top. Bear in mind that all of the Artist Oils brushes run out of paint so use short brush strokes. The result should look much like in Figure 14.12.

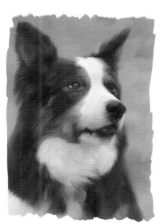

Figure 14.16 *The Artists Oil brush mask.*

Step 8 Now we will do the same process again using a different brush on a new layer. The combination of two brushes will give the edge a better finish.

Step 9 Make a new layer on the top of the layer stack.

Step 10 Effects> Fill with current color. Select White in the Color palette, this will block out the picture.

Step 11 Add a layer mask by clicking on the mask icon in the Layers palette.

Step 12 Click on the mask to make it the active layer.

Step 13 Select the Acrylics Dry Brush, size 78, opacity 100%, Feature 6.6 and paint into the mask with black. This brush will leave rough streaks on the picture so allow them to stay revealed on the edges but paint out the centre so that the dog is clear.

Figure 14.17 Final layers palette.

Step 14 The edge of the first mask defines the outer edge while the second mask adds texture to the picture. The final layers stack is shown in Figure 14.17 and the final picture at the start of this chapter.

Underpainting palette

Another way of creating soft edges is to make vignettes using the edge effects option in the new Underpainting palette.

In this palette under the heading of Edge Effect there is a simple menu where a particular shape of vignette can be selected, circular, rectangular or jagged and a slider to control the strength of the effect. Also in this palette are various options to alter the appearance of your picture, sliders to control tones, color and saturation, these are simple controls which are very easy to use.

The option called Color Scheme will overlay a preset color scheme on your picture, these have titles such as Classical, Watercolor and Sketchbook and can be used as a base for a clone picture.

Figure 14.18 Underpainting palette.

The examples in Figures 14.19–14.24 show some of the effects possible using this palette.

Figure 14.19 Rectangular vignette.

Figure 14.20 Circular vignette.

Figure 14.21 Jagged vignette.

Figure 14.22 Hue changed and the dog restored to original color with a layer.

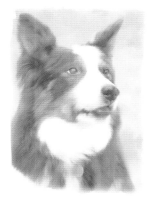

Figure 14.23 Saturation reduced and contrast increased.

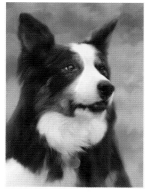

Figure 14.24 Chalk scheme with saturation reduced and contrast increased.

301

Figure 15.1 Portrait of Donna cloned with papers from sixteen different paper libraries.

15

Paper libraries

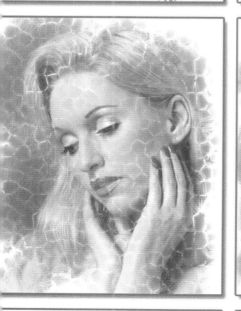

Papers are used extensively throughout Painter but there is no available reference where all of the papers can be easily viewed. This chapter illustrates all the papers available in the Painter X program including the additional libraries available on the Painter program CD.

Details of how to load the extra papers from the Corel Painter program CD are given in Chapter 5.

When you look at all the different papers available (and some of them are quite strange), try to imagine how they will look imposed on your own picture. It is important not to overwhelm the picture you are making with the pattern as the paper should support and enhance the image. Sometimes, of course, the paper texture can be used in a way that is an integral part of the image, as in the picture below which used the River Map paper from the Weird library.

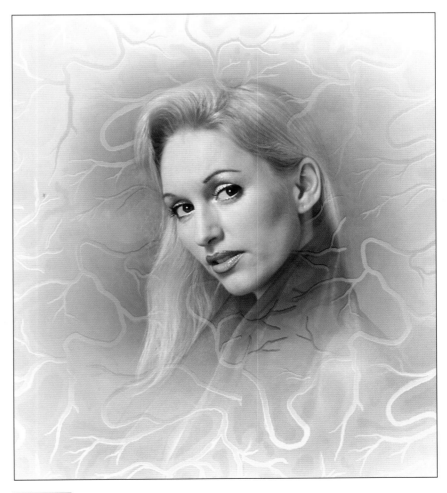

Figure 15.2 Cocooned

Painter X default papers

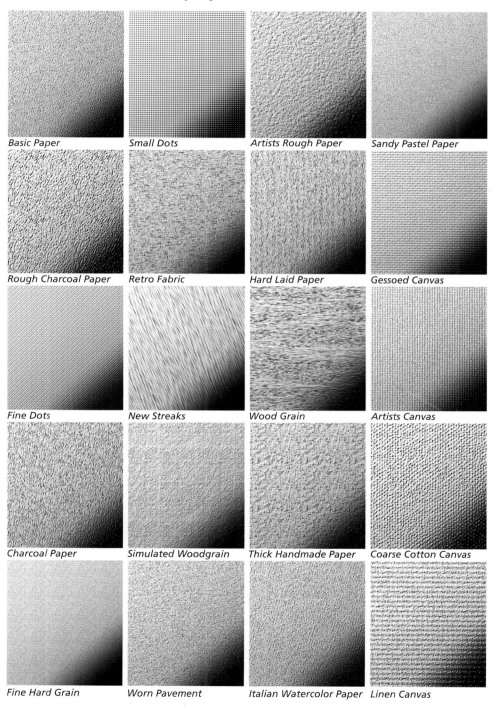

Basic Paper	*Small Dots*	*Artists Rough Paper*	*Sandy Pastel Paper*
Rough Charcoal Paper	*Retro Fabric*	*Hard Laid Paper*	*Gessoed Canvas*
Fine Dots	*New Streaks*	*Wood Grain*	*Artists Canvas*
Charcoal Paper	*Simulated Woodgrain*	*Thick Handmade Paper*	*Coarse Cotton Canvas*
Fine Hard Grain	*Worn Pavement*	*Italian Watercolor Paper*	*Linen Canvas*

Painter X default papers (*continued*)

Pebble Board *Hot Press* *French Watercolor Paper*

Assorted textures

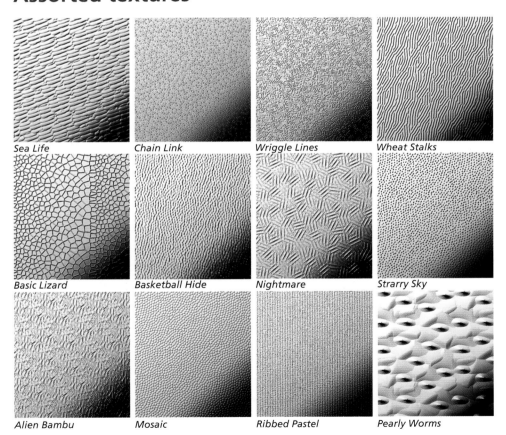

Sea Life *Chain Link* *Wriggle Lines* *Wheat Stalks*

Basic Lizard *Basketball Hide* *Nightmare* *Strarry Sky*

Alien Bambu *Mosaic* *Ribbed Pastel* *Pearly Worms*

Assorted textures (*continued*)

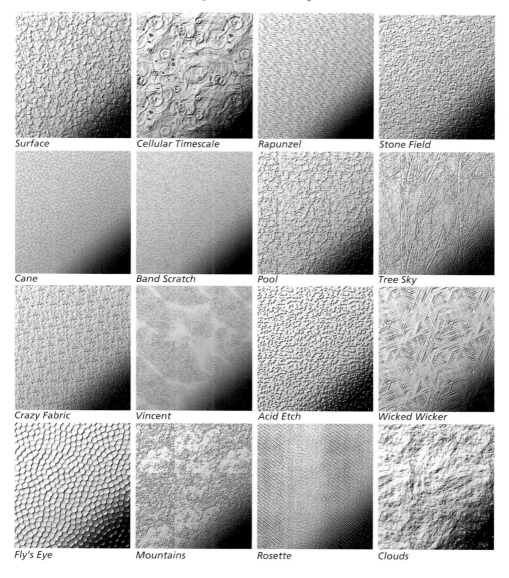

Surface	*Cellular Timescale*	*Rapunzel*	*Stone Field*
Cane	*Band Scratch*	*Pool*	*Tree Sky*
Crazy Fabric	*Vincent*	*Acid Etch*	*Wicked Wicker*
Fly's Eye	*Mountains*	*Rosette*	*Clouds*

Awesome textures

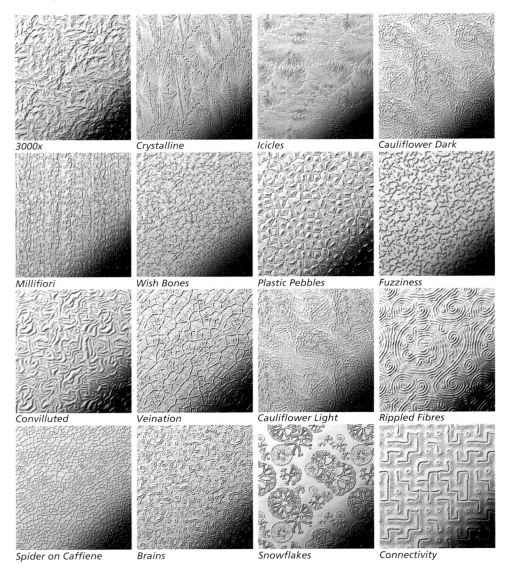

3000x Crystalline Icicles Cauliflower Dark

Millifiori Wish Bones Plastic Pebbles Fuzziness

Convilluted Veination Cauliflower Light Rippled Fibres

Spider on Caffiene Brains Snowflakes Connectivity

Biological textures

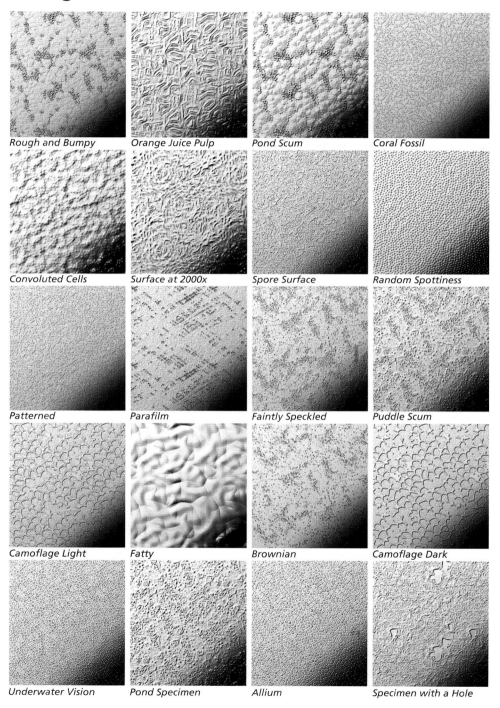

Rough and Bumpy

Orange Juice Pulp

Pond Scum

Coral Fossil

Convoluted Cells

Surface at 2000x

Spore Surface

Random Spottiness

Patterned

Parafilm

Faintly Speckled

Puddle Scum

Camoflage Light

Fatty

Brownian

Camoflage Dark

Underwater Vision

Pond Specimen

Allium

Specimen with a Hole

309

Branched textures

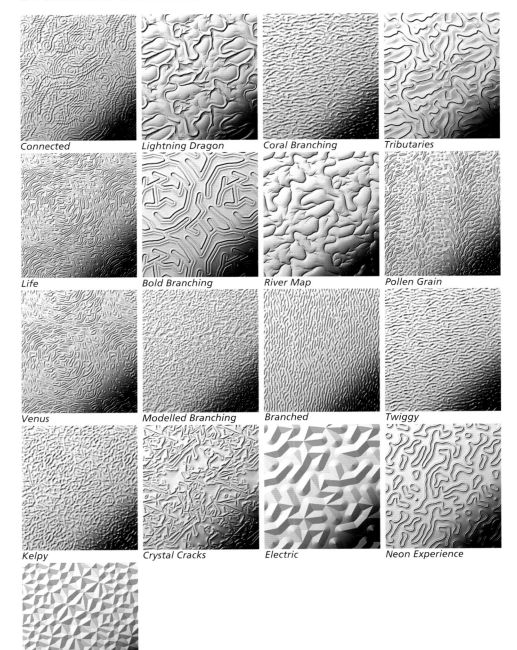

Connected

Lightning Dragon

Coral Branching

Tributaries

Life

Bold Branching

River Map

Pollen Grain

Venus

Modelled Branching

Branched

Twiggy

Kelpy

Crystal Cracks

Electric

Neon Experience

Neon Lattice

Contrasty textures

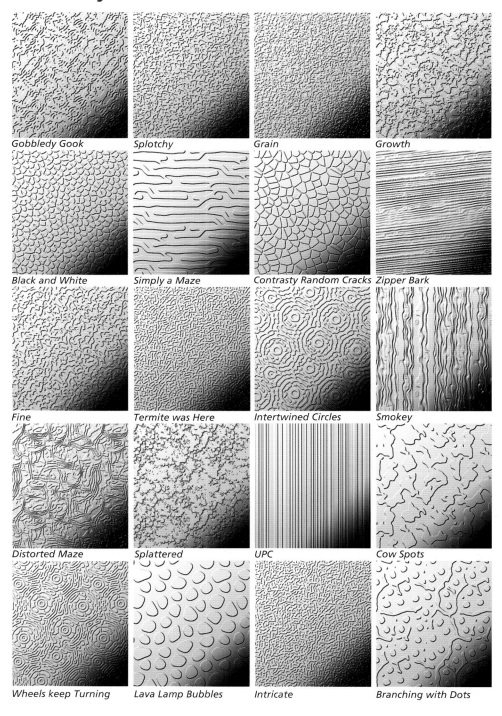

Gobbledy Gook | Splotchy | Grain | Growth

Black and White | Simply a Maze | Contrasty Random Cracks | Zipper Bark

Fine | Termite was Here | Intertwined Circles | Smokey

Distorted Maze | Splattered | UPC | Cow Spots

Wheels keep Turning | Lava Lamp Bubbles | Intricate | Branching with Dots

Contrasty textures (*continued*)

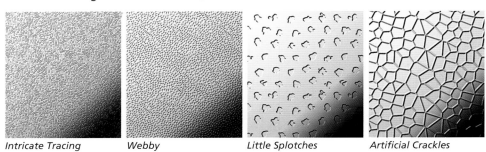

Intricate Tracing *Webby* *Little Splotches* *Artificial Crackles*

Crack textures

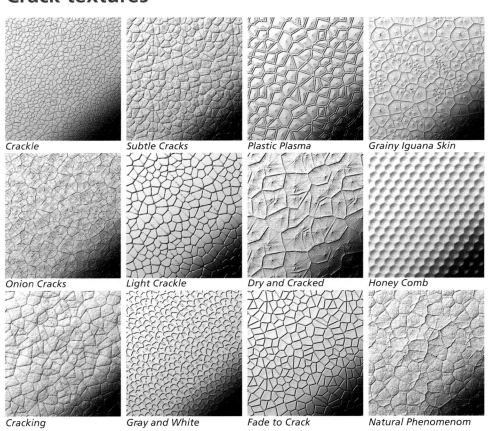

Crackle *Subtle Cracks* *Plastic Plasma* *Grainy Iguana Skin*

Onion Cracks *Light Crackle* *Dry and Cracked* *Honey Comb*

Cracking *Gray and White* *Fade to Crack* *Natural Phenomenom*

Crack textures (*continued*)

Faded Cracks *Cracked Universe* *Antique*

Crazy textures

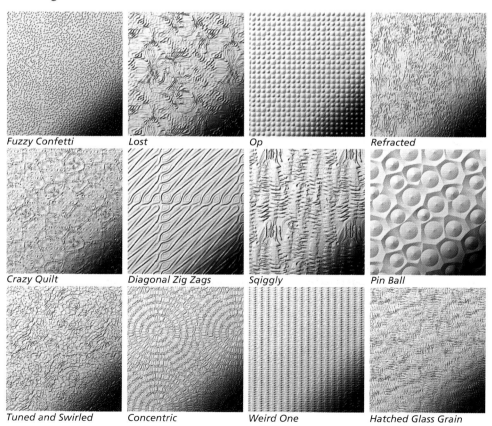

Fuzzy Confetti *Lost* *Op* *Refracted*

Crazy Quilt *Diagonal Zig Zags* *Sqiggly* *Pin Ball*

Tuned and Swirled *Concentric* *Weird One* *Hatched Glass Grain*

Crazy textures (*continued*)

Squares with Dots Mixed Confused

Drawing Paper textures

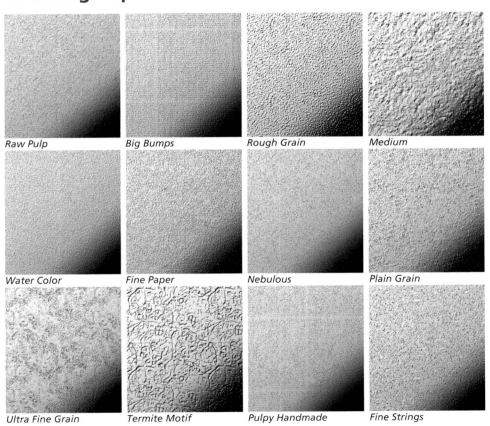

Raw Pulp Big Bumps Rough Grain Medium

Water Color Fine Paper Nebulous Plain Grain

Ultra Fine Grain Termite Motif Pulpy Handmade Fine Strings

Drawing Paper textures (*continued*)

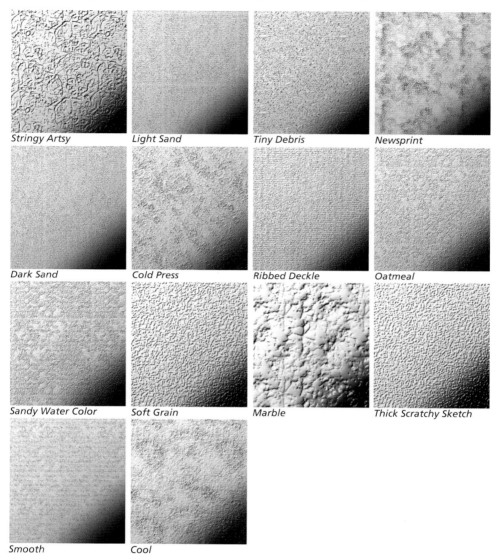

Stringy Artsy

Light Sand

Tiny Debris

Newsprint

Dark Sand

Cold Press

Ribbed Deckle

Oatmeal

Sandy Water Color

Soft Grain

Marble

Thick Scratchy Sketch

Smooth

Cool

315

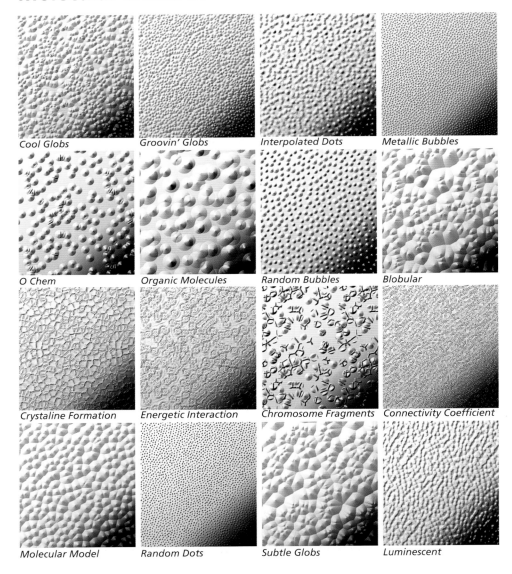

Molecular textures

Cool Globs

Groovin' Globs

Interpolated Dots

Metallic Bubbles

O Chem

Organic Molecules

Random Bubbles

Blobular

Crystaline Formation

Energetic Interaction

Chromosome Fragments

Connectivity Coefficient

Molecular Model

Random Dots

Subtle Globs

Luminescent

Organismal textures

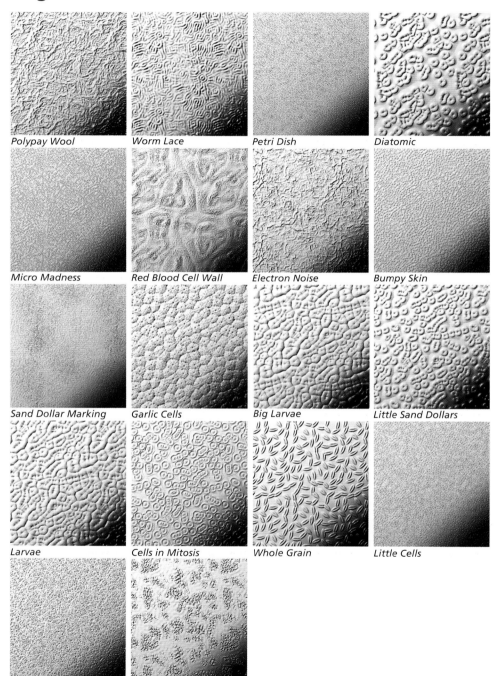

Polypay Wool

Worm Lace

Petri Dish

Diatomic

Micro Madness

Red Blood Cell Wall

Electron Noise

Bumpy Skin

Sand Dollar Marking

Garlic Cells

Big Larvae

Little Sand Dollars

Larvae

Cells in Mitosis

Whole Grain

Little Cells

Bumpy Elephant Skin

Plaque

Painter 5.5 textures

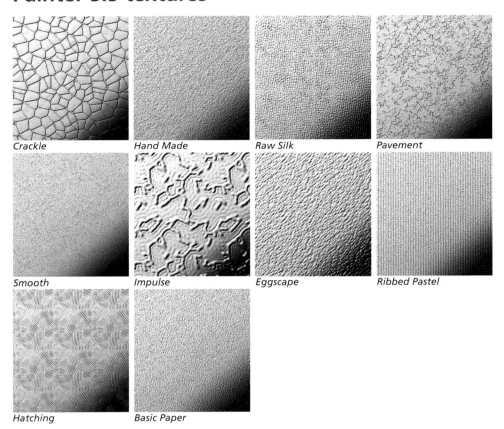

Crackle Hand Made Raw Silk Pavement

Smooth Impulse Eggscape Ribbed Pastel

Hatching Basic Paper

Painter 6 textures

(Where different to Painter 5.5 textures)

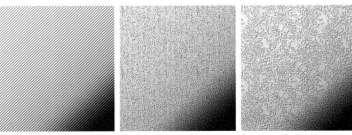

Halftone Regular Fine Big Rough Grain

Painter 7 textures

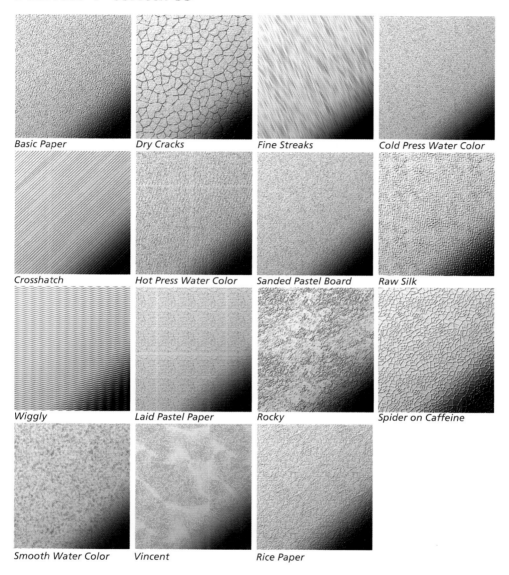

Basic Paper

Dry Cracks

Fine Streaks

Cold Press Water Color

Crosshatch

Hot Press Water Color

Sanded Pastel Board

Raw Silk

Wiggly

Laid Pastel Paper

Rocky

Spider on Caffeine

Smooth Water Color

Vincent

Rice Paper

Paper textures

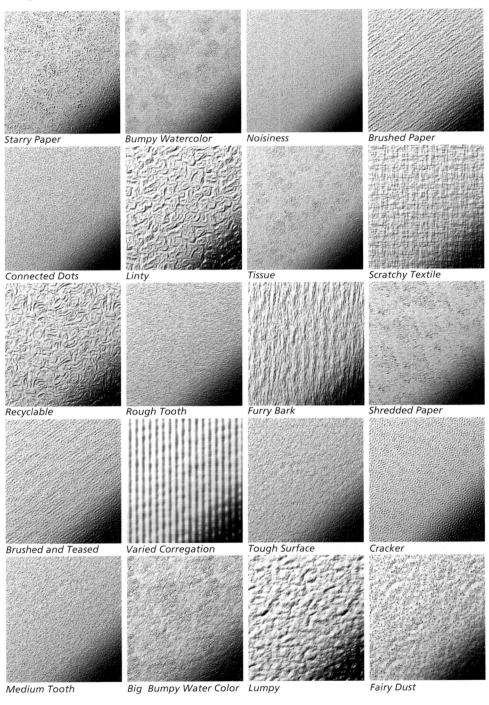

Starry Paper

Bumpy Watercolor

Noisiness

Brushed Paper

Connected Dots

Linty

Tissue

Scratchy Textile

Recyclable

Rough Tooth

Furry Bark

Shredded Paper

Brushed and Teased

Varied Corregation

Tough Surface

Cracker

Medium Tooth

Big Bumpy Water Color

Lumpy

Fairy Dust

Paper textures (*continued*)

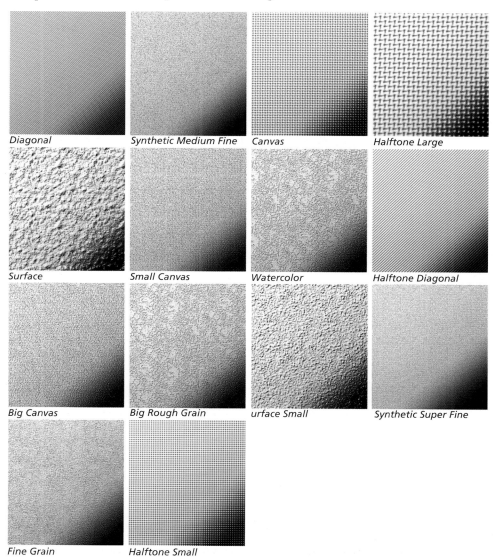

Diagonal

Synthetic Medium Fine

Canvas

Halftone Large

Surface

Small Canvas

Watercolor

Halftone Diagonal

Big Canvas

Big Rough Grain

urface Small

Synthetic Super Fine

Fine Grain

Halftone Small

Relief textures

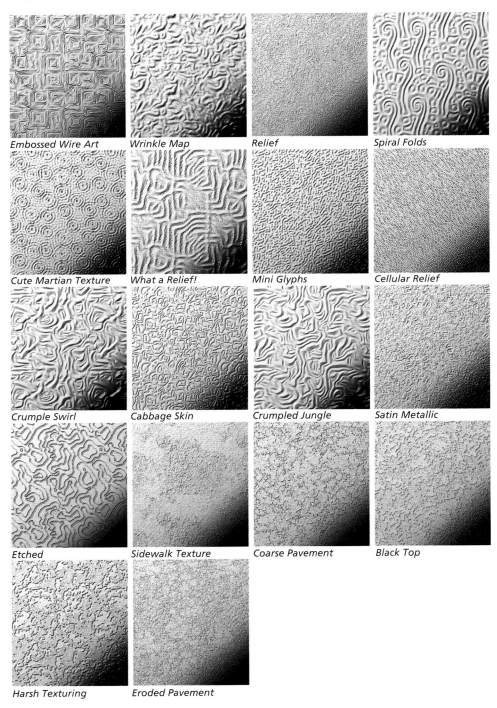

Embossed Wire Art Wrinkle Map Relief Spiral Folds

Cute Martian Texture What a Relief! Mini Glyphs Cellular Relief

Crumple Swirl Cabbage Skin Crumpled Jungle Satin Metallic

Etched Sidewalk Texture Coarse Pavement Black Top

Harsh Texturing Eroded Pavement

Subtle textures

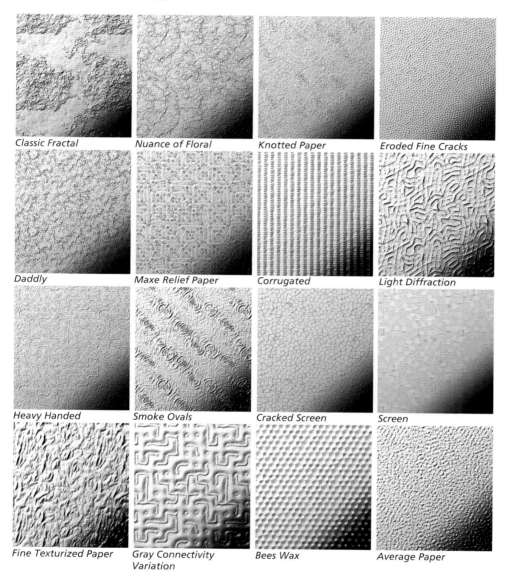

Classic Fractal

Nuance of Floral

Knotted Paper

Eroded Fine Cracks

Daddly

Maxe Relief Paper

Corrugated

Light Diffraction

Heavy Handed

Smoke Ovals

Cracked Screen

Screen

Fine Texturized Paper

Gray Connectivity
Variation

Bees Wax

Average Paper

Textile textures

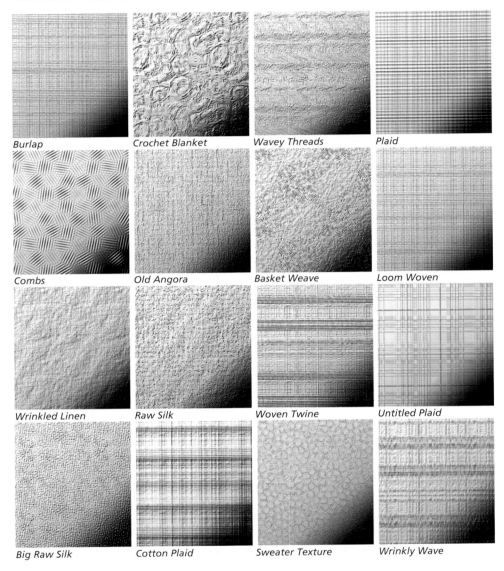

Burlap

Crochet Blanket

Wavey Threads

Plaid

Combs

Old Angora

Basket Weave

Loom Woven

Wrinkled Linen

Raw Silk

Woven Twine

Untitled Plaid

Big Raw Silk

Cotton Plaid

Sweater Texture

Wrinkly Wave

Weird textures

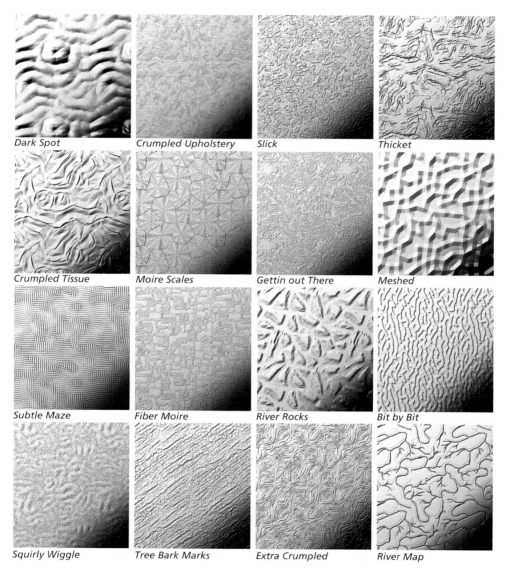

Dark Spot

Crumpled Upholstery

Slick

Thicket

Crumpled Tissue

Moire Scales

Gettin out There

Meshed

Subtle Maze

Fiber Moire

River Rocks

Bit by Bit

Squirly Wiggle

Tree Bark Marks

Extra Crumpled

River Map

Wild textures

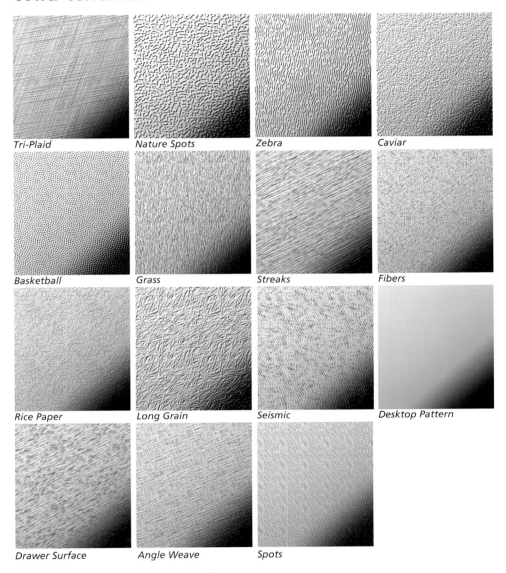

Tri-Plaid

Nature Spots

Zebra

Caviar

Basketball

Grass

Streaks

Fibers

Rice Paper

Long Grain

Seismic

Desktop Pattern

Drawer Surface

Angle Weave

Spots

Wild textures (*continued*)

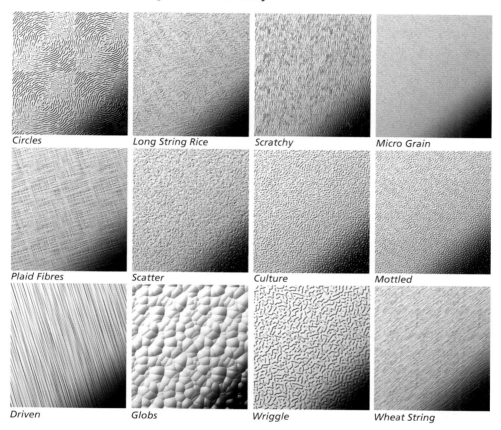

Circles Long String Rice Scratchy Micro Grain

Plaid Fibres Scatter Culture Mottled

Driven Globs Wriggle Wheat String

Last word

Congratulations!

You have now reached the end of the book and whether you have worked through the examples or just skimmed it and taken out bits, I hope that you have found it valuable and stimulating. So now it's over to you to use your own photographs and to create some top quality artwork.

This is not the end of course, it is just the beginning of what hopefully will be a fascinating and rewarding journey into using Painter for your creative uses. Painter X is after all just a tool for your own creativity, great tool that it is.

Practice lots and have fun!

Painter X for Photographers DVD

The accompanying DVD for this book contains video tutorials for many of the techniques described, this is an invaluable guide to see Painter in action with an audio commentary giving hints and tips as each picture progresses from a photograph to the final image.

It also contains all the original photographs for you to work through the step-by-step exercises in Painter X for Photographers together with more detailed versions of some of the images to clarify details which are not always apparent in the printed book.

Further resources

There are many resources on the web which you can access and often link to other sites, here are a few to start with.

www.painterforphotographers.co.uk

Painterforphotographers is the website which accompanies this book. There are additional step-by-step techniques, galleries, information and links to other Painter sites, plus amendments to this book and FAQs from readers.

www.corel.com

The home site of Corel is where you can find information on the latest versions of Painter, updates and training. Look out in particular for the Painter Canvas, a regular newsletter which has tutorials and news about Painter.

www.digitalpaintingforum.com

Marilyn Sholin runs this Digital Painting Forum which allows members to participate and share ideas and pictures with other Painter users.

Index